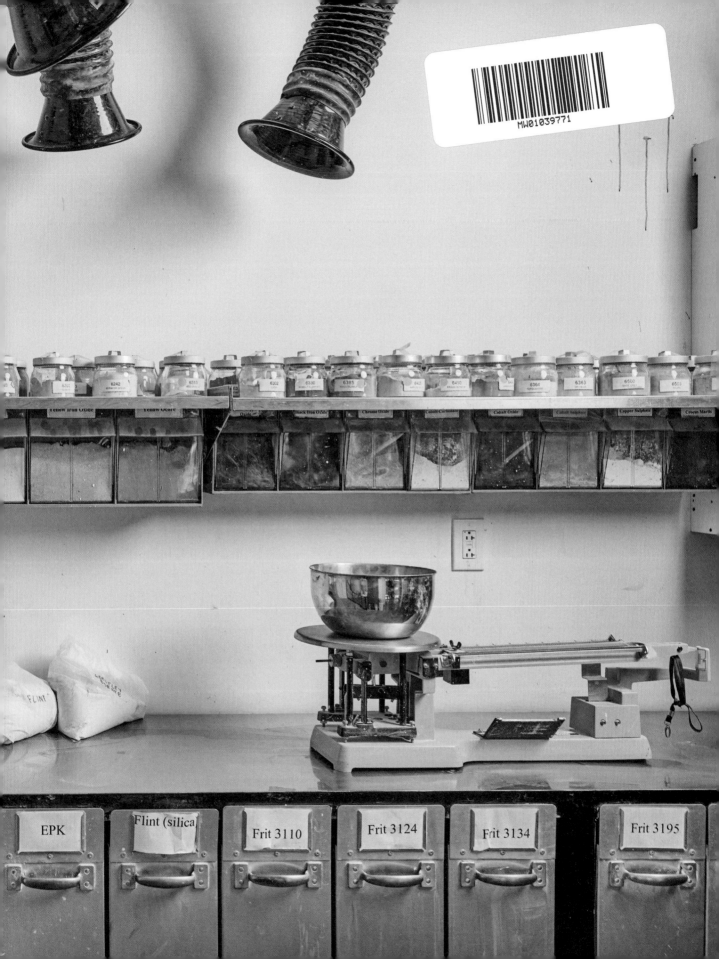

THE COMPLETE GUIDE TO

LOW-FIRE GLAZES

FOR POTTERS AND SCULPTORS

Matt Wedel *Flower Tree*.
Photo courtesy of Jeff
McLane.

THE COMPLETE GUIDE TO
LOW-FIRE GLAZES
FOR POTTERS AND SCULPTORS

TECHNIQUES, RECIPES, AND INSPIRATION FOR LOW-TEMPERATURE FIRING WITH BIG RESULTS

BEN CARTER

QUARRY

Quarto.com

© 2024 Quarto Publishing Group USA Inc.
Text and images © 2024 Ben Carter

First Published in 2024 by Quarry Books,
an imprint of The Quarto Group,
100 Cummings Center, Suite 265-D,
Beverly, MA 01915, USA.
T (978) 282-9590 F (978) 283-2742

Quarry Books titles are also available at
discount for retail, wholesale, promotional,
and bulk purchase. For details, contact
the Special Sales Manager by email at
specialsales@quarto.com or by mail at
The Quarto Group, Attn: Special Sales
Manager, 100 Cummings Center, Suite
265-D, Beverly, MA 01915, USA.

10 9 8 7 6 5 4 3 2 1

ISBN: 978-0-7603-8584-5

Digital edition published in 2024
eISBN: 978-0-7603-8585-2

Library of Congress Cataloging-in-
Publication Data available

Design and layout: Burge Agency
Cover Image: Dominic Episcopo (front),
 Jim Greipp (bottom back), and Catie
 Miller (top back)
Endpapers: Dominic Episcopo

Printed in China

ACKNOWLEDGMENTS

First, I'd like to thank my wife, Melissa Brzycki, for her encouragement and for being a sounding board throughout the writing process. She had the dubious honor of reading the first draft of this book, so I appreciate her perseverance and kindheartedness. Additionally, I'd like to thank Linda Arbuckle, Matt Katz, and Pete Pinnell for reading the book and providing valuable feedback. To my editor, Michelle Bredeson, thank you for stewarding me through the publication process. To my research partner, Celia Feldberg, a huge thank you for being a part of this book. Without your glaze testing and input, the book would never have materialized in its current form. Many thanks to Highwater Clays for donating the clay for our testing and to The Clay Studio for allowing us to use the glaze lab to conduct our research and shoot images for the book. And lastly, I want to thank the artists in the book who are pushing ceramics forward in new and exciting ways.

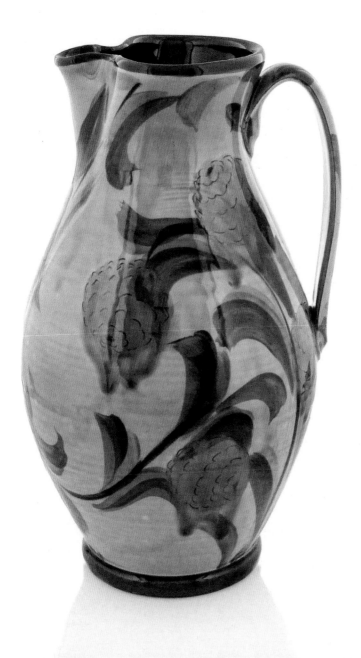

Ben Carter pitcher. Photo courtesy of Clay AKAR.

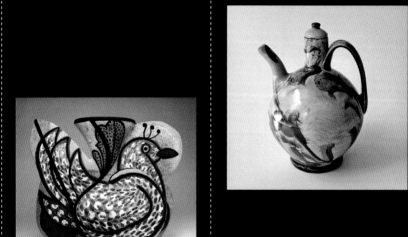

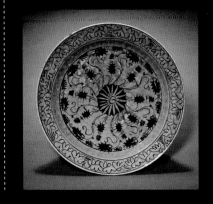

3

4

5

CHAPTER 3:
FINDING YOUR
SURFACE 61

Building Layers with Slip and Underglaze	62
Terra Sigillata	78
Tin Glaze	84
Glaze as Form: Goop, Nerifoami, and Low-Fire Porcelain	96
Satin and Matte Glazes	100
Atmospheric Firing	104
Luster	110
Decals	120
China Painting	126
Sculptural Surfaces	130

CHAPTER 4:
TRIED-AND-TRUE
GLAZE RECIPES 139

Gloss Glazes	140
Satin and Matte Glazes	148
Tin Glazes	155

CHAPTER 5:
LAB TESTS 163

Adding Colorants to a Glaze	164
Progression Tests	166
Understanding Colorants through Triaxial Blends	168

Resources	170
About the Author	172
About the Glaze Technician	172
Index	173

INTRODUCTION

This book is the guide I wished I had during my early career, as I spent years researching how to make functional pots in the low-fire genre. When I first came to ceramics in the mid-1990s, I was taught that low-fire glazes were superficial eye candy and that serious artists worked with high-temperature materials.

As I progressed in the field, I realized that this was not true. In fact, many of my favorite ceramic artists worked at low-fire temperatures. *The Complete Guide to Low-Fire Glazes* features reliable glaze recipes and focuses on ceramic artists who have worked in this genre of ceramics for much of their careers. The book is a comprehensive guide for potters, sculptors, and other artists who want to explore this temperature range.

The book is divided into five chapters that will guide your exploration of low-fire surfaces. Chapter 1 details how to set up your glaze lab and safely start testing new recipes. Chapter 2 focuses on the technical aspects of glaze formulation, including understanding the chemistry behind your materials. Chapter 3 is a broad survey of the surfaces artists are creating in the low-fire temperature range. Chapter 4 provides tried-and-true

recipes that are a foundation on which you can build your knowledge. Chapter 5 outlines testing methods that will help give definition to your research.

As you progress, make sure to document your testing through notes and pictures. I have found the ceramics community of Instagram and other social media platforms to be very supportive. If you feel up to sharing, post your research with the hashtag #lowfireceramics. I can't wait to see what you create.

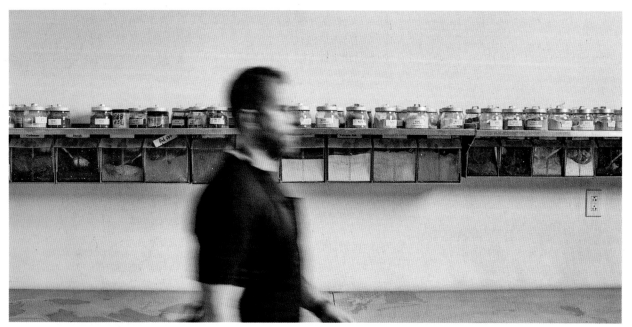

Photo courtesy of Dominic Episcopo.

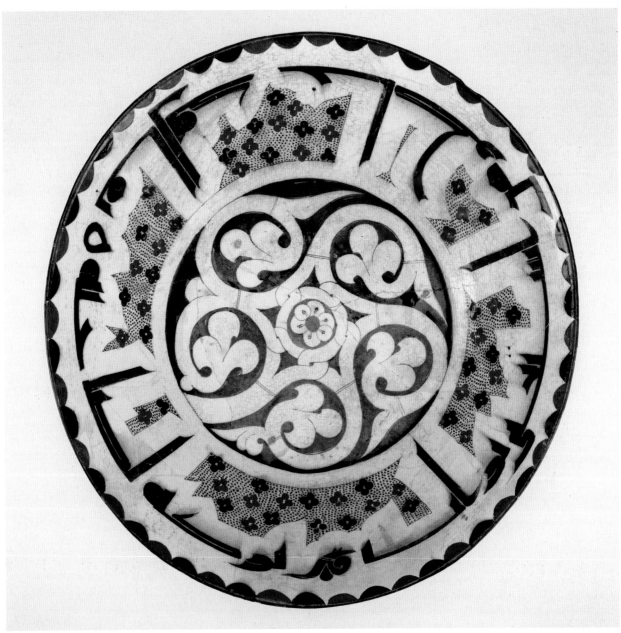

Samanid Bowl. Photo courtesy of the National Museum of Asian Art, Smithsonian Institution, Freer Collection, Purchase—Charles Lang Freer Endowment, F1957.24.

My appreciation for low-fire ceramics has been fueled by falling in love with historical ceramics. I had a particularly memorable moment at the Freer Gallery of Art in Washington, D.C., when I saw a Samanid Bowl from the tenth century. It stopped me in my tracks, and a firestorm of questions exploded in my mind: "Who made this? What does that writing say? How do you get a glaze to do that?" Seeing that one object set me on a research path that has taken many twists and turns over the years.

CHAPTER 1

GETTING STARTED

You might be asking yourself, "Why should I try low-fire ceramics?" With the materials available today, you can make versatile, durable, and beautiful glazes. The beauty of working at this temperature range is that you can count on vibrant color response from glaze materials that mature at lower temperatures. This translates to faster firings, less impact on your kilns, and cheaper firing costs. This chapter will help you set up your studio

SETTING UP
YOUR GLAZE LAB

My introduction to mixing glazes came in a high school ceramics course. We worked at mid-range temperatures and had a glaze closet stocked with mysterious powders. I dabbled with tried-and-true recipes like Floating Blue and did my best to memorize the names of the materials. When I enrolled in clay classes at Appalachian State University, I found a similar setup for glaze mixing with an organized lab centered around metal pullout bins.

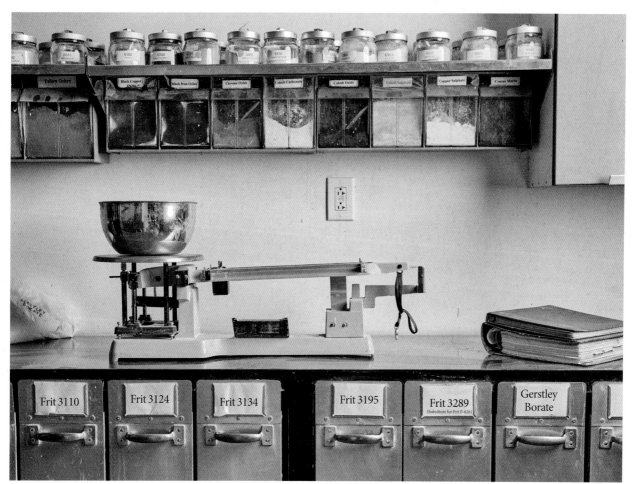

Glaze Lab at The Clay Studio, Philadelphia, PA. Photo courtesy of Dominic Episcopo.

This style of bin is a practical, durable solution for keeping materials separate, and they are the standard for glaze material storage at most academic institutions. However, when I was ready to set up my home glaze lab, I was shocked at how expensive these bins can be. Buying a set of those metal pullout bins would have cost as much as my first car.

In order to keep things simple and cost effective, I've chosen to work with smaller plastic containers with lids. When you're building your glaze lab, it's important to consider price, footprint, and maneuverability. While I still dream of buying a full set of metal pullout bins, in reality, they would not fit the small footprint of my glaze lab anyway. I do all my mixing in a converted one-car garage that also includes my kiln and workspace. I currently use Rubbermaid Slim Jim sixty-four–quart (61 L) trash cans with lids, each of which conveniently holds a fifty-pound (23 kg) bag of dry materials. They also slide easily under my worktables, which is a must for a small workshop. For smaller amounts of materials, I use Iris nineteen-quart (18 L) plastic bins with snap-on lids. This style of bin can hold quite a bit of material while not being too heavy to move. If you don't have a permanent studio space, consider how you might move your glaze lab as you're building it. I've moved studios almost a dozen times since becoming a potter, so I limit my glaze lab to the bare essentials for easy transport.

When setting up your studio, you don't need to buy all your materials at once. Start with the materials for your favorite glazes and expand from there when necessary. Consider carefully how much of each material you actually need. Early in my career, I bought large amounts of materials, thinking, "I'll definitely use this someday." Realistically, I could have saved money and studio space by buying materials in smaller amounts. Many clay materials are sold in dry powdered form in fifty-pound (23 kg) bags. That is a reasonable amount for working potters but might be overkill if you are just getting started. Consider buying materials in one-, five-, and ten-pound (0.5, 2.3, and 4.5 kg) increments. Clay distributors are used to helping people get started, so don't be afraid to ask if they can help you build your starter kit for glaze mixing.

LOW-FIRE STARTER KIT

The following materials appear in many recipes throughout the book and are a good place to establish a low-fire glaze lab. I suggest looking through the book to determine which glazes you want to test first and then purchasing small amounts to help you keep within a reasonable budget. Keep in mind that price per pound varies considerably between different components. Materials such as Old Mine #4 (OM4) Ball Clay are relatively cheap—currently $1.25 USD per pound, whereas lithium carbonate is $76.40 USD per pound. Materials marked (*) are essentials that you'll frequently use.

Edgar Plastic Kaolin (EPK)*

OM4 Ball Clay*

Silica 220 or 325 mesh*

Ferro Frit 3195*

Gillespie Borate or another Gerstley Borate substitute*

Spodumene or lithium carbonate

Whiting

Ferro Frit 3249

Ferro Frit 3110

Ferro Frit 3124

OTHER ESSENTIAL SUPPLIES

Once you have your materials, I suggest you label both the bags they came in and the containers (and lids) in which you'll store them. Many glaze materials look the same in their bag, so ten minutes of proper labeling will save you hours of guesswork in the future. If you spill a bit of a raw material when storing them, immediately wipe it up with a damp sponge. Spilled materials can lead to cross contamination and a dangerous abundance of clay dust in your studio. In addition to your raw materials, you'll also need the following pieces of equipment to keep you safe and organized while you're glaze testing:

Access to water and a good sink trap: If possible, use a utility sink that is large enough to wash your buckets and also tall enough to install a sink trap to collect glaze ingredients. There are many videos on YouTube that can guide you through making a sink trap using a five-gallon (19 L) bucket, which then can be removed and cleaned on a regular basis. Minimizing the amount of clay sediment that makes it into your plumbing will save you money in the long run.

Glaze buckets with lids: Two-gallon (8 L) and five-gallon (19 L) buckets are available at most hardware stores. Depending on the level of hydration, 3,000 grams of mixed glaze fits nicely in a two-gallon (8 L) bucket and 10,000 grams in a five-gallon (19 L) bucket.

Electronic scale: When buying a scale, consider how accurate you want it to be and how much you're willing to pay for that accuracy. The more decimal places you want to access in your measurements, the more expensive the scale will be. Thankfully, for less than $50 USD, you can buy an electronic scale that is accurate within

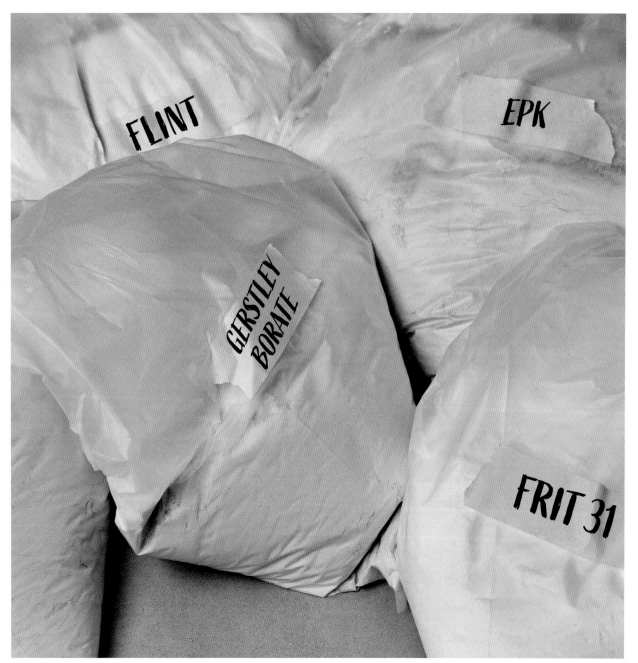

Bags of common ceramic materials. Photo courtesy of Dominic Episcopo.

+/− 1 gram. Visit thestudiomanager.com for helpful reviews of scales with budget and upgrade picks.

Apron: You want to keep your clay and glaze dust in your studio and away from your living space. Wearing an apron that you wash at the end of the day goes a long way in keeping your clothes and house clean.

Particulate mask with a N-95 rating: I suggest you invest in a half facepiece mask that has replaceable cartridges like the 3M 6000 Series mask (sold for less than $30 USD including N-95 rated filter cartridges). A shorter-term solution would be 3M's Aura mask ($1.50 USD), which is a disposable mask rated for particulates. Respirators should be wiped down and dried after each use, with their cartridges and mask being stored in separate zip top bags. Replace cartridges after eight hours of use or based on manufacturer's recommendation. I treat my respirator like my kitchen table. It's nice to have it clean when you need to use it.

Air purifier: For the past few years, I've been using a Coway Airmega AP-1512HH ($170 USD), which utilizes replaceable HEPA filters. While a mask is essential to glaze mixing, we tend to wear them only while we are mixing. An air purifier with a HEPA filter will take care of materials left in the air after you finish mixing. My studio is attached to my house, so I leave the air purifier running continuously to decrease the amount of particulates that might make it into my home.

Large square cleanup sponges: The rule of thumb I follow is that WET sponges work best for cleaning up DRY materials. Making a mess is a normal part of glazing, so I've made cleaning a part of my glazing routine.

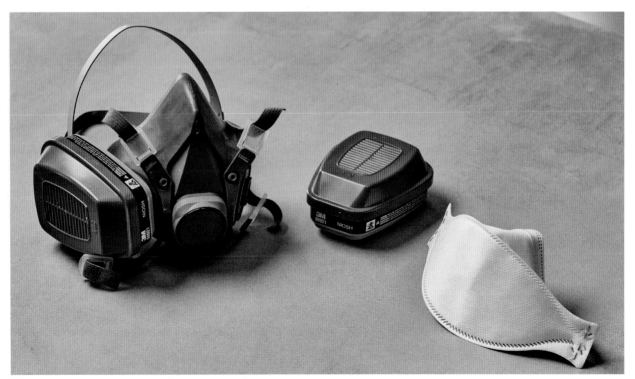

3M 6000 Series mask and a 3M Aura disposable N-95 mask. Photo courtesy of Dominic Episcopo.

STUDIO SAFETY
WHEN GLAZING

This book demonstrates a lot of 100- to 200-gram test batches in small containers. Once you find glazes you like, I encourage you to test them on full-scale wares and eventually use them in your regular studio cycle.

When you increase your batch volume, the weight of the bucket will increase dramatically as you add dry materials to water. After mixing, be mindful of lifting with your legs and not your back as you move buckets around the studio. You might consider buying or building small carts with wheels that allow you to move glaze buckets without having to pick them up.

My studio is a converted one-car garage with a slanted floor. This keeps me from putting my buckets on wheels, so instead, I built a low L shaped table that is twenty-seven inches (69 cm) high. The table can hold multiple five-gallon (19 L) buckets and is the perfect height for me to dip pots into glaze or slip without having to bend over.

Your glaze-mixing table height is another factor to consider when it comes to your back health. When mixing, you'll be standing with your hands in front of you, working on a repetitive task. If you're doing an action like wedging clay, a lower table is helpful so that you have leverage to move the clay around. An action like measuring, sifting, or stirring doesn't

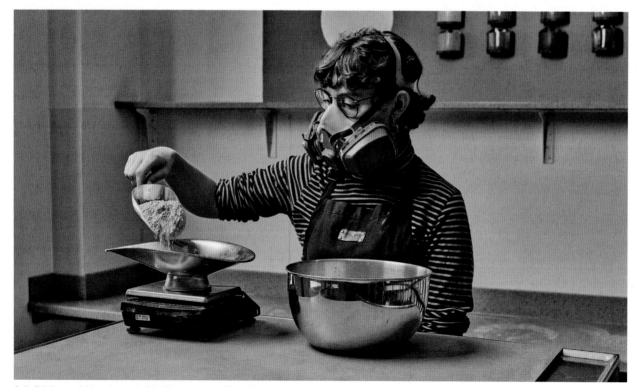

Celia Feldberg weighing glaze materials. Photo courtesy of Dominic Episcopo.

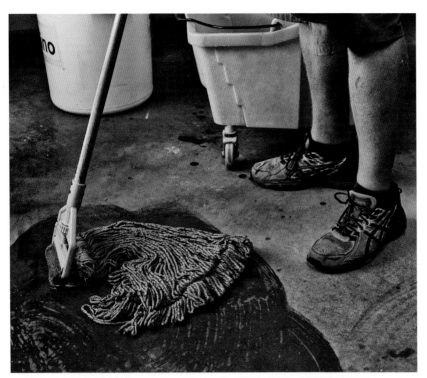

Mopping is a safe way to clean floors without kicking up dust. Photo courtesy of Dominic Episcopo.

require the same amount of forward motion, so I recommend working at a higher table. My studio table surface is thirty-eight inches (97 cm), allowing me to stand upright without hunching while I prepare glazes.

Wearing an N95 mask is essential for keeping ceramic particulates out of your lungs. Acute exposure can cause mild irritation in the respiratory system, while long-term exposure can lead to silicosis or other lung-related issues. Common sense precautions, like mask wearing and proper studio hygiene, can mitigate the majority of silica safety concerns in the studio. In 2008, The National Institute for Occupational Safety and Health released *Evaluation of Exposures at a Pottery Shop* by Lilia Chen, Jessica Ramsey, and Scott Brueck. Airborne silica levels were tested at a communal clay studio during clay mixing, glaze mixing, and other routine studio exposures. After extensive testing, there were no measurable silica levels in the majority of the studio, with the exception of the clay mixing area. This points to the hyper-local nature of silica exposure.

A key part to maintaining a clean studio is reducing the ability of ceramic materials to become airborne. Wet mopping or wiping surfaces down with wet sponges works better than sweeping because you're binding the dry clay particles by getting them wet. This makes cleanup easier and keeps particles from becoming airborne. In my experience, dry climates are much dustier to work in, even when doing the same amount of cleaning. When I worked in Colorado, I would spray down the studio floor daily. This helped deep clean the floors, while also introducing humidity into the environment. If you have floor drains, I recommend doing this between making and glazing cycles. My home studio is small enough that I clean daily as I switch between throwing, decorating, and glazing.

TOXICITY OF DRY MATERIALS

When thinking about toxicity in ceramics, it's helpful to consider the saying "the dose makes the poison." How much of a material and the path it takes to enter your body will help determine its level of toxicity. While it's hard to make a hierarchy of toxicity, there are a few materials that have more or less toxic sources. Iron, for instance, can be sourced as a colorant from red iron oxide, a safe insoluble form, or iron sulfate, a soluble form that is absorbed through the skin. When choosing your source, it's practical to pick the insoluble form for safety and ease of use. You could use iron sulfate safely by wearing gloves, disposing of waste water, and so on. But why would you when you can get your iron from a safer source? For the safety of yourself and those who might come into your studio, (e.g., kids, guests, and pets), it's best to avoid soluble versions of colorants or fluxes wherever possible.

There are a few common glaze materials that are sometimes thought to be toxic, but their toxicity must be contextualized. Barium carbonate, a flux, is toxic when orally ingested because the hydrochloric acid in your stomach changes it to absorbable barium chloride. Barium carbonate used in glazes is not water-soluble and cannot be absorbed through your skin. Manganese dioxide, cobalt oxide, and chrome oxide are metallic oxides that we use as colorants. You certainly should not eat spoonfuls of them, but they are also not water-soluble and cannot be absorbed through the skin.

In addition to skin absorption, respiratory inhalation is a path for material to enter the body. I talked previously about the need to wear a N95 respirator when you're mixing glaze, but it's also helpful to know when a material vaporizes and could be breathed during firing. I thought that manganese would fume when fired, but further research notes that it does not vaporize until 3,741°F (2,061°C), well above ceramic firing temperatures. Lead, a lesser used ceramic flux in contemporary times, will fume at 900°F (482°C), creating a toxic airborne hazard in your studio. I'm not suggesting that you use lead, but I am mentioning it because it's a material that will fume when fired at low-fire temperatures.

In chapter 2, I discuss popular ceramic colorants and their characteristics. I list individual toxicity where applicable, and I suggest you continue your research by listening to *Toxicology 101* with Sarah Urfer on the *For Flux Sake* podcast. Urfer is a clinical toxicologist and speaks in depth about ceramic toxicity risk with host Matt Katz.

CHOOSING YOUR CLAY

Choosing a clay body can be a fun and challenging part of working at low-fire temperatures. Most clay distributors have at least a few earthenware clay bodies available, which provide a good place to start your testing.

There are two basic types of low-fire clays: high-iron terracotta and white earthenware bodies. (Note: In this text, I use the term terracotta to mean both the plastic clay body that can be used right out of the bag and the raw material that is in the clay body.) Both types of clay can be used for making pottery, tile, or sculpture. When choosing a clay body,

consider the following: Does it have the plasticity needed for your style of building? How much grog do you prefer? Is the body available locally at a reasonable cost? Clay is heavy, so shipping quickly drives up costs. How does the color of the clay affect your potential glaze choices? Does the clay mature at the temperature you want to fire to?

The availability of the raw materials in the clay bodies will also affect your choices. Many white earthenware bodies rely on talc as a core component along with ball clay. In recent years, one of the main talc mines in the United States shut down, creating a serious shortage of the material. Suppliers are testing new materials and new sources of talc, but at

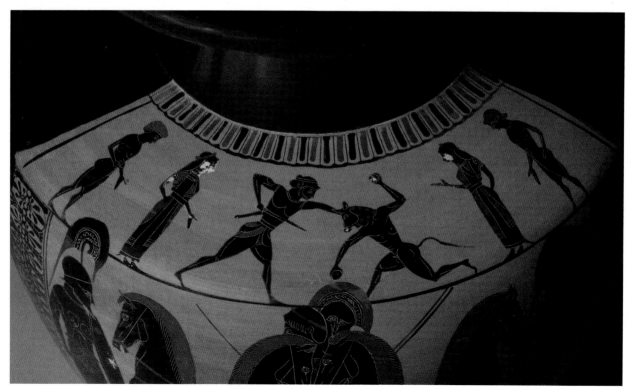

Theseus and Minotaur (Shoulder of a Black-Figure Hydria), c. 520 BCE. Attributed to Antimenes Painter. Photo courtesy of the Cleveland Museum of Art.

the time I am writing there are no easy substitutions. Terracotta clays are easy to build with, with or without grog, but their high iron content creates a darker representation of your glaze than on a white body. Many terracotta makers cover their clay with slips to create a lighter background for glazes. "Building Layers with Slip and Underglaze" in chapter 3 is devoted to this style of decoration.

Terracotta is a high-iron secondary clay that matures between 1,800°F (982°C) and 2,020°F (1,104°C). Many cultures have used terracotta clays because they are easily available around the world. The name comes from the Latin words *terra cocta*, which translates to "baked earth." Unlike primary clays, which are typically located in the mountains, the mining of terracotta is often as simple as traveling to a riverbed to dig up clay from its banks. The main ingredient in many American terracotta clays is Cedar Heights Redart Clay, which is a clay mined in Ohio from the banks of an ancient lake. Lantz clay is a beautiful terracotta originating in Nova Scotia, and it has supplied a lineage of eastern Canadian potters. Regardless of the specific source, most terracotta clay bodies have a blend of ingredients that help increase plasticity, such as ball clays, and fluxes that help increase durability.

One odd property of terracotta is that it will not vitrify even if it's fired successively hotter. Above 2,100°F (1,149°C) it may start to bubble, bloat, and collapse, all while maintaining porosity. Terracotta often gets a bad rap because of its porosity. The industry standard for an object to be vitrified (nonporous) is that it will have less than 0.5 percent absorption, which is difficult to achieve in most

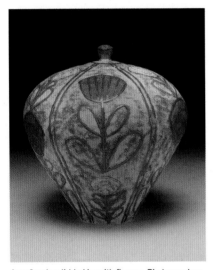

Amy Sanders lidded jar with flowers. Photo courtesy of the artist.

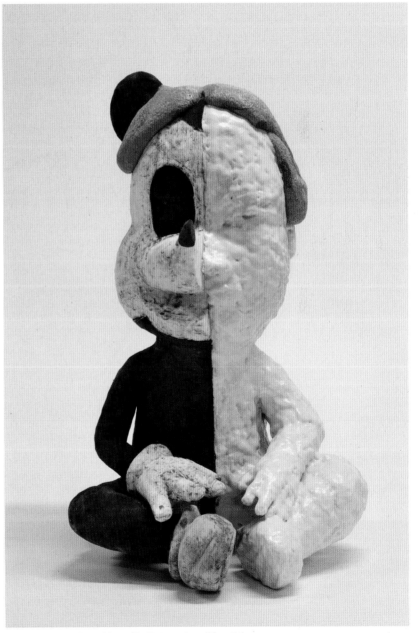

Kensuke Yamada *Mickey Mouse Me*. **Photo courtesy of the artist.**

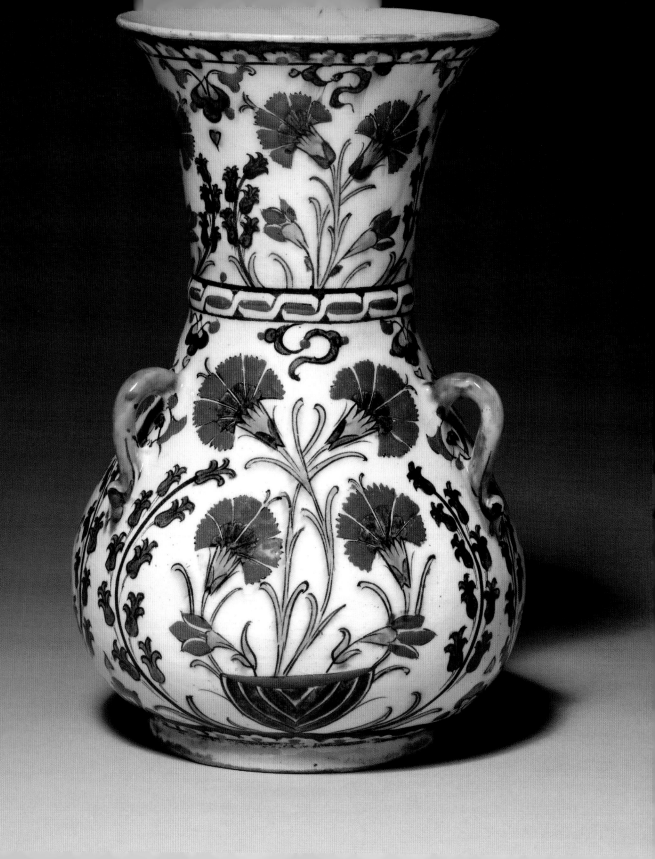

earthenware clays. While low porosity is important, I don't think it's the only concern in functional pottery. In the field of handmade ceramics, aesthetics and safety are equally important. The personal balance I strike is that I want a terracotta body with 2 to 4 percent absorption that is glazed with a durable craze-free functional glaze. My goal in this book is to provide you with dozens of clays and glazes that have these qualities. As a side note, there is an upside to terracotta's porosity, which is that it's a better insulator and can withstand more heat shock than denser clays. This comes in handy when you want to keep your coffee warm on a cool morning.

When choosing a clay body, it's best to avoid efflorescence, or "scumming." This phenomenon happens when soluble salts mix with water in the terracotta body and then transfer to the surface of the pot during drying. A white residue is left that will continue to appear even after washing. Including a small amount of barium carbonate (0.5 to 2 percent) in your clay body will bind the soluble salts during firing. You'll find commercial clays already have this covered. It's best to blunge your barium in water until it's completely mixed before adding the solution into your clay mixer. This will ensure even distribution.

While the majority of historical low-fire pots used red terracotta, there are beautiful examples of white earthenware. In the Middle East, potters blended silica sand with crushed glass and small amounts of clay to create white "fritwares." Their goal was to copy Chinese porcelains with their local materials at much lower firing temperature. The clays were very white, but their plasticity and workability were poor. The forms the artists could make were limited to what could be slumped over bisque molds or thrown in simple parts based on cylinders, like the Iznik Mosque Lamp pictured opposite.

Alex Anderson's *Excision* is made from commercial white earthenware before being decorated with slips, underglaze, and luster. Modern white earthenware relies on white kaolins and ball clays being mixed with talc and other fluxes. With the shortage of talc, we might see other

fluxes take over the role talc plays in being both a filler and a flux. Tony Hansen has researched a talc replacement and has had success with 80 percent nepheline syenite and 20 percent dolomite as a straight replacement. To access his research, visit digitalfire.com.

When choosing your clay, you might also consider the cultural significance it carries. Mixed media artist Joey Quiñones thinks about terracotta's utilitarian ubiquity across many cultures in their choice to use the material.

"When I look at the work of Taínos from the Caribbean, terracotta pots, plates, and spoons are everywhere. When I look out towards Spain, there are terracotta tiles and roofs. When I look towards West Africa, I see the figurative terracotta sculptures of the Nok and the figurative terracotta sculptures of Mali dating back all the way to the thirteenth century.

Terracotta connects me deeply to all the parts of my Puerto Rican identity, across time and space. So, in my work I think of it as the foundation, the starting place for complex conversations about race and class and history."

You can see this on the next page in their piece *El mito del regreso (The myth of the return)* where they juxtapose the patterns of the colonial elite with the black bodies of the people they enslaved. The figure is cast with terracotta and is displayed on terracotta tiles.

On page 23 are recipes that will provide a starting place for you to mix your own clay. Note that you will have more plasticity if you can fully hydrate the blends into a slip before drying them out to your desired workability. If you have these mixed by a clay supplier, try to find one with a filter press, which can make amazingly plastic clay.

Alex Anderson *Excision*, **2022. Photo courtesy of the artist.**

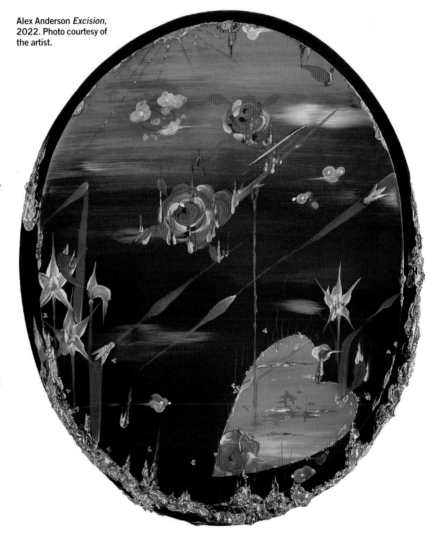

Opposite: Mosque Lamp, 1585–95. Turkey, Iznik, Ottoman Period. Photo courtesy of the Cleveland Museum of Art.

Joey Quiñones *El mito del regreso (The myth of the return)*. Photo courtesy of the artist.

Close-up of *El mito del regreso (The myth of the return)*. Photo courtesy of the artist.

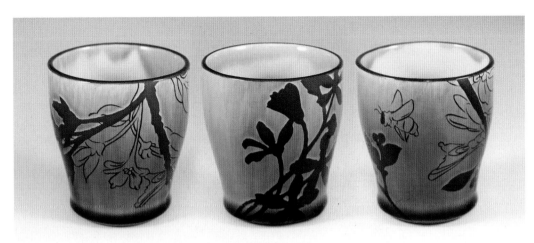

LINDA ARBUCKLE'S RED CLAY (CONE 04-2)

Redart Clay	45
Goldart Clay	10
Foundry Hill Creme	14
XX Sagger	16
Cedar Heights Fire Clay	8
Silica	6
Talc	6
Spodumene	3
Barium	0.5
Bentonite	2
Fine grog	2

ANDRÉA KEYS CONNELL'S SCULPTURE BODY (CONE 04-1)

Redart Clay	60
OM4 Ball Clay	30
Talc	5
Nepheline syenite	5
Grog	25
Sand	25
Bentonite	2

1 handful of fiber and a handful or 2 of red iron oxide to increase the depth of the clay color

RAMSAY RED FRITWARE CASTING SLIP (CONE 04)

Redart Clay	40
Goldart Clay	20
Ferro Frit 3110	15
Silica	15
Talc	5
Tennessee #1 Ball Clay	5
Barium carbonate	0.2
Darvan No.7	0.4–0.6

LISA NAPLES RED CLAY (CONE 02-2)

Fired to cone 1, this clay has less than 1% absorption.

Redart Clay	65
Goldart Clay	10
OM4 Ball Clay	10
Talc	4
Nepheline syenite	3
Wollastonite	7
Bentonite	1
Barium (to prevent scumming)	0.5

CARTY WHITE EARTHENWARE (CONE 04-02)

(Used by Lisa Orr, page 58)

Talc	42.66
C&C Ball Clay	40.00
Silica 325	12.00
Whiting	5.30
Volclay Bentonite	2.0

GEORGIE'S LOW-FIRE WHITE CASTING SLIP (06-04)

(Used by Shalene Valenzuela, page 68)

Talc	50
OM4 Ball Clay	33.3
PV Clay	16.7
Water	42.5
Sodium silicate	0.35
Soda ash	0.06

TESTING A
CLAY BODY

As an early student of ceramics, I thought clays were magical and that finding the right one would be my key to success. When I would get frustrated by my lack of throwing skill, I would think, "If only this clay had more grog, I could pull this pot higher." This might have been partially true, but I misunderstood the relationship between clay and maker.

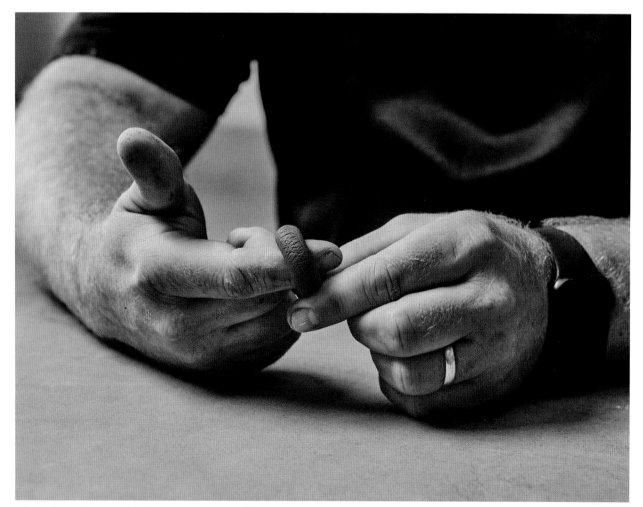

Using a rolled coil to test plasticity. Photo courtesy of Dominic Episcopo.

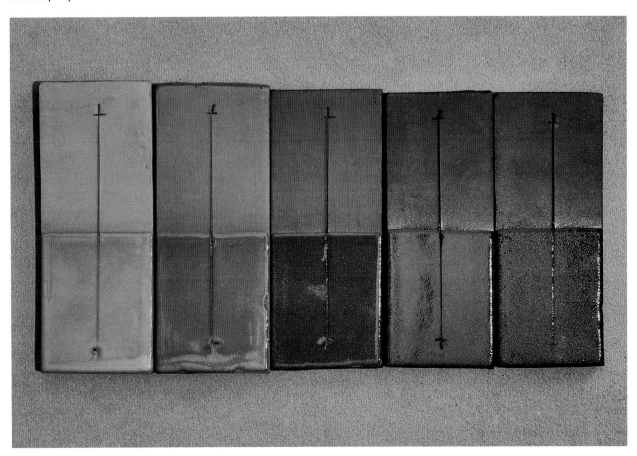

All clays have positive attributes, and it's my job as the maker to figure out what they are and how to make something that highlights those attributes. Some practical considerations when testing a clay body are its plasticity, shrinkage, and absorption. You can easily test these qualities by mixing up a 1,000-gram batch of your recipe. Add water to create the consistency of thick pudding and let sit for up to three days (24 hours at minimum) to let the particles fully hydrate. If after resting the clay it's still too wet to wedge, pour it out onto a plaster bat and monitor until it's wedgeable.

To measure plasticity, roll a coil the thickness of your finger that is approximately 4 inches (10 cm) long. Wrap the coil around your finger and observe any cracks that might form on the surface of the clay. No cracking indicates you have a plastic clay body that would be good for throwing or handbuilding. If your coil breaks, then try adding more plastic kaolins and/or ball clay to the recipe. The goal is to have a well hydrated blend of small, medium, and large particle sized materials. Your local clay distributor will have plastic clays for you to experiment with and might suggest other ways to modify your clay body for your purposes.

To test shrinkage, roll out a slab that is 0.5 inch (1.3 cm) thick. Cut a bar that is 2 inches (5 cm) wide and 5 inches (13 cm) long. Clearly mark a 10-centimeter (4 inch) line on the middle of the bar with a pin tool. Measure the length of the same line at bone dry and then after you fire to the temperature your glaze will mature. You'll see most of your shrinkage in two phases: between wet and bone dry and then again from bisque to finished fired. Each clay body will be different, so make sure to record shrinkage and write on the back of the tile with a permanent marker for later reference.

To test absorption, you can use the bar you just used for shrinkage, or you might choose to make a new one. Before doing an absorption test, place the new bar in your next glaze firing so that it will reach the maximum temperature for your use. After firing, measure and notate the weight of the bar. To perform a simple absorption test, let the bar sit totally submerged in water for 24 hours. For a more accurate test, boil the bar in water for 5 hours and then submerge for 19 hours. With both methods, you'll then remove the bar and wipe down with a damp sponge before measuring. Subtract the weight of the dry bar from the weight when it was wet. The number is the amount of water absorbed. Then, divide that number by the weight of the dry bar. This will give you a number, which you can multiply by 100 to establish the percentage of absorption.

Subtract dry weight (e.g., 4 g) from wet weight (e.g., 4.4 g) = 0.4 g H_2O absorbed.

Divide the H_2O absorbed (e.g., 0.4 g) by dry weight (e.g., 4 g) = 0.1.

Multiply 0.1 by 100 to establish percentage of absorption = 10%.

In this case, the clay would have 10 percent absorption at the highest temperature you plan to fire your clay. A value of 10 percent is too high. We are aiming for 4 percent or below, so more testing would be needed. You could try firing your clay hotter, but make sure to monitor the effect on the glazes (running or bubbling). You could retest the recipe after decreasing the more refractory clays, such as kaolins. You could retest your clay with more flux added, which will make the body more dense and durable for functional use. At this point, you might also decide to look for another clay body that has lower absorption.

Another test related to absorption is moisture expansion. When a fired ceramic body absorbs water, it might (or might not) expand. An immature body with high porosity will expand, putting stress on your glaze and inducing crazing. Most delayed crazing with earthenware is due to moisture expansion. An easy test for expansion is to put glazed test tiles in a dishwasher and leave them there for a week. Cycling between wet and dry, under elevated heat, is a good real-world test of your clay glaze fit. You could also put the tile in a pressure cooker (the kind used for canning food) for 30 minutes at 15 psi, which is similar to the industry standard test that uses an autoclave. If a glaze remains uncrazed after it's been in the pressure cooker, it will probably never craze.

We used Highwater Clay's Stan's Red and White Earthenware to test glazes for the book. We tested both clays for shrinkage and absorption to find the best temperature for functional pots. For Stan's Red (named after Stan Andersen), the optimal firing would be between cone 01 and cone 2. That created absorption rates under 4 percent. You can see how the color darkens and the body shrinks as it's fired hotter, from cone 06 up to cone 4. Stan's Red, like many earthenwares, can start to bloat at cone 4 or above. At these temperatures iron starts to decompose, releasing gases that become trapped as bubbles that swell within the surface of the clay body.

The last quality that is important to consider when testing is how the clay looks when you use it. Plasticity, shrinkage, and absorption are practical considerations, not aesthetic ones. After testing multiple clays, you might find two that perform similarly, but the fired color of one clay is more attractive than the other. Your decorative process might also inform your choice. If you use sgraffito in your work, you might find the particle size of one clay is too coarse for drawing the line quality you desire. My top clay priority is low absorption for functional fitness, followed by working properties like plasticity, and finally the fired color of the clay.

STAN'S RED SHRINKAGE AND ABSORPTION

Temperature	Absorption	Shrinkage
^06	6%	12.60%
^04	8%	8.30%
^02	10%	5.20%
^2	11%	1.10%

DESIGNING AND MAKING TILES FOR TESTING GLAZE

To help you progress on your own glaze odyssey, you'll need a test tile that provides the most information possible. Think of your tiles as miniature stand-ins for your pots and create them the same way you do your work.

For years, I used a standard test tile consisting of a thrown bottomless cylinder cut into individual tiles at leather-hard. They are efficient to make and are great for highlighting the behavior of a glaze on a vertical surface, but not on an interior surface, like a cup. The next style I tried was made by throwing small cylinders the size of my pointer finger off the hump. They felt more pot-like but again lacked information on how a glaze would pool on the inside of a pot.

For this book, I'm using an extruded test tile with four sides and a slab bottom, which solves this problem. The advantage of this style is that each side showcases a different surface technique that I use in my work. Side one has two stripes of underglaze, side two has cross-hatching made with a serrated rib, side three has dipped slip, and side four has slip trailing to create a raised surface. Roughly 1 inch (2.5 cm) from the bottom of each tile, I marked the surface with an indentation

that indicates where to stop when dipping the glaze. When testing, I pour the glaze into the tile to coat the full interior and then dip down to the line on the outside. From this four-sided test tile, I can see how the glaze will behave based on four separate variables: texture, underglaze color, interior/exterior surfaces, and breaking over edges or crawling. As you start your testing, consider what questions you might ask about a glaze and then engineer a tile that will test those factors for you.

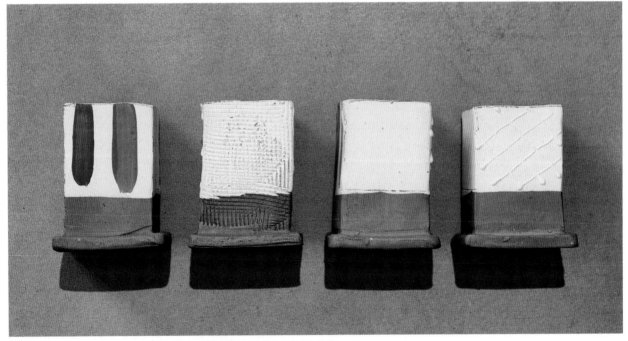

Each of the four sides of the test tile we used for testing. Photo courtesy of Dominic Episcopo.

CHAPTER 2

GLAZE FORMULATION

The ceramic unknown can be scary, especially when
you have a glaze or slip that does not act the way you
thought it should. Glaze formulation is not a body of
knowledge that you can learn all at once. This book will
be part of a glaze journey in which you might feel you're
taking two steps forward and then one step back.
Mistakes and experiments are important parts of the
learning process. This chapter will help you cultivate a
global understanding of glaze that will evolve and grow
as you experiment with the materials. I encourage you
to follow your instincts and focus on the information
that feels most relevant at the moment. You'll have
plenty of time to work on the rest later.

BASICS OF CERAMIC CHEMISTRY

In ceramics, we harvest minerals from the earth, shape them using tools, and then bind them together using heat from our kilns. The beginning of the process might start in a clay pit, as pictured below in Camden, South Carolina, but the end result is the ceramic art that we all love, like the Chinese Tang Dynasty horse opposite now held in the Cleveland Museum of Art.

At its core, the ceramic process relies on the same melting and cooling that the earth went through as it cooled around 4.5 billion years ago. What we see as colorful glazed pots are compositionally very similar to the geologic materials that cover our landscape. This is no coincidence, as most of our ceramics materials are literally crushed up rocks from the earth's crust. The three basic things that constitute glazes are glass formers, fluxes, and stabilizers. In community studios, schools, and backyard pottery sheds around the world, people are combining powdered versions of these same materials in different ratios, before adding them to water and applying them to the surface of a pot.

Before going further, I want to mention that in ceramics we largely source our raw materials from oxides. These are chemical compounds that have at least one oxygen molecule bound with one element of the periodic table. Throughout the book, I'll often use the overarching chemical name in place of the full oxide. For instance, I'll state we use Gillespie Borate to source boron. Technically, we are sourcing diboron trioxide, but the norm I was taught, and that largely continues today, is to just say boron.

The most common ceramic material you'll be using is silica. It's one of the most abundant materials on earth, appearing in 59 percent of the earth's crust. In glazes, it's the predominant glass former. When melted and cooled, it forms a durable

Clay pit in Camden, South Carolina. Photo courtesy of Steve Blankenbeker.

glaze surface that is perfect for ceramics. The only downside is that it melts at 3,100°F (1,704°C), a temperature that is energy intensive to achieve. Thankfully, fluxes can be used in a glaze with silica to bring down the melting point. The fluxes we typically use are sodium, potassium, lithium, calcium, barium, strontium, magnesium, zinc, and lead. These are grouped into alkali metals (sodium, potassium, and lithium) or alkaline earths (calcium, barium, strontium, and magnesium), along with the ungrouped fluxes zinc and lead.

Lead is the only traditional flux that produces practical glazes at earthenware temperatures, which is why traditional low-fire glazes were almost always based

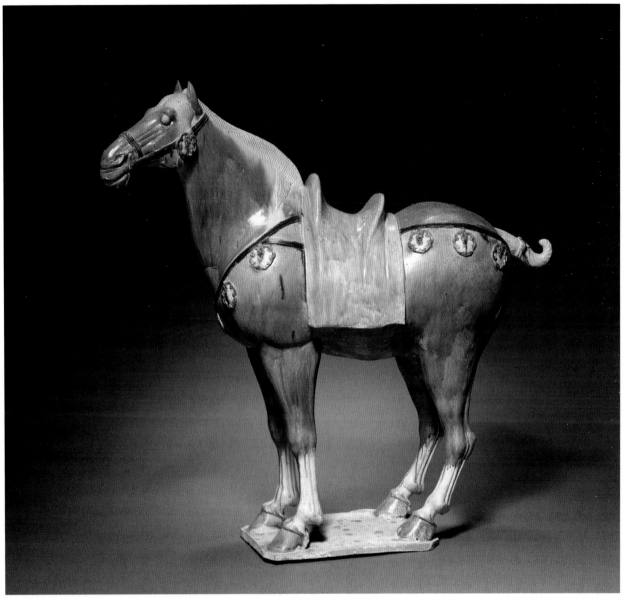

Horse, Tang Dynasty China. Photo courtesy of the Cleveland Museum of Art.

on lead. We now know about the extreme toxicity of lead, which takes its use off the table. What has taken its place is boron, which has been used extensively in the modern era. You'll often see boron referenced as a flux, but it functions as an additional glass former, similar to silica. It has a lower natural melting point than silica, so using it starts the melting process at a lower temperature. While technically, as a glass former, its early melting temperature allows us to formulate practical, durable glazes without the toxicity of lead.

Alumina is the material we use to help create the glass structure within the glaze. Alumina increases the viscosity of the glaze melt, distinguishing glaze (higher alumina) from glass (lower alumina). Surface reflectivity and translucence are affected by anorthite crystals that form in satin or matte glazes as calcium bonds with excess alumina during cooling. The ratio of glass formers, fluxes, and alumina in a glaze is one factor that determines if a glaze will be shiny, satin, or matte.

Some of our materials are found in more or less pure forms, while others are found in combination. Relatively pure

silica, for instance, can be purchased from any clay supplier. Lithium, however, can be found in both lithium carbonate or bound with silica and alumina as spodumene. You can choose to use either group of materials to source the chemistry you need for the glaze, but you might want to use spodumene to avoid the high cost and water solubility of lithium carbonate. Thankfully, glaze calculation software makes understanding your materials and calculating the math behind your glazes much easier. As you progress through the book, I recommend you use software (Hyperglaze, Glazy, etc.) to track your glaze testing.

UNDERSTANDING A GLAZE RECIPE

Understanding glaze chemistry starts with identifying the core minerals each ingredient brings to a glaze. Let's look at Quigley Clear Base Glaze, which I used with colorants on the ewer pictured below (3 percent copper for green and 1 percent copper + 0.5 percent cobalt for blue). This glaze was developed by Tony Hansen, glaze aficionado and creator of the ceramic database Digital Fire, digitalfire.com.

Quigley Clear Base Glaze is made from three common Ferro Frits: 3195, 3110, and 3249. Frits are manufactured ceramic materials that are a core provider of materials in low-fire glazes. Companies that make frits provide the exact materials that are in the recipe and the specific temperatures at which they melt. For example, Ferro Frit 3195 will reliably melt at 1,800°F (982°C). You can see in the chart at right that each frit brings fluxes to the recipe, while also providing silica (SiO_2) and alumina (Al_2O_3). Ferro Frit 3195 provides sodium, calcium, and is a concentrated source of boron, an important glass former at low temperatures. Ferro Frit 3110 is relatively high in sodium, and Ferro Frit 3249 is a source of magnesium. Understanding the role of the various fluxes will help you predict melting characteristics and color response.

All oxides in a material are important, even in small amounts. Let's look at Ferro Frit 3249, which has magnesium, a very low expansion flux that is key to adjusting glaze fit. Quigley Clear Base Glaze was engineered around Ferro Frit 3195 with medium thermal expansion, Ferro Frit 3110 with high thermal expansion, and Ferro Frit 3249 with low thermal expansion. The value of blending these in a recipe is that you can easily adjust the formula to fit your clay body. If your Quigley Clear Base Glaze crazes, or cracks, due

QUIGLEY CLEAR BASE GLAZE

	%	SiO_2	Al_2O_3	B_2O_3	Na_2O	K_2O	MgO	CaO
Ferro Frit 3195	65	1.93	0.28	0.78	0.22			0.49
OM4 Ball Clay	15	0.51	0.15			0.01	0.01	
Ferro Frit 3110	10	0.43	0.01	0.01	0.09	0.01		0.04
Ferro Frit 3249	10	0.26	0.05	0.15			0.11	0.02
Total	100	3.13	0.5	0.95	0.31	0.02	0.12	0.55

to higher thermal expansion than the clay body, test with more Ferro Frit 3249. If the glaze is shivering, or flaking off, due to its lower thermal expansion than the clay body, then increase Ferro Frit 3110.

The last material in the recipe is OM4 Ball Clay, which provides alumina and silica. Those are helpful chemical additions, but the OM4 Ball Clay in this recipe is there for its physical benefits. It helps your glaze stay suspended in the bucket, contributing to glaze application adjustment and post-glaze handling. If you tried to use a glaze that is 100 percent frit, it would likely settle in your bucket so hard that you would have to continuously stir while glazing. With no clay, it would also flake off the pot when you picked it up to move it to the kiln. The addition of the OM4 Ball Clay solves these problems.

As you read later sections of the book, I encourage you to break down the recipes. I find it helpful to become familiar with the materials and makeup of a glaze before beginning the testing stage. If you're starting fresh with low-fire glazes, it might be helpful to pick glazes with varying dominant fluxes so that you see the broadest range of possibilities before narrowing your research.

When reading the Quigley Clear Base Glaze recipe left to right, you see its ingredients, the percentage of each in the recipe, and then an analysis of the glaze using the Unity Molecular Formula. (See Resources on page 170 for more on UMF). To mix the glaze, you'll multiply the percentage of each ingredient by the amount of increase in order to get the specific amount you want. If you want to

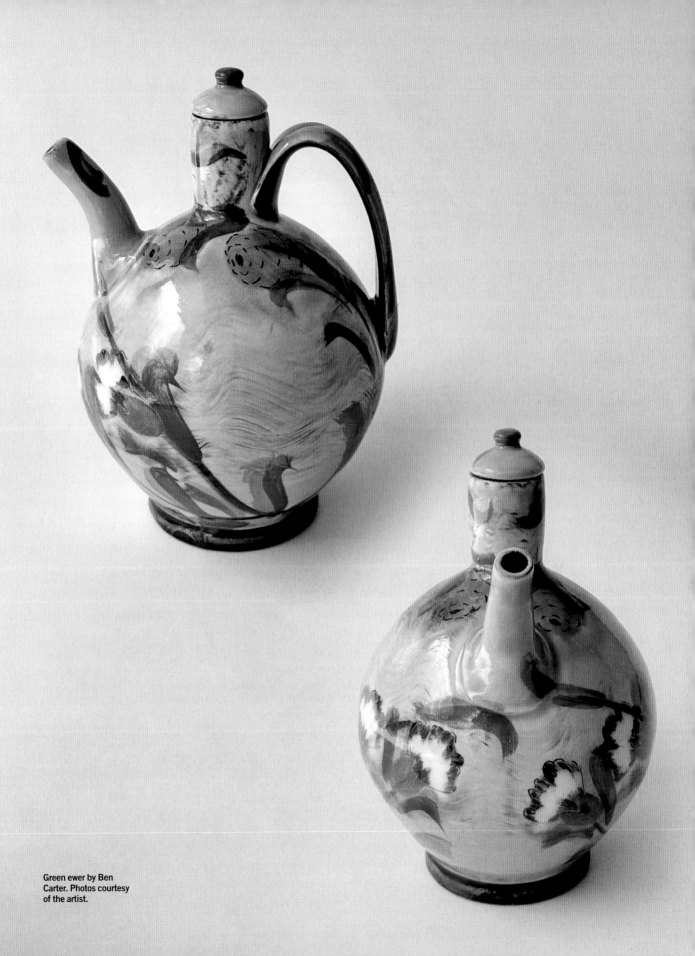

Green ewer by Ben Carter. Photos courtesy of the artist.

Bagged dry materials.
Photo courtesy of
Dominic Episcopo.

make a 10,000-gram batch, you multiply each by 100. If you want a 5,000-gram batch, you multiply by 50. When calculating your glaze, don't forget to account for the water you will add in the bucket. In this case, I am using 70 percent water to hydrate the glaze.

FLOCCULATION VS. DEFLOCCULATION

When most of our common dry materials are mixed with water, their solution is in a flocculated state. Their particles loosely stack on top of each other like a jumbled house of cards. When you add a deflocculant, like sodium silicate or DISPEX, the particles take on positive electrostatic charges, which repel each other, making the solution more fluid. The effect is similar to two positively charged magnets sliding across each other's surface instead of sticking to each other. If you wanted to attract the particles to each other, you would add a flocculant, like Epsom salts.

You'll run across these terms when a liquid needs its viscosity adjusted without adding more water to the recipe. If you deflocculate a glaze or slip, it will become more fluid, but you haven't changed the specific proportion of dry materials to water in the glaze. Above, I mentioned that having OM4 Ball Clay in the Quigley Clear Base Glaze will help with glaze application adjustment. This is because you can more easily flocculate or deflocculate a glaze that has clay.

FRITS, WATER SOLUBILITY, AND GERSTLEY BORATE

To make a frit, ceramic materials are dry mixed, melted into molten form, and then released into a water bath where they shatter into very small particles as they cool. The material is then harvested from the bath, crushed, and dried before being packaged as a powder for sale. The process is energy intensive and more expensive than mining, but it creates reliable materials that rarely change in composition.

Frits provide an accessible way to have fluxes become active at low-fire temperatures As mentioned at the beginning of the section, the fluxes that make glazes practical and durable (calcium, barium, magnesium, strontium, and zinc) aren't active at low temperatures when sourced from natural materials. When they are combined with boron in a frit, they become active participants in the glaze's chemistry and lend the glaze durability and good color response.

Frits are also a handy solution for solving problems that are associated with water-soluble materials. For instance, sodium could be sourced from salt, but its solubility would allow it to recrystallize in your glaze bucket or migrate through a porous clay body, creating many technical issues. When sodium or other soluble materials are fritted, their water solubility is reduced, which decreases their potential absorption through the skin. Fritted materials also melt more quickly and evenly, as their previous melting speeds up the process.

MIXING A GLAZE RECIPE

	Percentage	10,000-gram batch plus 70% water
Ferro Frit 3195	65	6,500
OM4 Ball Clay	15	1,500
Ferro Frit 3110	10	1,000
Ferro Frit 3249	10	1,000
Water		7,000

You'll see many glazes that use Gerstley Borate as a source of boron, an important glass former at low-fire temperatures. It's no longer being mined and will become unavailable as supplies run out. Gillespie Borate is often used as a replacement, and frits can be used as a source of boron. I've included a chart of common low-fire frits in the Resources section of the book. For in-depth analysis of frits, you can also visit digitalfire.com/glossary or glazy.org.

FIXING COMMON GLAZE FAULTS

As you experiment with glazes in this book, you'll probably find one that is your dream glaze. The color and surface are right, and it fires surprisingly well with the rest of your glaze palette. Then, you put it into full production and notice that your dream glaze has shortcomings under specific circumstances.

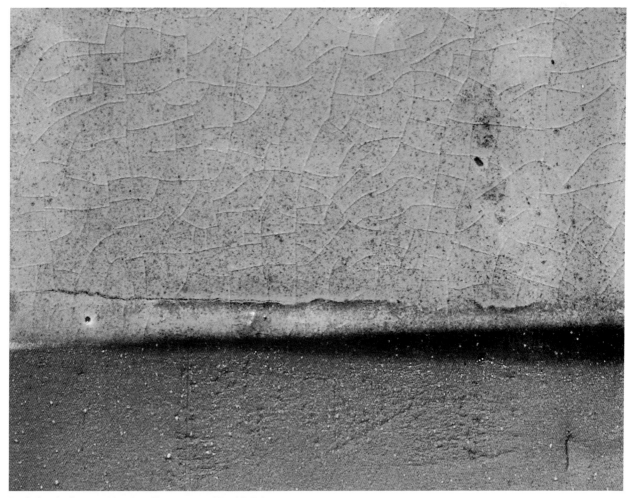

Detail of crazing in a water blue glaze. Photo courtesy of Dominic Episcopo.

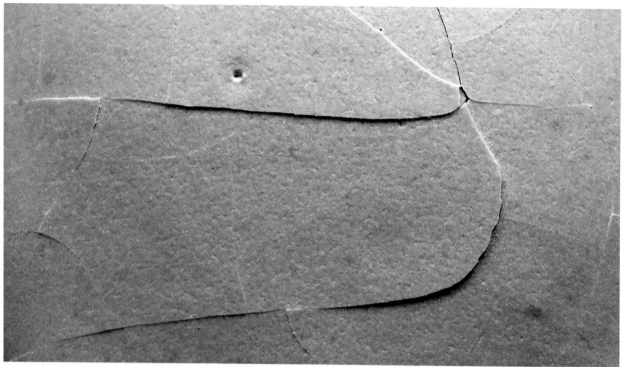
Glaze shivering. Photo courtesy of Matt Katz.

This section will help you troubleshoot those defects. As you problem solve, remember to test one variable at a time. If you change your water amount/glaze thickness, materials, firing schedule, and cooling rate all at the same time, it can be hard to tell which variable solved your problem.

CRAZING

This crackle pattern in a glaze occurs when the glaze has a higher thermal expansion than the object it is on. Often seen as an asset in celadon glazes that are used with vitrified high-fired clay bodies, these microfine cracks allow water to be absorbed into nonvitrified clays, eventually degrading the body. The tricky thing about crazing is that glazes can release tension long after they have cooled. You might have a craze-free pot that suddenly "pings" as it forms crazes to release tension in its smooth surface. This could be from the clay expanding underneath the glaze as hot coffee was poured into the cup or more likely from the inherent high thermal expansion of the glaze's chemistry. One myth is that cooling your kiln slowly will keep your glazes from crazing. This isn't true, as glazes craze due to their chemistry and not their

cooling. There are multiple approaches to eliminating crazing, all of which decrease the glaze's thermal expansion relative to the clay body.

Our first approach is to change the glaze by adding silica, which has moderate thermal expansion counteracting the high-expansion materials in your recipe. You can also test with kaolin, which will provide both silica and alumina, a tag team that can be helpful in eliminating crazing. A similar glaze-based approach would be to change the ratio of fluxes based on their chemistry. This is not an ideal or easy solution for every glaze but works perfectly with the Quigley Clear Base Glaze. To fix crazing, you would add more Ferro Frit 3249, which has a low expansion magnesium. This can have ramifications on color, as magnesium pushes cobalt towards purple instead of blue. If you're working with a glaze that uses sodium or potassium as the primary flux, you could substitute a small portion of lithium, which has a similar color response with less expansion. Lithium is a bit of a wildcard to test with though, as it alters glazes in new and exciting ways. Its tendency to make crystalline glazes in high amounts can create interesting surfaces, but its solubility might cause it to crystallize in your bucket over time.

A second solution is to change your clay body to better match the thermal expansion of the glaze. If you use premixed clays, you can ask your clay supplier for a similar clay that has higher expansion that matures at the cone 06–2 firing range. If you mix your own clay, you could add more silica, which has higher thermal expansion. The downside would be adding too much silica could potentially decrease densification and vitrification. A common cause of delayed crazing is moisture expansion from the clay body being underfired. As mentioned in the section on clay bodies, some bodies need to be fired to a hotter temperature in order to eliminate delayed crazing due to moisture expansion. An effective third solution would be to fire your pots hotter. Luckily, boron glazes tend to have a much broader firing range than other kinds of glaze, so they will often work just fine at a slightly higher temperature.

SHIVERING

Shivering comes from the opposite expansion issue as crazing. In this case, the glaze isn't expanding enough. When the clay expands more than the glaze, the glaze layer separates from the clay and pops off. This can happen on the edges of handles, rims, and places where the glaze

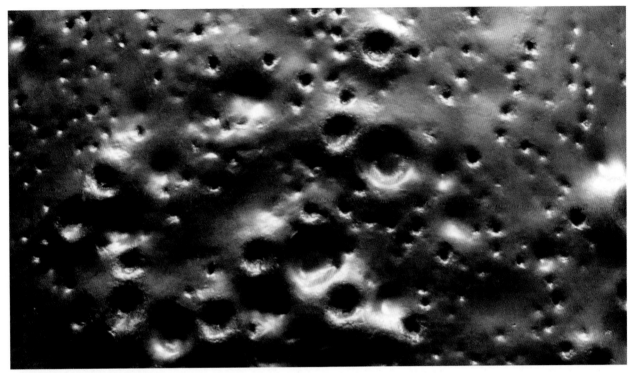

Glaze blistering. Photo courtesy of Matt Katz.

turns a corner. Matt Katz of the Ceramics Materials Workshop provided this image of a glaze about to shiver off its surface and many of the other close-up images of glaze defects. To fix this problem, you need to add a higher expansion flux. In the Quigley Clear Base Glaze example, this means you would increase the Ferro Frit 3110 and decrease the Ferro Frit 3249. If your glaze doesn't have a clear frit substitution like this, you would look for a likely low expansion flux in the glaze and decrease it in ratio. If your glaze has high amounts (3 percent or above) of lithium carbonate, you could substitute for a sodium or potassium source that would have higher expansion, likely decreasing shivering.

BLISTERING

Glazes blister when gases are released inside of the glaze, causing the surface to bubble. Firing a cone lower or using a drop-and-hold kiln schedule is helpful. An amber glaze I used in grad school blistered badly at cone 03 but looked amazing after soaking at cone 05 for an hour. The lower soak allowed the glaze to heal.

PINHOLING

Pinholing is a phenomenon where a small hole is created through the glaze to the clay surface. Like a craze mark, this creates a potential for water to seep into the clay surface. After testing many solutions for pinholing over the years, I've found the best solution is a thicker glaze coat. In my attempts to get thin glaze coats for glossier clear glazes, I would mix my glazes very thin (thinner than skim milk). This worked great for transparent glazes, which can be milky from microbubbles where thick, but the downside is that I had lots of pinholing. When I started bisquing lower to cone 05, it increased the clay's capillary suction, drawing on a thicker coat of glaze. As a glaze chemist friend explained, this works because greater capillary suction increases the particle packing of the glaze surface. During firing, this leads to a thicker and often smoother glaze coat.

Another solution for pinholing is to use a drop-and-soak firing schedule in a computer-controlled kiln. The idea is to fire to a higher temperature before holding at a lower one. The melted glaze will have lower viscosity at higher temperatures, allowing it to seal over pinholes. Try firing to cone 04 (1,945°F [1,063°C]) and then drop 100 degrees (38°C) before holding for 15 minutes. You'll notice your cones reflect

a hotter firing because of the increased heat work associated with staying at a higher temperature. Heat work is the relationship between temperature and time, and we deal with it most commonly in the kitchen. You might bake a cake for forty-five minutes at 350°F (180°C) but only need to bake it for 30 minutes at 400°F (200°C) to achieve the same amount of work heat. Both temperatures will result in a baked cake, but the qualities of the cake will be different depending on your method.

DUNTING

Dunting is catastrophic clay failure that is caused by uneven levels of stress, in or on the clay body. Imbalances can happen when the inside of a pot is glazed but the outside is not or occasionally when a kiln experiences rapid uneven cooling or heating. In the first scenario, you would equalize stress by applying glaze on both the interior and exterior of the pot, excluding where the foot touches the kiln shelf. As low-fire clays are not vitrified, I don't recommend leaving a portion of a pot unglazed for aesthetic reasons. Dunting and shivering often happen at the same time because they have the same cause: too much compression of the glaze by the ceramic body as the pot contracts during cooling. When the clay body fails from this

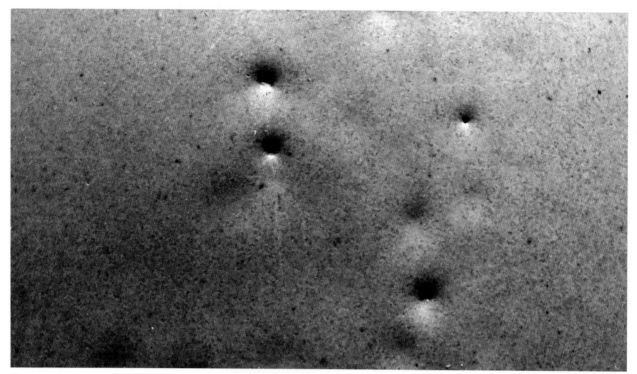
Glaze pinholing. Photo courtesy of Matt Katz.

mismatch of thermal expansion, we call it dunting. When the glaze fails, we call it shivering.

A lack of strength in your clay body can also induce dunting, so be mindful of high absorption rates, indicating a weak clay body. I witnessed dunting in a workshop when using a clay body for functional pots that had 16 percent absorption at cone 04. In hindsight, this could indicate the clay is a mid-range body being sold as low-fire or a clay formulated for sculpture. A beginner student accidently created a glaze coat that was multiple times thicker on the inside than the outside. We did not notice until unloading when we heard what sounded like gunshots, as cracks formed through the glaze and clay, splitting the pot right in half. It's a good reminder that what defines a clay as good or bad is your intended use. That clay might have been fine for tile or sculpture, but it was a disaster for functional low-fire wares.

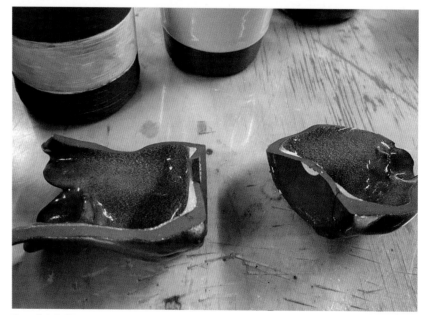
Cup split in half from dunting. Photo courtesy of Matt Katz.

Image of a glaze formulated to crawl. Photo courtesy of Matt Katz.

CRAWLING

Crawling can be caused by two conditions: excessive shrinkage in the dry state, creating cracks in the glaze during drying, or high viscosity during the glaze melt, causing the glaze not to heal into a smooth surface. During firing, small blob-like bumps form in the surface of the glaze, exposing the clay body to water absorption. The first condition is caused by the ingredients that most expand and contract when they are wetted in the glaze. The usual culprit is clay, so substitute less plastic clays (kaolins) for their high shrinkage counterparts (ball clays). In some cases, you might need to calcine a portion of your clays to decrease their potential shrinkage. To do this, fire the dry material in a bisqued bowl above 1,000°F (538°C), which drives off the chemical water in the molecule. The second condition of high viscosity during glaze melt can be caused by high alumina, insufficient temperature, or other chemistry-related factors in the formula. To address melt viscosity, you would decrease a source of alumina or increase the glaze melt with more temperature or flux.

The worst crawling I've experienced came from glazes with high water content oversaturating the wall of my bisque pot. This happens with thin-walled slip-cast vessels, or in my case, pots that were trimmed thin. When glazing, your first glaze coat decreases the capillary suction of the bisque for successive coats. For instance, when I poured the inside and dipped the outside, the crawling would happen on the outside, which was already hydrated. To fix, let the glaze dry on the inside of your pot for a few hours before dipping the outside. If possible, dip the pot all at once using glaze tongs to simultaneously get an even thinner coat on the inside and outside.

There are particular trouble spots for crawling like the right angle at the interior base of a straight sided vessel. Try putting a slight curve at this juncture to address the problem spot. Layering on multiple coats of glaze can induce crawling, due to the top layer rewetting the bottom layer of glaze, causing them both to shrink away from the pot. Potters that use multiple layers of glaze formulate their recipes with materials that don't greatly expand in their wet state.

LICHEN GLAZES

Sometimes, glaze defects can be changed into assets in the right circumstance. Many artists, including Ronan Peterson, have accentuated this occurrence and use it to their advantage. The olive green glaze on Ronan's pot is a lichen glaze, which is a subset of crawling glazes. If you compare crawling glazes, you'll often find the presence of magnesium carbonate at 10 percent or higher. Magnesium is a strange material that is not very dense (you will get a garbage bag full when you buy just a few pounds) and is very hard to mix into water. It's an oddball, but a must for crawling or lichen glazes.

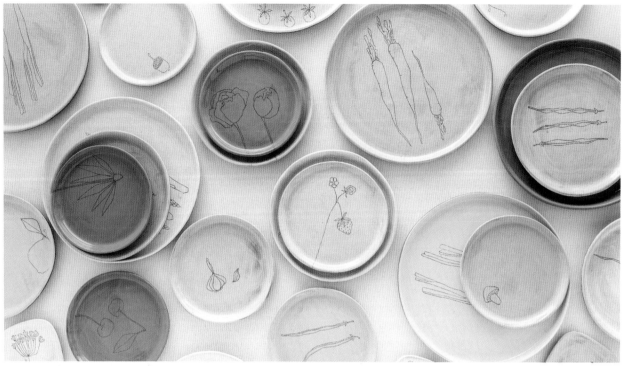

Plates by Jenna Vanden Brink. Photo courtesy of the artist.

PETERSON LICHEN GLAZE (CONE 04-6)*

Crawly, beaded surface that is nice over shiny glazes. Dry, flaky, and sharp when by itself. *Not Food Safe.

Ferro Frit 3110	50
Ferro Frit 3124	25
Gerstley Borate	6
Edgar Plastic Kaolin	7
Silica 325 mesh	10
Lithium carbonate	3
Magnesium carbonate	34
Bentonite	2
Copper carbonate	8
Red iron oxide	3

BISQUE TEMPERATURE AND DENSIFICATION

Bisque firing has many advantages, including making the pot easier to handle during glazing and starting the chemical process of vitrification. Many low-fire artists bisque higher than they glaze to get the value of a denser body, while still glazing at lower temperatures. Jenna Vanden Brink (pictured above) bisque fires to cone 2 before glazing to cone 05 with AMACO's LG-10 Clear Transparent. Low-fire clays are well suited to high bisque because you have a porous body even when you fire hotter.

An important caveat is that high bisque lowers porosity, which will affect your glazing process. When bisquing above cone 04, I notice I need a longer dipped application of glaze to achieve the same thickness. If you brush on your glaze, you might find you need a thicker consistency of glaze to adjust to less porosity.

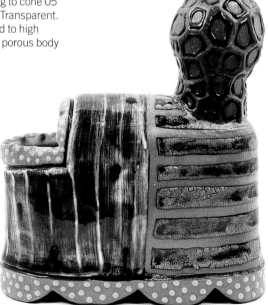

Ronan Peterson *Morrel Vase*. Photo courtesy of the artist.

THE WORLD OF COLORANTS

Ultimately, you might not care what is in a glaze as long as it creates the color and surface you desire. Creating specific colors is a matter of having the time to do the testing, as well as understanding how colorants interact with fluxes in a glaze.

As a young student, I remember seeing images of a beautiful turquoise blue on earthenware pots from Iran and a similar lighter celadon blue color on porcelain pots from China. The only blue I had heard of at that point was cobalt, so I thought they must be blue from having cobalt in the glaze. I was shocked to find out that neither of these iconic colors used cobalt as their colorant. In fact, the turquoise color is often referred to as water blue and relies on copper to create its color in a high alkaline glaze, while celadons rely on small amounts of iron being fired in a reduced kiln atmosphere. The other

key difference beyond the colorants and fluxes was that the pots were fired at very different temperature ranges. The water blue glaze is low-fire, and celadons are high-fire glazes. The point I want to make here is that colors come from specific chemistry, colorants, kiln atmospheres, and temperature ranges.

It can be difficult to pinpoint exactly how a colorant will act in a given glaze, but there are some general principles to think about when you're setting up your testing. Through years of teaching glaze chemistry to students, my mentor Linda Arbuckle has compiled a comprehensive

list of color interactions that I will draw from on the following pages. You can find her complete notes on color on her website (lindaarbuckle.com), where she generously provides handouts on a variety of technical topics. In addition to her comprehensive knowledge of glaze, she has developed a broad color palette in majolica.

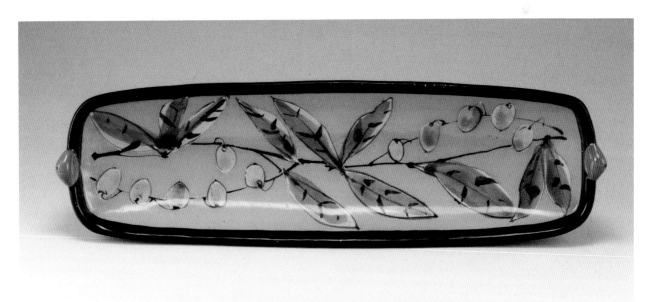

Linda Arbuckle tray. Photo courtesy of the artist.

IRON (FE)

Iron (Fe) can be used to make buff, ochre, rust, browns, and blacks in both slips (0.5 to 8 percent) and glazes (1 to 15 percent). Iron is the most common ceramic colorant largely because it appears so frequently in the earth's crust. Iron will act as a flux even in low-fire temperatures. It's sometimes found in soluble forms that should not come into contact with skin. The Italian plate pictured at the top of the opposite page uses iron in a lead base for the brown color.

Iron is the colorant that gives terracotta and many other clays its color. Akan memorial heads, or *nsodie*, were made from terracotta and used in religious memorials in West Africa, including this one from the late 1600s in the collection of the Cleveland Museum of Art. Their curators write, *"Before they died, Akan royal family members commissioned terracotta portraits, including heads like this one, from female artists. After royal burials, these idealized substitutes were placed in sacred groves outside the village where they were the focus of periodic libations, offerings, and prayers."* It should be noted that African objects were often looted by European colonialists prior to them being displayed in contemporary museum collections.

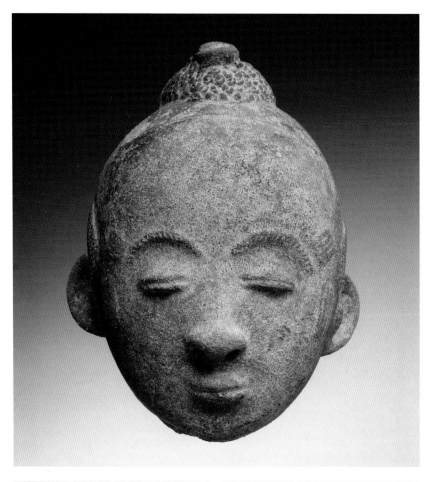

Akan memorial head. Late 1600s–early 1700s. Ghana. Photo courtesy of the Cleveland Museum of Art.

BEHAVIOR IN USE

+ Lead = translucent amber

It is used to make amber in Tang Dynasty Sancai glaze. Use barium, or better yet strontium, to produce iron ambers similar to lead colors.

+ Sodium, potassium, and lithium (alkali metal fluxes) = cooler amber to brown tones
+ Zinc = duller iron colors
+ Ca (calcium) = bleached Fe colors

1–3% tans
4–6% red browns in most, but olive yellow in high alkali glaze
6–10% deep browns (tin may help)

There are many iron-bearing clays that have been traditionally used as slips, such as Barnard/Blackbird Slip Clay, Alberta Slip, Albany Slip (no longer available).

SOURCES OF COLORANT

Red iron oxide (Fe_2O_3) has finer particles than black iron (Fe_3O_4), which often leads to more color dispersion in a glaze. Yellow iron oxide (H_2O 10 Fe_2O_3) is a less concentrated form of red iron oxide.

Crocus Martis, or anhydrous ferrous sulfate ($FeSo_4$), is purple maroon raw. It is used INX titanium, but with more iron. It often comes in a powdered granular form that can be used to create speckling.

Ochre (yellow ochre), sienna (raw or burnt), and umber (raw or burnt) are all blends of iron and manganese.

Iron chromate has a mixture of iron and chrome. It can be used to make taupe colors.

Iron sulfate is soluble so it should never touch your skin. Wear gloves if using.

COPPER (CU)

Copper (Cu) can be used to make a variety of green and turquoise colors in slips (2 to 8 percent) and glazes (up to 6 percent). More than 6 percent in glaze can create a metallic pewter surface that is interesting but not suitable for functional ware. Copper will fire green in oxidation but can create deep reds in reduction. It can be found in soluble forms that should not come into contact with skin. It will vaporize at high temperatures and fume surrounding wares and shelves. Sandy Simon's jar below is glazed with a green glaze that has 3 percent copper carbonate, 12 percent iron oxide, and 0.25 percent chrome. The presence of iron oxide and chrome modulate the copper from turquoise to grass green in this high sodium glaze.

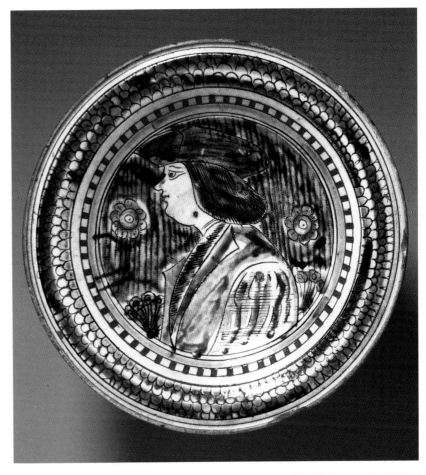

Plate with a Portrait of a Gentleman, c.1500–1510. Italy, Ferrara. Photo courtesy of the Cleveland Museum of Art.

Sandy Simon jar. Photo courtesy of the artist.

BEHAVIOR IN USE

+ Sodium, potassium, and lithium (alkali metal fluxes) will be a turquoise color. It was used in Egyptian paste and the translucent water blue glazes of the Middle East.

+ Matte glazes that use high amounts (30%) of barium will be light robin's-egg blue. Barium carbonate is toxic, when ingested orally. Strontium can produce colors similar to barium.

+ Zinc will create intensified copper colors.

+ Lead will create transparent grass green. It was used to make green in Tang Dynasty Sancai.

SOURCES OF COLORANT

Copper carbonate ($CuCO_3$) has finer particles than black copper oxide (CuO) or red copper oxide (Cu_2O). The latter is surface coated to prevent oxidation and therefore does not mix well in water.

Copper sulfate ($CuSO_4$) looks like pale turquoise crystals before it's mixed with liquid. It is highly soluble, and therefore toxic, and should not come into contact with your skin.

COBALT (CO)

Cobalt (Co) can be used to make a variety of blue slips (0.25 to 2 percent) and glazes (0.25 to 2 percent). It's one of the most dominant colorants, meaning a little goes a long way. It's also extremely expensive, but thankfully, it's only used in small amounts in ceramics. It can be softened with iron or other colorants. Cobalt oxide can spit during firing, causing discoloration on your kiln shelves or other work. It can be found in soluble forms that should not come into contact with skin. Catie Miller screen prints with cobalt-colored slips on newsprint before transferring the pattern to the surface of the pot. Her *Turkey Hen and Poults Platter* shows the variety of colors you can get with the material.

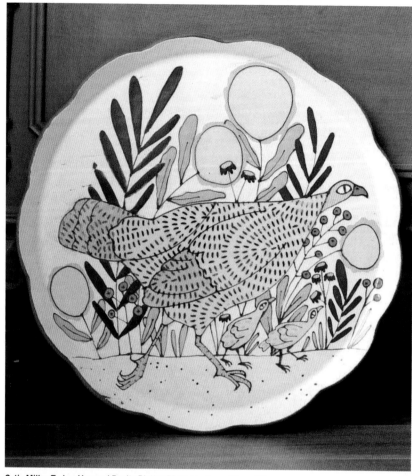

Catie Miller *Turkey Hen and Poults Platter*. Photo courtesy of the artist.

BEHAVIOR IN USE

+ Sodium, potassium, and lithium (alkali metal fluxes) will be a brilliant blue towards ultramarine.

+ Lead will create warm blues.

+ Magnesium will create purple to lavender in small amounts.

+ Zinc will create intensified blue colors.

When mixed with other colorants:

+ Rutile or titanium will create crystalline greens.

+ Chrome will create teal colors.

+ Pink or red inclusion stains can create purples in combination with cobalt.

SOURCES OF COLORANT

Cobalt carbonate ($CoCO_3$) is often lavender when raw and has finer particles than cobalt oxide (CoO), which is black when raw.

Cobalt sulfate ($CoSO_4$) looks like pale lavender crystals before it's mixed with liquid. It is highly soluble, therefore toxic, and should not come into contact with your skin.

MANGANESE (MN)

Manganese (Mn) can be used to make a wide range of brown, pink, and maroon purple slips (2 to 10 percent) and glazes (2 to 20 percent). When used in 2 to 4 percent, it will disperse in a glaze. From 5 to 40 percent, the high saturation can create bronze metallic surfaces. The women's shawl in this image from the Metropolitan Museum of Art is an example of manganese in a lead-based majolica glaze.

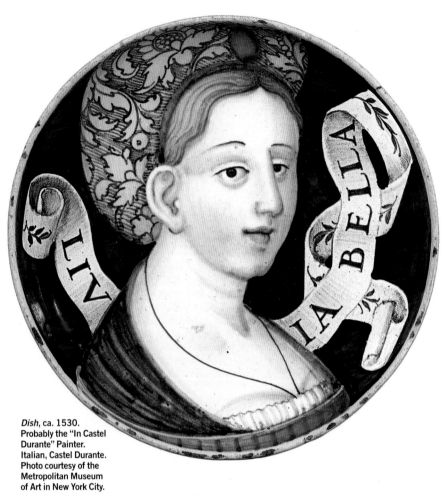

Dish, ca. 1530. Probably the "In Castel Durante" Painter. Italian, Castel Durante. Photo courtesy of the Metropolitan Museum of Art in New York City.

BEHAVIOR IN USE

+ Sodium, potassium, and lithium (alkali metal fluxes) and low alumina with 1–3% manganese can create violet.

+ Lead will create warm purple. It was used to make purple in Tang Dynasty Sancai glaze.

When mixed with other colorants:

+ Tin will create the color of coffee.

+ It is used in stains to create pink, such as Mason Stain 6020 Manganese Alumina Pink.

SOURCES OF COLORANT

Manganese oxide (MnO)

Manganese dioxide (MnO$_2$)

Manganese carbonate (MnCO$_3$)

CHROME (CR)

Chrome (Cr) can be used to make green and brown slips (0.5 to 2 percent) and glazes (0.25 to 2 percent). It is one of the most dominant colorants. In the United States, the shade of chrome green is commonly referred to as John Deere Green. Christy Culp uses green underglazes with both copper and chrome. The leaves on her vase show the two side by side. The underglaze with more chrome is the dark green on the outsides of the leaves.

Christy Culp *Carrot Vase*. Photo courtesy of Charlie Cummings.

BEHAVIOR IN USE

+ Sodium, potassium, and lithium (alkali metal fluxes) and low chrome can create chartreuse. Chrome in higher amounts will be John Deere Green.

+ Zinc creates browns.

+ Lead can create red orange glazes, like Otto's Texture, or yellow with lead and sodium.

- Chrome is refractory, so adding significant amounts will reduce the melt of your glaze. In majolica, chrome decorating colors require additional flux.

When mixed with other colorants:

+ Tin (5% or more) and small amounts of chrome will create pink in a glaze with a calcium alkaline earth flux, such as Mason Stain 6000 Shell Pink.

SOURCES OF COLORANT

Chrome oxide (Cr_2O_3) is dark green raw.

Iron chromate ($FeCrO_4$), potassium bichromate or dichromate (bright orange crystals raw), and lead chromate are all soluble in water and are highly toxic if absorbed, inhaled, or swallowed. Use extreme caution when using, including gloves and respirator.

Be aware zinc will turn chrome brown in glazes even when its source is a stain. The same applies for slips.

VANADIUM (V)

Vanadium (V) can be used to make warm yellow slips (5 to 20 percent) and glazes (5 to 10 percent). It usually comes in the form of commercial stains because the raw material vanadium pentoxide (V_2O_5) is toxic. Tom Bartel's *Memento (Figure with Inverted Heart)* is painted with a commercial underglaze that looks like it has vanadium stain.

Tom Bartel *Memento (Figure with Inverted Heart)*. Photo courtesy of the artist.

BEHAVIOR IN USE

+ It is a warm yellow regardless of flux.

SOURCES OF COLORANT

Vanadium pentoxide (V_2O_5)

Commercial stains: Mason Stain 6404 Vanadium Yellow

PRASEODYMIUM (PR)

Praseodymium (Pr) can be used to make cool yellow slips (5 to 20 percent) and glazes (5 to 10 percent). I think of this as the cousin of vanadium in that they are both yellow, but vary in their warmth and tone. Praseodymium yellows tint towards green, whereas vanadium tints towards orange. Kari Radasch adds Mason Stain 6450 Praseodymium to her terra sigillata. You can see how the Praseodymium provides a cooler, more acidic yellow.

Kari Radasch dish. Photo courtesy of the artist.

BEHAVIOR IN USE

+ It is a cool yellow regardless of flux.

SOURCES OF COLORANT

Commercial stains: Mason Stains 6410 Canary and 6450 Praseodymium

ANTIMONY (SB)

Antimony (Sb) can be used to make yellow glazes. It is toxic though, so Vanadium and Praseodymium are better options.

BEHAVIOR IN USE

+ It is used in combination to make yellows. It is combined with lead to make Naples yellow and combined with titanium or rutile in body stains.

SOURCES OF COLORANT

Commercial stains: Mason Stain 6405 Naples

Antimony oxide (Sb_2O_3)

TITANIUM (TI), RUTILE (TI + FE), AND ILMENITE (FE + TI)

Titanium (Ti) can be used to create off-white, antique white, buff, and tan glazes (5 to 10 percent) and slips (5 to 15 percent). It will induce phase separation under specific circumstances, which creates opacity. It also has an opacifying effect due to titanium forming crystals in the glaze.

Rutile (Ti + Fe) can be used for tan, yellow, off-white slip colors (2 to 6 percent) and tan to modulated blues in glazes (4 to 20 percent). It is predominantly titanium mixed with iron (up to 15 percent) and traces of other minerals. It is often used for brushwork with overglaze washes. Rutile is a mined, not manufactured, material, so there will be variation between sources. It can be bought labeled as light, which is calcined for concentration, or dark rutile, which is not calcined.

Ilmenite (Fe + Ti) has similar color response to rutile but with more iron. In granular form, it's used to make black-brown specks in clay and glazes. Joe Pintz colors his matte glaze with 3 percent rutile to create the warm white pictured at right. The darker color beside it is the clay showing through the glaze.

Joe Pintz plates. Photo courtesy of the artist.

BEHAVIOR IN USE

+ It is refractory and will need a flux when used for overglaze decoration. Try 1 rutile, 4 Ferro Frit 3124, and 0.5–1 bentonite by volume. It will be a rusty orange when used over majolica glaze.

+ Rutile can produce a golden microcrystalline surface.

When mixed with other colorants:

+ It is great for modifying other colorants. It is used with cobalt for greens or grays and chrome for yellower greens.

SOURCES OF COLORANT

Titanium dioxide (TiO_2) is a white powder.

Rutile: Most common forms are powdered and are tan, gray, and brown when raw. Granular rutile will produce a speckled surface.

Ilmenite: Granular and powdered forms are available. It is black in its raw state.

NICKEL (NI)

Nickel (Ni) can be used to create a wide spectrum of colors from blue gray, purple, yellow, and tan browns. It's commonly used in lower percentages in slips (1 to 6 percent) and in glazes (1 to 4 percent).

BEHAVIOR IN USE

+ It crystalizes and may matte out a glaze above 2%.

+ High calcium = brown colors

+ High barium = tan purples

+ It can create blues due to the presence of cobalt in source material.

When mixed with other colorants:

+ It is used with cobalt for blue grays.

SOURCES OF COLORANT

Nickel oxide can be green (NiO) or black (Ni_2O_3) in its raw state.

Nickel carbonate ($NiCO_3$)

Present in manufactured stains like Mason Stain 6274 Nickel Silicate, which is an olive green.

CADMIUM (CD) AND SELENIUM (SE)

Cadmium (Cd) and Selenium (Se) are used in low-fire red commercial glazes. They are toxic heavy metals that were traditionally blended with lead and fired below cone 05. They can be found in encapsulated stains, which can be fired in all temperature ranges and atmospheres. Encapsulation makes them safer to handle but is very expensive. They should be used only in noncrazing glazes to avoid fracturing the encapsulated stain and exposing them to food or drink. Ben Owen uses a stain no longer in production to create his signature red glaze that he fires to cone 08 in oxidation.

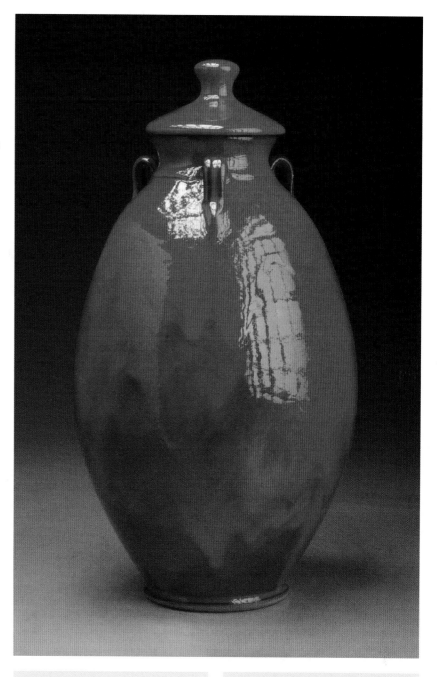

Ben Owen *Covered Jar*. Photo courtesy of the artist.

BEHAVIOR IN USE

+ These become vaporous above cone 06 so fuming of other pieces in close proximity is common.

+ Inclusion stains use encapsulated cadmium to create bright reds, yellow, and oranges. It is expensive and can need 10% or more to create consistent color in slips.

SOURCES OF COLORANT

Stable sources come from encapsulated stains. These should not be ball milled, as this can release the raw oxides.

Both are highly toxic in their raw oxide form. They should be avoided and treated as a hazardous waste.

RARE EARTH COLORANTS ERBIUM (ER) AND NEODYMIUM (ND)

Erbium (Er) and Neodymium (Nd) can be used to make pink, purples, and yellows in glazes (8 to 10 percent). They are used in the energy industry, so are often very expensive.

BEHAVIOR IN USE

+ Erbium produces pale translucent pink.

+ Neodymium can produce both lavender and blue depending on the type of light it's seen under. It creates a rare shape-shifting color.

+ The rare earth colorants are very dense and settle in glazes. David Pier has done a lot of research in high-fire settings and recommends adding a CMC gum solution to suspend in the glaze.

SOURCES OF COLORANT

Erbium oxide (Er_2O_3) is a pink powder.

Neodymium (Nd) is a blue powder.

OPACIFIERS

Opacifiers work by clouding the glaze with undissolved particles. Tin (Sn) and zirconium (ZrO_2) create white and off-white glazes (5 to 10 percent) and slips (5 to 15 percent). Tin was historically used (up to 10 percent) to create majolica glazes that covered clay underneath and were painted with overglaze colorants. The apothecary jar on page 53 is a classic Italian tin glaze from the workshop of Giunta di Tugio made in the mid-1400s. The vase on the page 52 was made recently by Stan Andersen, who uses 7 percent Zircopax in his majolica glaze.

High percentages of stains also have an opacifying effect. On page 53 you see Walter Ostrom's dish, which has a layer of black majolica (12 percent black stain) under a tin glaze. The effect when combined with layers of wax creates black outlines around the overglaze colors.

BEHAVIOR IN USE

+ Tin (5%) with small additions of chrome will fume to create pink. This combination is used to make pink stains. If you don't want chrome-tin pinking, try replacing half the amount of tin with zirconium.

+ At low-fire temperatures tin will not melt in the glaze, making it a suspended inert particle. Tin can increase melt viscosity, creating a potential for crawling.

+ Zirconium Silicate is a modern opacifier that is sold under various brand names. It is used in slips and glazes (5–12%). It creates a brighter white glaze than tin or titanium but is less concentrated by volume. For every 1% of tin, you will need to add 1.5% Zirconium.

+ It creates more translucent whites because it is a suspended inert particle. More concentration creates less translucency.

SOURCES OF COLORANT

Tin oxide (SnO2) is a white powder.

Tin can also be found in chrome-tin pink stains.

Zirconium can be used at 10% to create a dense white.

Strength of suspended opacifiers relates to particle size. The smaller particle sizes will create more opaque surfaces in smaller concentrations.

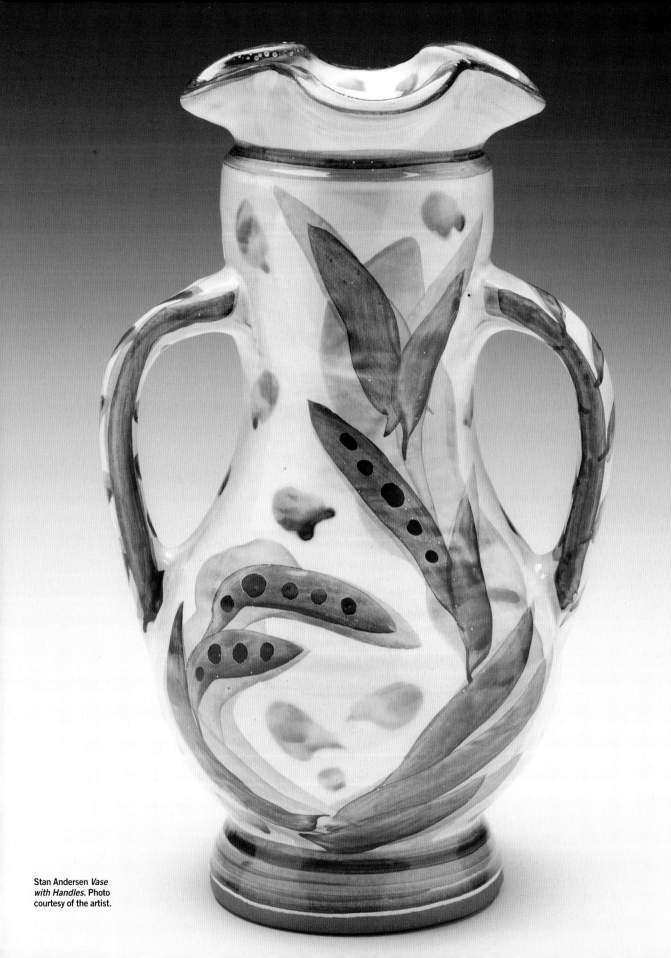

Stan Andersen *Vase with Handles*. Photo courtesy of the artist.

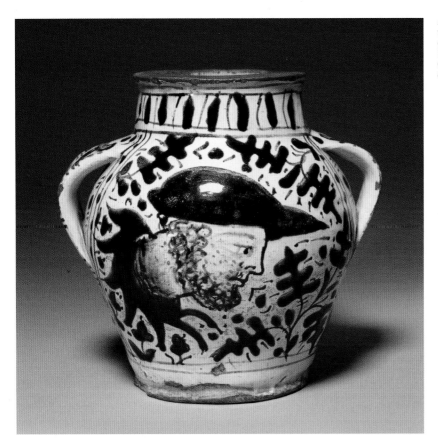

Apothecary Jar,
workshop of Giunta
di Tugio, 1431.
Photo courtesy of the
Cleveland Museum
of Art.

Walter Ostrom dish.
Photo courtesy of the
artist.

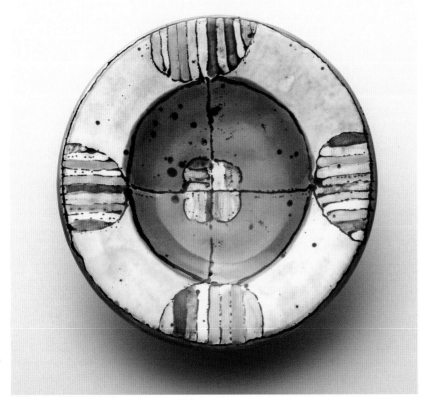

DEVELOPING
COLOR

It's important to learn the independent visual qualities of colorants, but ultimately, our perception of a color is shaped by what surrounds its borders. This section highlights how artists use color theory in their own studio.

We are fortunate that we have commercial stains and other refined ceramic materials to help us harness the color spectrum. Shoko Teruyama creates amazingly subtle and powerful color relationships with her glaze palette. She says of the process: *"I mostly use one base glaze with about fifteen different colorants. I always think about how to develop layers of glazes and over wraps. I pay attention to what combination of glazes work well next to each other. I will write it down in my sketchbook as well as mental notes. I often work with stronger colors underneath and softer color on top to achieve depth. For example, copper green dots underneath with rutile/copper on top, cobalt dots underneath with turquoise on top, intense red dots underneath with softer red on top."*

In the flower plate pictured at left, notice how the yellow grabs your attention as it contrasts with the cool blues and greens. The combination is so vibrant that at first glance you barely notice the pink blooms. This push and pull of color energizes the already undulating sgraffito flowers drawn in the slip underneath the glaze. You can flip forward to chapter 4 for an in-depth analysis of her versatile transparent glaze.

Shoko Teruyama flower plate. Photo courtesy of the artist.

KIRK MANGUS AND EVA KWONG DRY SLIP

Whereas Shoko Teruyama's approach relies on brushing color over a predetermined pattern, Nicholas Bernard takes a broader approach as he sprays colored slips. His large globe forms have multiple layers of colored slips sprayed over a thick textured slip. He says of the process, *"The color is sprayed on greenware. As many as nine layers of color are applied. Once all the color is applied pieces are (bisque) fired to cone 04. They are then washed with black copper and fired again."* Notice how the color choice alters the way you see the form. When the color is monochromatic, you see the outline of the form. When the colors contrast, you look at the highest value color, which in this case is orange.

Bernard uses this greenware base slip recipe from Kirk Mangus and Eva Kwong for all his slips. Up to 20 percent of a Mason Stain can be added to create your desired color. He mentioned that he adjusts the recipe, either decreasing the amount of silica or adding Ferro Frit 3124 depending on the refractory nature of the Mason Stain.

Throughout the book, you'll often see Mason Stains mentioned. They are made by the Mason Color Works, a family-owned company in business for over a century. Their stains are widely and commonly used by ceramic artists in North America. Those living outside of North America can find similar stains made by companies in their region of the world.

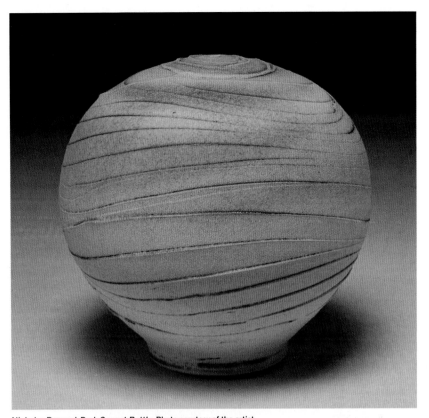

Nicholas Bernard *Dark Sunset Bottle*. Photo courtesy of the artist.

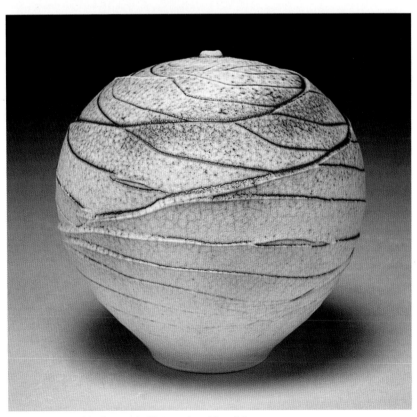

Nicholas Bernard *White Topography*. Photo courtesy of the artist.

KIRK MANGUS AND EVA KWONG DRY SLIP (CONE 04+)

Gerstley Borate	13
Nepheline syenite	12
Ball clay	25
Kaolin	25
Silica	25

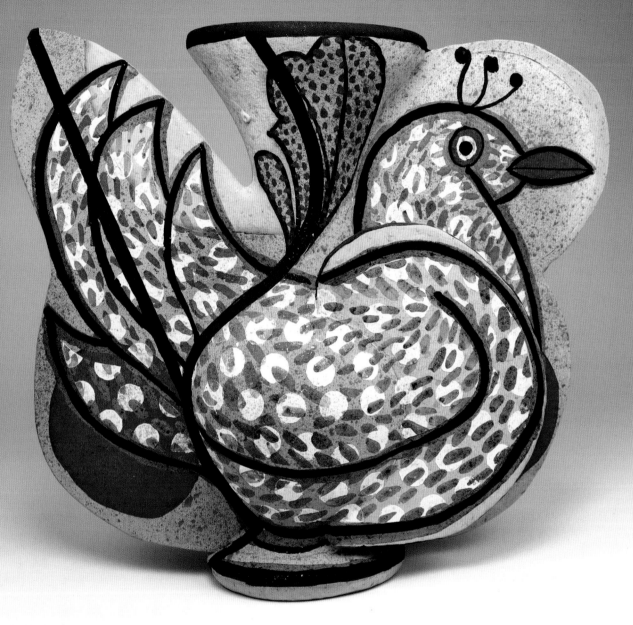

Andrea Gill decorated
this winged bird vase
with slips before
splattering the form
with clear glaze. The
technique provides
color and sheen without
being overly glossy.
Photo courtesy of the
artist.

BARTEL ENGOBE BASE

Tom Bartel uses a vitreous slip to surface his sculptures. The recipe is similar in nature to most low-fire slips except that its increased flux gives it a slight sheen. This can really punch up the colors, as well as mimic the moisture present in human skin tones. After bisque firing, Bartel adds a copper oxide wash into the cracks of the slip to create a patina of age for his figures.

Tom Bartel *Memento (Figure with Inverted Heart)*. Photo courtesy of the artist.

BARTEL ENGOBE BASE (CONE 04-02)

OM4 Ball Clay	15
Edgar Plastic Kaolin	30
Silica	15
Ferro Frit 3110	35
Gerstley Borate	10
Borax	5

FAUX LEAD BASE

Ronan Peterson blends slip trailing with colored terra sigillata and glaze to create his aesthetic. The combination of color, sheen, and surface texture makes his earthenware pottery a joy to use.

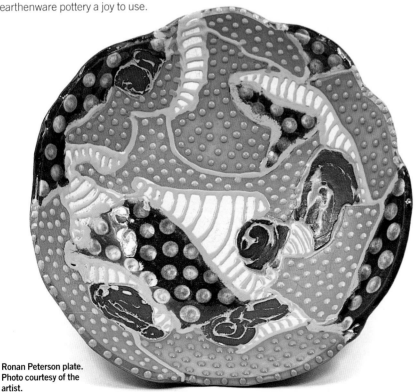

Ronan Peterson plate. Photo courtesy of the artist.

FAUX LEAD BASE (CONE 04-02)

Ferro Frit 3110	31
Gerstley Borate	33
Edgar Plastic Kaolin	26
Silica 325 mesh	5
Wollastonite	3
Strontium carbonate	3
Bentonite	2

Amber: 6% red iron oxide
Namor Green: 0.4% chrome, 0.5% copper carbonate
Grape Ape: 0.5% cobalt carbonate, 0.5% manganese

ORR CRACKLE-FREE BASE

Perhaps no artist can top Lisa Orr's exuberant use of color. Influenced by the bright colors of Mexican terracotta, Orr has created a multi-layered, more-is-more aesthetic. Lead has been used in a variety of cultures to create fluid translucent glazes but is now avoided for its toxicity. To create a similar surface, Orr builds forms with a white earthenware, which she then decorates with colored slips before applying Redart terra sigillata. After bisquing to cone 02, she then applies layers of high-alkaline translucent glazes. Over years of experimentation, she has matched her clay and glaze fit to minimize crazing. If you need help solving this glaze issue, check back to chapter 2 for a list of solutions.

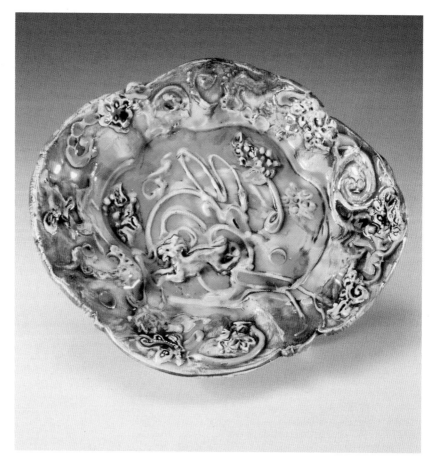

Lisa Orr dish. Photo courtesy of the artist.

ORR CRACKLE-FREE BASE (CONE 04)

Ferro Frit 3110	57
Ferro Frit 3134	25
Edgar Plastic Kaolin	8
Silica 200	10
Bentonite	2

Light Turquoise: 1.0% copper carbonate

Cobalt Blue: 0.25% cobalt carbonate

Water Blue: 3% copper carbonate

Teal: 5–7% copper carbonate, 0.25% chrome

Amber: 10.0% synthetic iron oxide

French Blue: 1.25% cobalt carbonate, 5.25% copper carbonate

Manganese: 3.0% Mason Stain 6194 Manganese Silicate

Grape Purple: 0.75% cobalt carbonate, 2.0% Mason Stain 6194 Manganese Silicate

Bottle Green: 10% synthetic iron oxide, 3% copper carbonate, 0.25% chrome

FINE AMBER SPARKLE AVENTURINE

Another unique aspect of Orr's work is her use of aventurine glazes. These glazes feature metallic microcrystals that form and precipitate towards the surface as the glaze cools. You can see a band of the crystals sparkling against the yellow glaze in the picture at right.

Detail of Lisa Orr's aventurine glaze. Photo courtesy of Ben Carter.

FINE AMBER SPARKLE AVENTURINE (CONE 04)

Pemco Frit P-25 or Ferro Frit 3269	63.41
Silica	8.13
Lithium carbonate	8.13
Edgar Plastic Kaolin	4.07
Nepheline syenite	8.13
Bentonite	1.63
Red iron oxide	11
Mason Stain 6404 Vanadium Yellow	1

CHAPTER 3

FINDING YOUR SURFACE

The goal of this chapter is to show the broad
range of sheen, color, and reflectivity that are
possible within the low-fire genre. The featured
artists and techniques are loosely divided by glaze
type, and each section pairs recipes with images
of the glazes in use. As the chapter progresses,
you'll move from under-glaze decoration (slip,
underglaze, and terra sigillata) to in-glaze
decoration (majolica and glaze layering), to
overglaze decoration (luster, decals, and China
paint). Atmospheric firing and sculptural surfaces
round out the chapter. This chapter will help you
choose a surface to start experimenting with in
your own studio practice.

BUILDING LAYERS WITH SLIP AND UNDERGLAZE

Terracotta and other low-fire clays are often placed on the bottom rung of the ceramic ladder beneath stoneware and porcelain. Is this due to the temperature at which the clays mature or is there a deeper cultural perception that goes beyond its physical qualities?

Kyle Carpenter plate interior. Photo courtesy of the artist.

Terracotta's utilitarian nature has made it perfect for everyday wares, flowerpots, and roof tiles. On the other end of the spectrum, porcelain is harder to work with and for many centuries was difficult to get outside of China. It was used by the aristocracy and became one of the most important trade goods of the second millennium's Silk Road. As I have talked to

low-fire potters over the years, I've noticed a tendency to embrace the hardworking qualities of the material, while also pushing against this hierarchy of value.

One visual tactic practiced by historical low-fire potters was to change the aesthetic value of their low-fire clay through decoration. As porcelain passed through the Middle East and

ALL PURPOSE WHITE SLIP (CONE 04-10)

Edgar Plastic Kaolin	28
OM4 Ball Clay	28
Silica	22
Ferro Frit 3124	22
Zirconium	5

Ron Meyers lidded jar. Photo courtesy of the artist.

the Mediterranean, potters from various cultures copied the aesthetics of porcelain by covering their red and buff earthenware clays with white slip. The simple decorative impulse to lighten the surface of a pot opens the door to more formal possibilities than would be available to a dark terracotta body. This section focuses on artists that build layers of slips and other pigments as their main decorative technique.

Slips can be applied through brushing, pouring, or spraying, depending on the scale of the object and its level of hydration when they are applied. Pictured at left, you see Kyle Carpenter's beautiful brushwork over a base layer of brushed slip. It's important to match the shrinkage of the slip with that of the clay on which it is applied. I've been using a versatile slip for many years that can be easily adjusted to fit your clay body's shrinkage.

I find it helpful to break down slip ingredients into shrinking and nonshrinking particles. Edgar Plastic Kaolin and OM4 Ball Clay are both clays that expand and contract when wetted. Silica and Ferro Frit 3124 are nonshrinking particles that stay the same size when wetted. In comparison, the shrinking particles are 56 percent of the recipe while the nonshrinking particles are 44 percent. This formula is great for greenware applications because it shrinks a large amount to match what the ware does when drying. To adjust it for bisqueware application, where the ware has done a good percentage of its shrinkage, you would decrease the clays and increase the silica and frit. The frit in the recipe helps flux the slip, adhering it to the body. If your slip is flaking off your clay, decrease the clay content to reduce shrinkage or add a flux to help it adhere to the body. If you're looking for a vitreous slip, check out Tom Bartel's recipe in the "Developing Color" section of chapter 2. His slip is more fluxed and dense than a nonvitreous slip and can be used without a glaze on top.

BETTY'S BISQUE SLIP (CONE 04-2)

Silica	40
Nepheline syenite	26.67
OM4 Ball Clay	26.66
Ferro Frit 3195	6.67
Zirconium	6.67

Maura Wright *Juicy Fruit Jar*. Photo courtesy of the artist.

Maura Wright uses a bisque slip that she tints with Mason Stains. Notice that it has a relatively low clay content to reduce shrinkage. This helps it fit bisque, which has already shrunk during its firing. She describes making her *Juicy Fruit Jar*: *"The pattern was applied with bisque slip stained with Mason Stain 6242 Bermuda (Green) at 10 percent and Mason Stain 6255 Jade Green at 15 percent. A clear glaze was applied over the bisque, fired, and then sandblasted to achieve the satin finish."* I love the pop of reflectivity and visual rest the lustered handle provides for the otherwise checkered pattern.

Low-fire pottery is often fired in electric kilns, simply melting glaze materials without adding the unique surface information that is present in an atmospheric firing. Low-fire artists are challenged to supply the visual interest, rather than harness the effects of the kiln. Many artists create visual energy by layering slips with washes and glazes. Michael Connelly does this on his large platter by contrasting the poured slip against the geometry of his urban landscapes.

"Architecture and mark making is a prominent focus in my work both structurally and visually. When glazing, I use masking tape in an effort to build lines into my drawings. I work in both an additive and subtractive manner to build up tonal variations and layers of color. I use wax resist to seal a section. I might carve through the wax and inlay a contrasting line of color as well."

The image on the right was taken mid glaze as he was applying black oxides to the dry surface of the glaze.

Photo courtesy of Michael Connelly.

Michael Connelly plate and in-process detail. Photo courtesy of the artist.

Holly Walker painted movement onto the surface of her *Palette Serpentine* platter. The colors come from a combination of layered slips and glaze. I was talking to Holly once about my quest for a good pink, and she told me to think of decorating with slips like painting. She suggested I try putting a red slip under a translucent white slip with a little glaze. It's a good reminder that you're not limited to out-of-the-bottle or premixed colors.

Holly Walker *Palette Serpentine*. Photo courtesy of Clay AKAR.

Paul Andrew Wandless working on *Print Maker*. Photo courtesy of the artist.

Paul Andrew Wandless monoprints with clay to create his images. He says of the process: "*First, the imagery is created on a plaster bat with a smooth flat surface, which acts as the printing plate. The imagery can be created with commercial underglazes or colored slips, but the ceramic materials must be clay-based and not glazes since this is the greenware stage. Once the design is dry, a 1-inch [2.5 cm] tall clay retaining wall is placed around the perimeter of the bat, creating a mold box to cast a clay slab. The casting slip is poured into the mold box, covering the imagery as it fills up to the desired height.*

"*The casting slip rehydrates the image, allowing it to be captured in the stiffening clay. Once the cast slab is firm to the touch, the clay retaining walls need to be cut from the cast slab and removed. When the cast slab reaches the desired stiffness, it can be lifted from the plaster bat revealing your one-of-a kind clay print.*"

Above, you can see Paul working on *Print Maker* from his series about studio life.

Shanna Fliegel uses sgraffito and Thermofax, a form of screen printing, to create her surreal images. She describes her process: "*Once the slip is bone dry, I typically sketch the drawings with a dull pencil. Using a sharp pin tool I then outline, stipple, and carve the imagery. Thermofax prints add a graphic appeal, and AMACO Velvet Underglazes are blurred to create an ephemeral 'blurred out' look. After bisquing, I layer on a black wash and wipe away the excess to highlight the etched lines. With fine brushes, I painstakingly paint sections of the images with glaze. Stroke & Coats, thinned Amoco Velvet Underglazes, and personally mixed glazes comprise my palette.*"

The hard outline of the Thermofax print creates defined separation for the intense glaze colors she uses.

LOBSTER (CONE 04)

Nepheline syenite	13
OM4 Ball Clay	25
Edgar Plastic Kaolin	25
Gerstley Borate	12
Silica	25
Add: Lithium carbonate	5
Mason Stain 6026 Lobster	3

Opposite: Shanna Fliegel detail from *What If We Could Ask Our Future Selves a Question?* Photo courtesy of the artist.

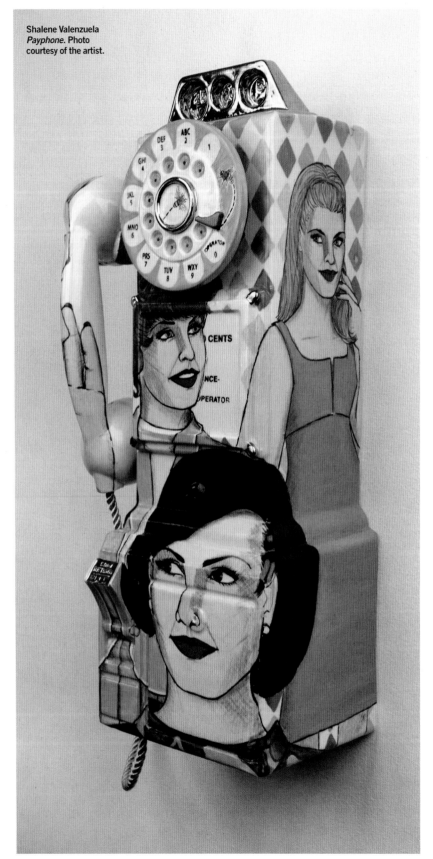

Shalene Valenzuela
Payphone. Photo courtesy of the artist.

Pattie Chalmers *Turquoise Chesterfield with Abstract Painting Cup.* Photo courtesy of the artist.

Underglaze is a commercial version of slip that is often enhanced with brushing additives like CMC gum. A variety of companies make underglazes with their own proprietary color blends. Shalene Valenzuela and Pattie Chalmers both use layers of underglaze to define the human bodies and narratives that populate their forms. The amount of detail possible with underglazes is in part due to the fact they do not move under the glaze when they are fired. It's possible for underglazes to burn out as they are fired hotter, but thankfully, this doesn't happen in the low-fire range.

The fine particle size of underglazes makes them perfect for diluting like watercolors. Celia Feldberg uses this to great effect on the trees in her *Treehouse* cake plate (opposite page bottom). After painting watered down underglaze into the sgraffito pattern, she dips the whole pot in a clear glaze. Check out the subtle spectrum of green in this piece. If you want to blend underglazes together, try using a plastic watercolor palette. They are great for creating and storing special blends of underglaze.

Drawing through slip with a carving, also known as sgraffito, exposes the red clay underneath. Beginners often find this a natural technique because it mimics drawing with a pen on paper. Joan Bruneau uses a pouncing technique to set up the sgraffito on her terracotta forms.

"When the slip and piece is very stiff leather-hard, I pounce patterns using paper stencils and powdered graphite in

Joan Bruneau flower brick. Photo courtesy of the artist.

Celia Feldberg *Treehouse* cake plate. Photo courtesy of the artist.

a pouch that is dragged over the paper stencil. Then, using a small Kemper Sgraffito Stylus (ball carving tool), I carve through the slip, revealing the dark clay line. I paint patterns in some areas using commercial underglazes (such as cobalt blue underglaze) and copper or cobalt sulfate, which will later be covered with clear glaze, and leave other carved areas bare, which will later be glazed with polychrome glazes after the piece is bisqued."

A key to Jessica Brandl's surface development is how she encourages the running of slips and glazes based on their application and melting viscosity.

"I will dip the whole piece in my Hard Clear, which ensures a first even coat on

HARD CLEAR BASE (CONE 05–2)

Ferro Frit 3195	73
Magnesium carbonate	10
Silica	7
Edgar Plastic Kaolin	10
Bentonite	2
Epsom salts	0.3

RUNNY CLEAR BASE (CONE 05–2)

Gerstley Borate	25
Lithium carbonate	4
Ferro Frit 3124	29
Nepheline syenite	19
Edgar Plastic Kaolin	5
Calcined Edgar Plastic Kaolin	5
Silica	13
Bentonite	2

Photos courtesy of Jessica Brandl.

GAIL KENDALL AMBER (CONE 04-2)

Gerstley Borate	55
Edgar Plastic Kaolin	30
Silica	15
Burnt umber	8

my functional surfaces. When this base coat has completely dried to the touch, I apply color accents with my satin and runny clear bases. I am staging drips, building a glassy atmosphere by way of the tinted glass, and returning to the flowing energy I had when I worked with wet slip in the beginning stages of production."

Slipware was produced in England starting in the mid-1600s and continues to influence contemporary artists like Doug Fitch and Hannah McAndrew. They make terracotta pots using slip trailed and pelleted decoration, which continues an aesthetic tradition that was based on the use of lead glazes. Many potters in the United States replicate the lustrous shine of lead through boron or strontium glazes.

Doug Fitch *Large Ribs and Pellets Jug.* **Photo courtesy of Shannon Tofts.**

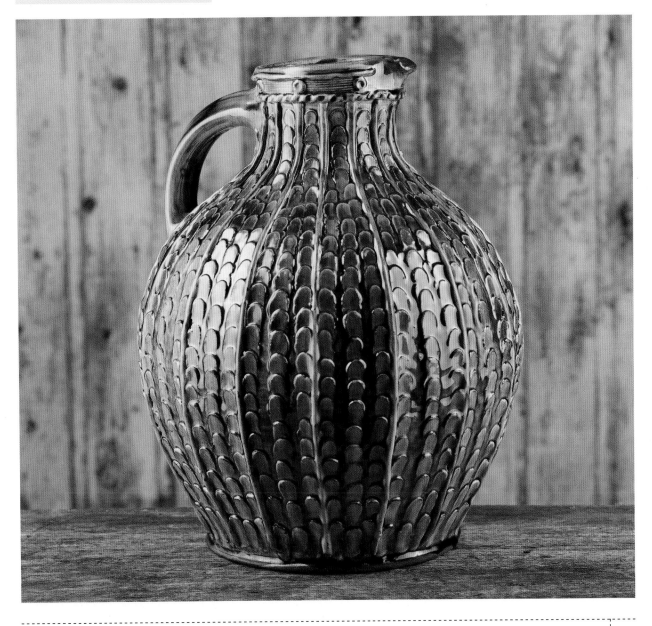

The honey color specific to a lead glaze is hard to exactly match, but check out Gail Kendall's Amber glaze for a good place to start. It's the recipe Lisa Buck used on her platter below and the same recipe as the Shoko Clear Glaze that I write about in chapter 4.

Sana Musasama and Rebecca Chappell both bring a maximalist perspective to their use of slip and underglaze. Sana Musasama applies multiple layers of gestural underglaze brushwork to her forms. After firing, the strokes blend with the base terracotta color to enhance the silhouettes of her large sculptures. I love how this work reveals itself the closer you get to its surface. Rebecca Chappell's focus is less about layered mark making and more about her vibrant combinations of color. She uses the commercial glaze Spectrum Hot Pink 751 beside white slip and gold luster. This is a perfect combo for candlesticks that glimmer in the presence of light and a historical nod to high-fire works made for Madame de Pompadour at Sèvres in 1760s France.

Hannah McAndrew *Abundance Charger*. Photo courtesy of Shannon Tofts.

Lisa Buck tray. Photo courtesy of the artist.

Photo courtesy of Sana Musasama.

Below: Sana Musasama *House* series with brush details. Photo courtesy of the artist.

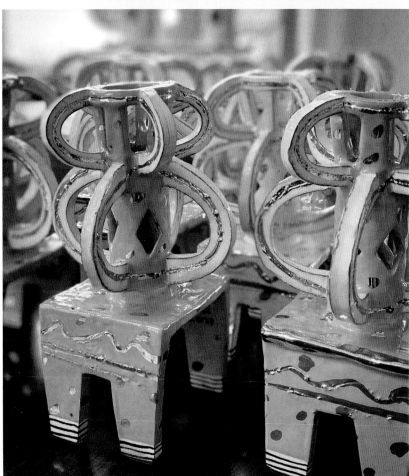

Rebecca Chappell candlesticks. Photo courtesy of the artist.

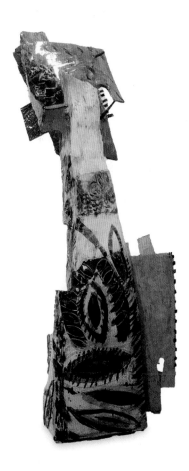

CLARKE OVERGLAZE/ UNDERGLAZE STAIN MIX

Gerstley Borate 3–4 parts by volume

Mason Stain 1 part by volume

"I use this as an underglaze right on top of white slip at leather-hard. It can be used as an overglaze on bisqueware. I use it on earthenware, but it works fine at cone 10 as well, although maybe substitute 1 part clay for 1 part Gerstley Borate at higher temperatures." —Bede Clarke

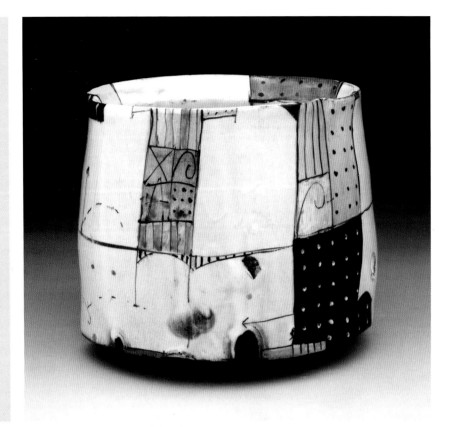

Bede Clarke cup. Photo courtesy of the artist.

"I began using commercial glazes 25 years ago in the high school ceramics classes I teach. Consistency in the product and having access to smaller quantities allowed me to experiment and test combinations with low material investment. The time invested and positive outcomes influenced my decision to use them in my personal work for the past 20 years. Commercial glazes have been a tremendous resource in the evolution of my work." —Christy Culp

She uses AMACO LG-10 Clear Transparent over her slip and underglaze.

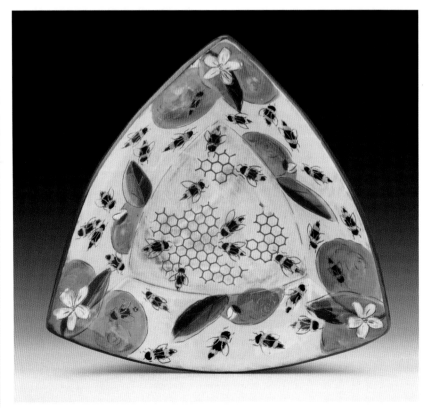

Christy Culp Orange blossom and bee plate courtesy of Charlie Cummings Gallery.

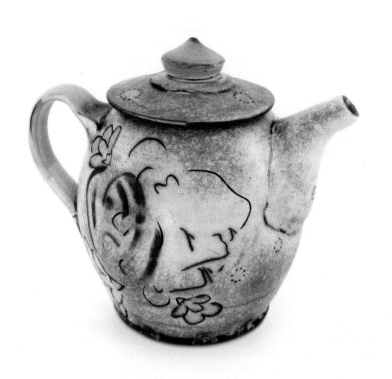

Maria Dondero teapot. Photo courtesy of the artist.

"After bisquing, I stain the sgraffito lines with a black iron and copper oxide. Next, I brush the color glazes (blue, yellow, and green) over the sgraffito, highlighting images with patches of bright color. Then, I use an atomizer to lightly spray on the final clear glaze (which I add 1% red iron oxide to for depth). I fire to cone 1 in an electric kiln." —Maria Dondero

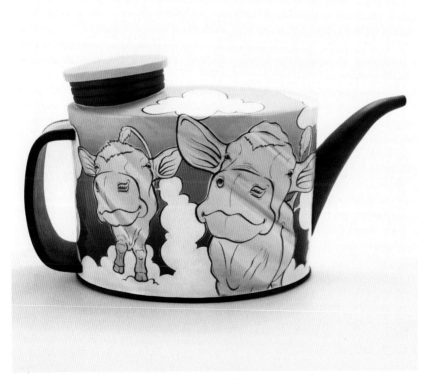

Kip O'Krongly Methane Cow teapot. Photo courtesy of the artist.

Kip O'Krongly decorates her forms with white slip before drawing motifs with sgraffito. She then latex resists the motif and brushes a blend of colored slip to create the background color. Clear glaze is applied on leather-hard, followed by terra sigillata at bone dry. She finishes the piece by single firing to cone 02 in an electric kiln. Visit the process section at kipokrongly.com for a more in-depth look at the way Kip uses stencils.

Kevin and Anna Ramsay slip cast red fritware, which is decorated with white slip. They brush their slip onto the leather-hard clay over paper resists before peeling them back to apply sgraffito decoration. Their slip casting clay recipe is featured in the "Choosing Your Clay" section in chapter 1 of the book.

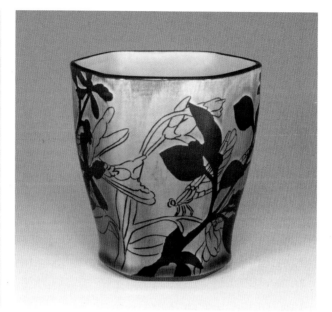

Ramsay Ceramics cup. Photo courtesy of Kevin and Anna Ramsay.

"These pieces are constructed from thrown parts that are put together when they are leather-hard. All the pieces are covered in colored slips or underglazes, some areas are painted with terra sigillata." —Victoria Christen

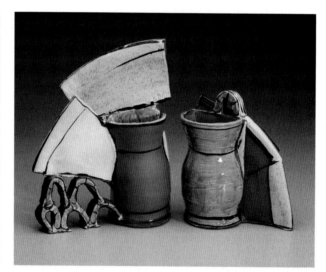

Victoria Christen Turquoise Diptych vase. Photo courtesy of the artist.

Ursula Hargens outlines her motifs with black glaze before filling them in with color glazes. This is a great nod to the *cuerda seca* style developed in Turkey.

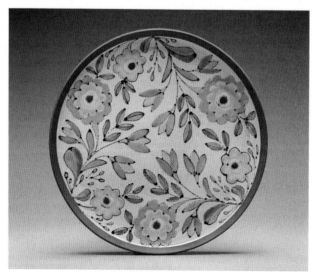

Ursula Hargens platter. Photo courtesy of the artist.

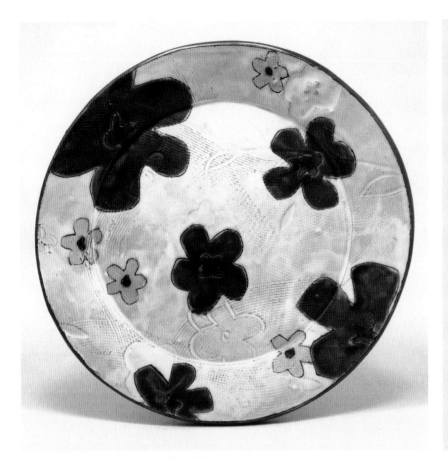

Kaitlyn Brennan plate. Photo courtesy of the artist.

Kaitlyn Brennan creates layers of textures underneath her color slip motifs. To ensure her pots absorb no water, she glazes them all over and fires them on stilts. After firing, the stilt marks are ground down.

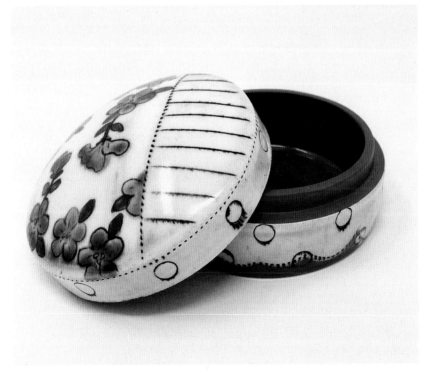

Jenn Cole Jar. Photo courtesy of Clay AKAR.

When decorating, Jenn Cole uses watered down underglazes like watercolors to soften her floral motifs. After bisque, she then inlays cobalt wash into her sewn lines.

TERRA SIGILLATA

Terra sigillata, also referred to as terra sig or even just "sig," is the "cream" that rises to the top of all slips. This food metaphor does not fit perfectly, but it illustrates that terra sig and slip are similar in nature.

To make a sig, blend dry powdered clay in water along with a deflocculant for 5 minutes. After mixing, set aside to be undisturbed during the settling process. Over the course of 24 to 48 hours, you'll see the heaviest particles settle to the bottom of your container. It's best to use a transparent container so that you can easily see the stratification that happens with settling. Pete Pinnell provides a simple adage, "By weight, mix one part clay to two parts water." If you scale this to fit a five-gallon (19 L) bucket, the recipe will be 28 pints (3.5 gallons) of water + 14 pounds (6.4 kg) of dry clay + 0.25 cup of sodium silicate. After settling, this will yield about 2 gallons (8 L) of sig. The teapot at right features a Redart sig layered over a textured slip surface with a patina overtop.

In this image, you see two distinct layers of sedimentation. The lower sediment consists of large particles that are not useful for sig and will be thrown out. It might be tempting to recycle that sediment, but remember the presence of a deflocculant in the recipe, which will make your reclaim thixotropic and hard to use. The top layer is the fine particles that make up terra sig. In some cases, you'll see three layers with water being the top layer. While you can use any dry clay as your base, I've found Redart Clay works well for dark sig, and XX Sagger or OM4 Ball Clay work for lighter sigs. Once you have collected

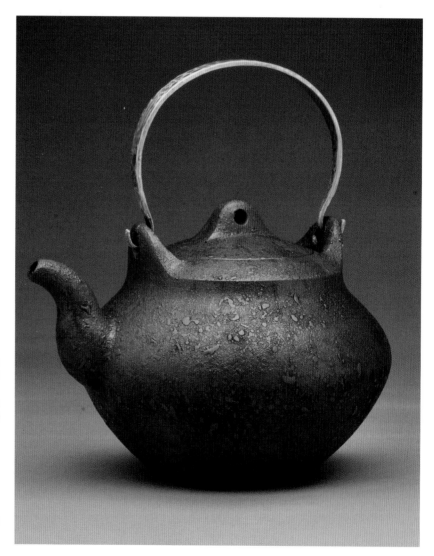

Pete Pinnell teapot with brass handle. Photo courtesy of the artist.

Redart sig and OM4 sig with blue stain. Photo courtesy of Palmer Planter Company.

Sediment settling before terra sig is siphoned off. Photo courtesy of Dominic Episcopo.

RADASCH OM4 BASE RECIPES: ALL USE 1 CUP (235 ML) OF TERRA SIGILLATA AS BASE

Soft White: 2.5 teaspoons (12.5 ml) Zircopax, 0.5 teaspoon titanium dioxide

Antique White: 3 teaspoons (15 ml) titanium dioxide

Toothpaste White: 3 teaspoons (15 ml) Zircopax

Soft Orange: 2.5 teaspoons (12.5 ml) Mason Stain 6027 Tangerine, 0.5 teaspoon titanium dioxide

Orange: 3 tablespoons (15 ml) Mason Stain 6027 Tangerine

Soft Red: 2.5 teaspoons (12.5 ml) Mason Stain 6026 Lobster, 0.5 teaspoon titanium dioxide

Light Blue: 3 tablespoons (15 ml) Mason Stain 6376 Robin's Egg

Yellow: 3 tablespoons (15 ml) Mason Stain 6450 Praseodymium

Red: 1 part AMACO Bright Red Velvet Underglaze (V-387), 3 parts OM4 Ball Clay

Gray: 1 teaspoon Mason Stain 6503 Taupe, 0.5 teaspoon titanium dioxide

Peach: 1 teaspoon Mason Stain 6129 Golden Ambrosia

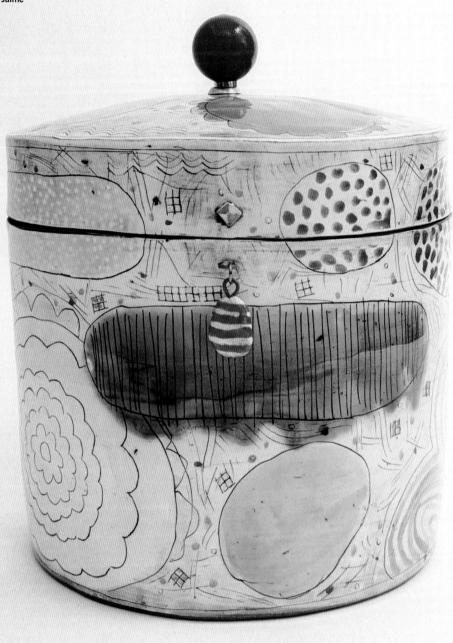

the sig, it can be tinted with colorants, like Crocus Martis, which makes a beautiful plum sig that polishes to a mirror shine when burnished.

Kari Radasch colors her OM4 sig base with both underglazes and stains to increase her spectrum of color. She also glazes over top of her sig, which brightens colors and allows the warm terracotta to show through the sig. She says the following of her approach: *"I have always been a better cook than baker, and so I have really leaned into both wet and dry volumetric measurements. I much prefer 'rain coat' to the 'lab coat' method as Pete Pinnell would say. I keep a 2.5 gallon [9.5 L] container of finished OM-4 sig in my studio and can quickly mix up a* new batch without heading into the glaze mixing room. In general, 3 tablespoons [45 ml] of Mason Stain per 1 cup [235 ml] of terra sigillata base gives me a bold, saturated color. However, each stain will saturate the base at different levels. This standard amount keeps things consistent, allowing me to scale up easily, with only a bit of mental math."

A unique aspect of terra sig is that it's highly susceptible to surface variation. The subtle colors that can be achieved when layering oxides or fluxes under or over a terra sig are endless. At right, you see a Mark Pharis teapot that looks atmospheric. This effect comes from layering a blended XX Sagger and Newman Red terra sig over a slip that has 2 to 3 percent lithium carbonate. Below, you see Mike Cinelli's ewers have a wash of Ferro Frit 3124 and black copper oxide over their sig. The Pete Pinnell teapot that starts this section has a wash consisting of two parts Gerstley Borate and one part coloring oxide, which is likely iron oxide. You can also use borax or frits in place of the Gerstley Borate to create different effects.

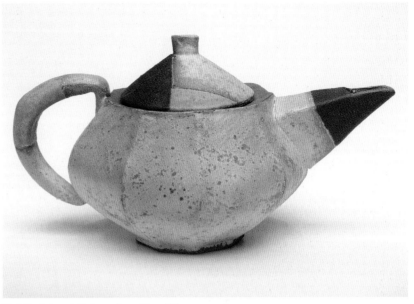

Mark Pharis teapot. Photo courtesy of the artist.

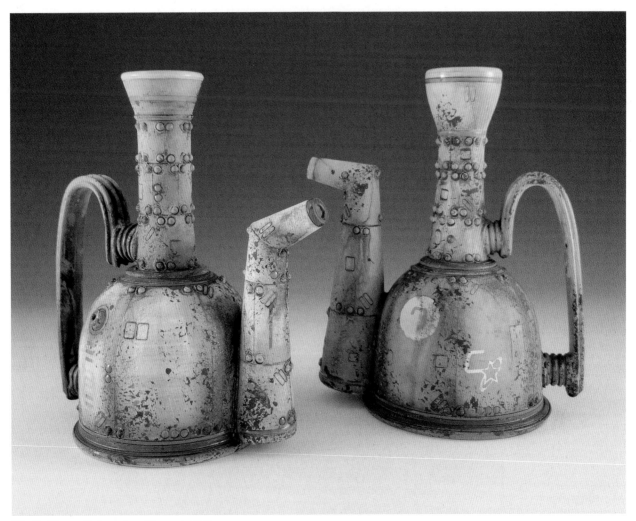

Mike Cinelli ewers. Photo courtesy of Companion Gallery.

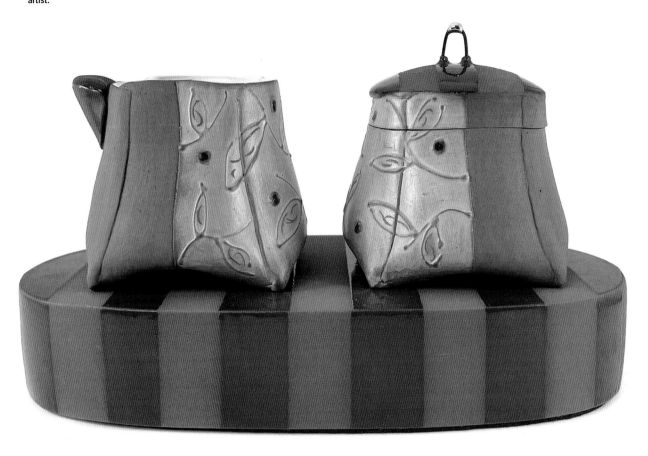

To create a satin surface, you can burnish your sig after the last layer has dried to the point where no fingerprints are left. I find wrapping a plastic shopping bag tight around my finger makes for the smoothest glossy surface, whereas burnishing with a cloth only creates a slight sheen. If you find your sig is not burnishing, you might have too many coarse particles, which are not packing down for the glossy finish. You can allow your sig to settle further to decrease the coarse particles or you can ball mill your slurry for four hours before settling. I found ball milling my Redart sig for three hours increased the yield of each batch dramatically, as well as caused a tighter surface when burnished. Too much ball-milling can break down clay platelets and destroy sig, so be mindful not to overdo it.

Liz Zlot Summerfield contrasts the burnished sheen of her blue terra sig with the alternating matt and gloss surface of AMACO's Bright Red Velvet Underglaze (V-387). The high gloss stripes on this tray are glazed with AMACO LG-10 Clear Transparent, a popular commercial low-fire glaze. When testing the sheen of your sig, you can experiment with the firing temperature of your work. The hotter you fire, the dryer the surface of your sig will be. Summerfield fires her work to cone 03. It allows her burnished sig to have a nice satin feel.

Rhonda Willers has written extensively about terra sig in her book *Terra Sigillata: Contemporary Techniques*. I love her combination of sgraffito with layers of sig.

RHONDA'S BLUE/BLACK TERRA SIGILLATA

$^1/_2$ cup (120 ml) liquid OM4 Ball Clay Base Terra Sigillata

$^1/_2$ cup (120 ml) liquid Newman Red Clay Base Terra Sigillata

+ 2 teaspoons cobalt carbonate

+ 1 teaspoon cobalt oxide

Opposite: Rhonda Willers vessels. Photo courtesy of the artist.

TIN GLAZE

Contemporary tin-glazed pottery has a long and crooked family tree with roots to seventh-century Mesopotamia, thirteenth-century Europe, and fifteenth-century Central America. Over the centuries, potters have turned to decorating their earthenware with an opacified glaze that could be directly painted on with pigments.

The often labor-intensive process relies on an artist's commitment to making decisive brush strokes, which cannot be smudged after they are laid down. At right, you see William Brouillard's *Steam-Punk Buddha* platter, which spans twenty-six inches (66 cm) and is a tour de force of modern tin-glazed wares. Tin glaze has historically been referred to as majolica, maiolica, and faience, as well as other names. For this text, I will use majolica, which I was taught to pronounce *(my o li kah)* similar to the Spanish island of Majorca.

Majolica glazes are built around two important principles. The glazes have high viscosity when fired, which is helpful for keeping the decoration in the place you want it. This also means that glaze thickness and style of application is very important. Runs and other imperfections can show up in the fired piece, so it can be necessary to sand and smooth the dry glaze surface before applying pigments. Many artists I talked with dipped their glaze, but some brush or spray for an even coat.

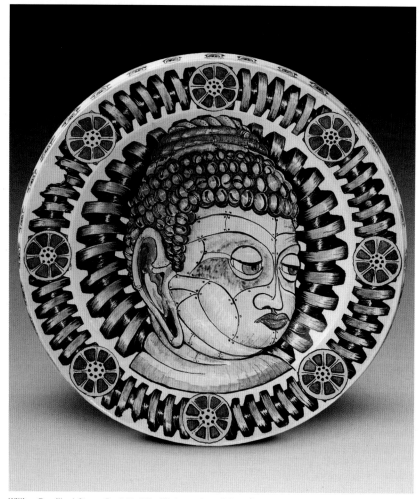

William Brouillard *Steam-Punk Buddha*. Photo courtesy of the artist.

Linda Arbuckle cup.
Photo courtesy of the
artist.

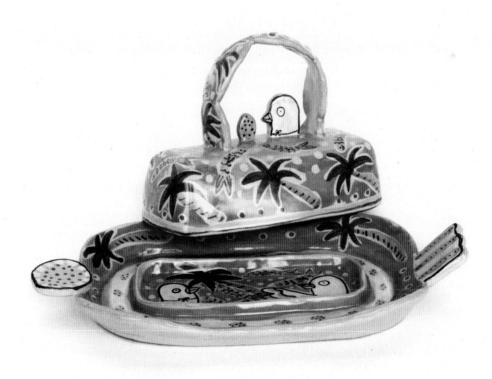

Michelle Im butter
dish. Photo courtesy
of the artist.

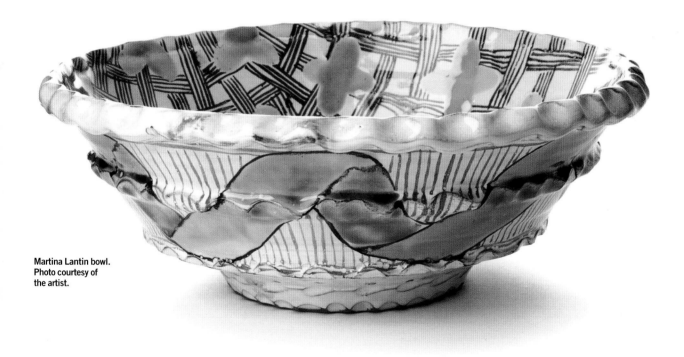

Martina Lantin bowl.
Photo courtesy of
the artist.

The amount and type of opacifier used determines the brightness of underlying white and affects the color response of the colorants painted on the dry glaze. Tin and zirconium can be blended to give you everything from refrigerator white (more zirconium) to cream white (more tin). Michelle Im uses 10 percent Zircopax in her glaze, which provides the bright white of the chickens on her butter dish.

Linda Arbuckle uses 9 percent Zircopax and 4 percent tin for a warmer white that balances well with her palette.

In previous sections of the chapter, we talked about underglaze decoration. Slips and underglazes are painted on clay in the greenware state, then bisqued, and then glazed. Majolica is an in-glaze decoration technique where pigments are painted onto glazed bisqueware. This has some

advantages because the bisquewares are more durable when you are handling them. This also means you can make a large batch of pots and then slowly decorate them. Walter Ostrom worked on his *Dutch Treat* for six years before putting on the finishing touches. While this might be an extreme example, it points to ways majolica potters decorate in stages.

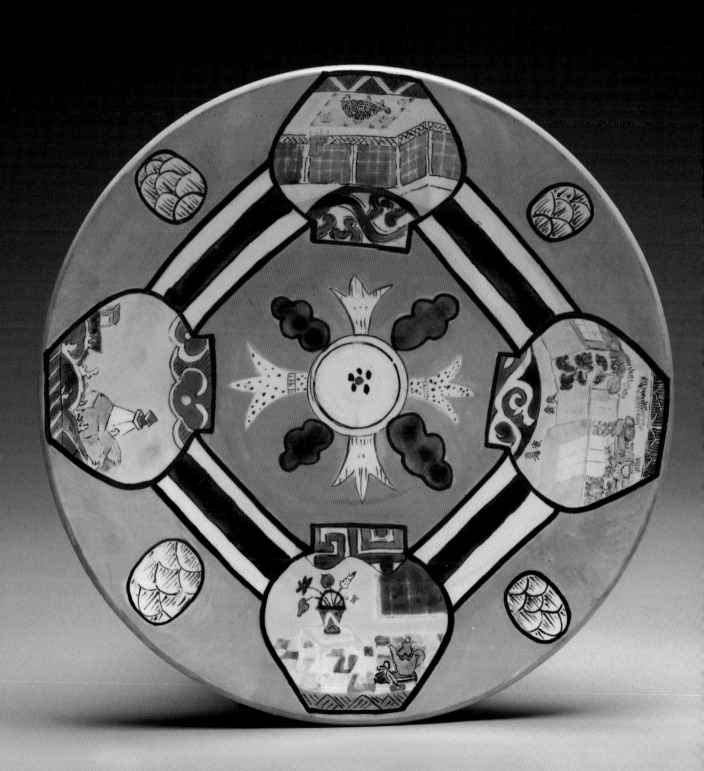

Detail of Lindsay Montgomery's *The Fountain*. Photo courtesy of the artist.

Linda Arbuckle's brushes. Photo courtesy of the artist.

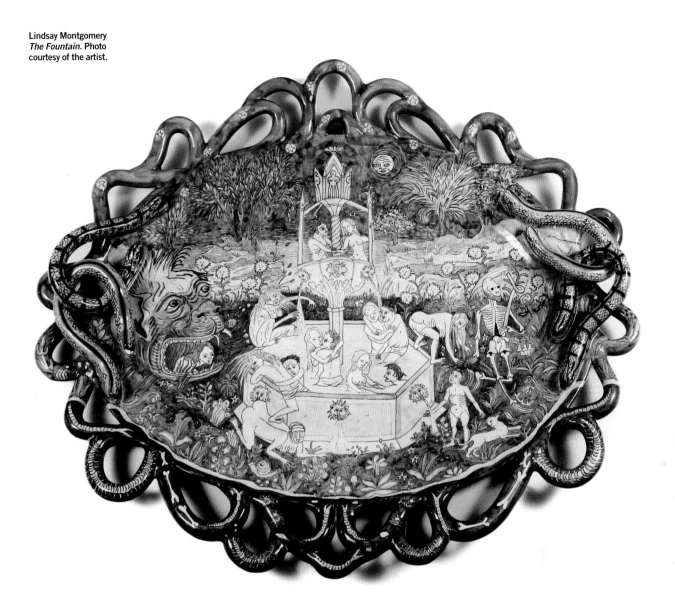

To achieve distinct color separation, artists will lay down a section of the pigment and then wax over top. When dry, this layer of wax protects the glaze surface underneath. Martina Lantin's serving bowl is a wonderful blend of tight line work within a larger pattern that is made possible by applying layers of wax. She also uses translucent glazes within the winding ribbon, which are a nice contrast to the opaque majolica glaze.

The pigments used in majolica can come from dry powdered oxides, stains, or premixed commercial sources. Lindsay Montgomery talks about the source of her color palette. *"For colors, I love the Spectrum 300 series Majolica Colors as well as AMACO Velvet Underglazes mixed with CMC gum solution to thin them and* *increase brushability. I scavenge for color anywhere I can and have a great variety of stains and commercial colorants in my studio. With powdered stains, I mix them with Frit 3124 at a ratio of 40 percent stain to 60 percent frit. I mix up all my colors using a CMC gum solution of 3 percent CMC gum to water."*

She also uses black pigment to define the figures within her narratives, much like a comic book painter.

The brushes used in majolica lend a specific line quality to the work. Hake brushes can be used to lay on the base coat of glaze, and pigments are usually applied with a variety of finer tipped brushes. A soft brush is important so that you aren't removing the underlayer of glaze when you make your directional brush stroke. Linda Arbuckle uses a variety of brushes and mark-making tools to create her signature surfaces. She suggests using brushes that are "soft, resilient, and hold liquid," which allows you to make long fluid brush strokes. Brushes that lack resiliency can shed their hairs into the glaze surface, which can ruin a large majolica piece. It's worth it to buy a better brush up front then pay in the long run with replacement costs or lost work due to preventable mistakes. In the image opposite (bottom), Linda lists her tools from left to right: sgraffito tool, small dagger liner, large dagger liner, small short liner, small liner, liner brush with reservoir, Japanese brush made from single animal hair, Japanese brush with different inner and outer hair, French mop watercolor

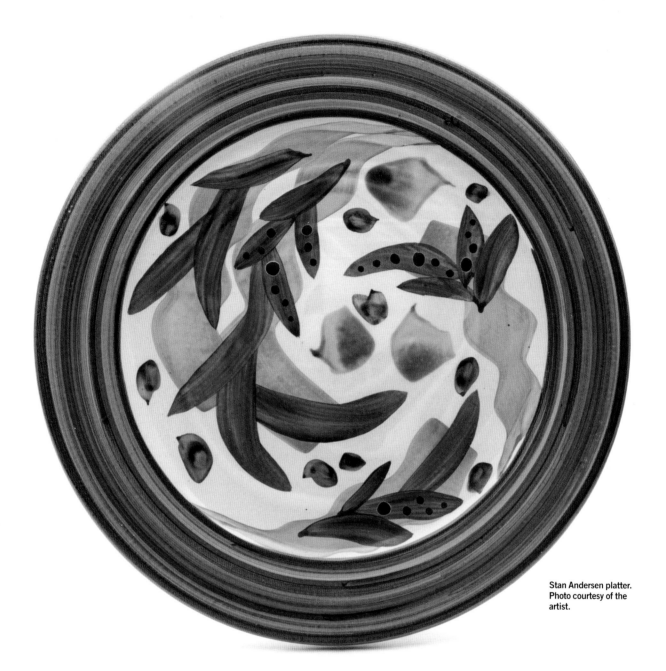

Stan Andersen platter. Photo courtesy of the artist.

brush made with squirrel fur, Filbert or cat's tongue watercolor brush, synthetic flat shader, and a flat Hake brush. In stores, you'll see brushes sold by shape and type of hair. A variety of animal hairs and synthetic fibers work well for brush making, and many potters choose to make their own brushes. Troy Bungart teaches workshops on brush making, as well as selling handles and animal fur for the purpose.

Stan Andersen uses foam brushes to create his signature wide strokes. *"Because I want my pots to be used, and used daily, I don't want to give the*

impression the maker has painstakingly labored over the decoration. I paint quickly and directly on the raw glazed surface, creating liquid flowing lines, splashes of color, and overlaps of brushstrokes that I hope result in a feeling of exuberance and casual spontaneity. Rhythm and grace in the brushstrokes are important to both my pleasure in the process and my pleasure in the end result."

Majolica was a major part of the Italian renaissance thanks to the popularity of the Della Robbia family. Luca della Robbia, along with other family members, are known for their dynamic terracotta

relief sculptures that are glazed with a saturated majolica color palette. The tondo *Prudence* is attributed to Andrea, Luca's nephew, and was part of a series that relates to the Cardinal Virtues by Luca on the ceiling of the Chapel of the Cardinal of Portugal in San Miniato, Florence. You can see the family's influence in contemporary artists, like Joanna Powell, who depict fruit and foliage in the dense style of the della Robbia's.

Contemporary sculptors have turned to majolica for what it represents. Natalia Arbelaez talks about the symbolism of the material. *"In the work, I wanted to talk*

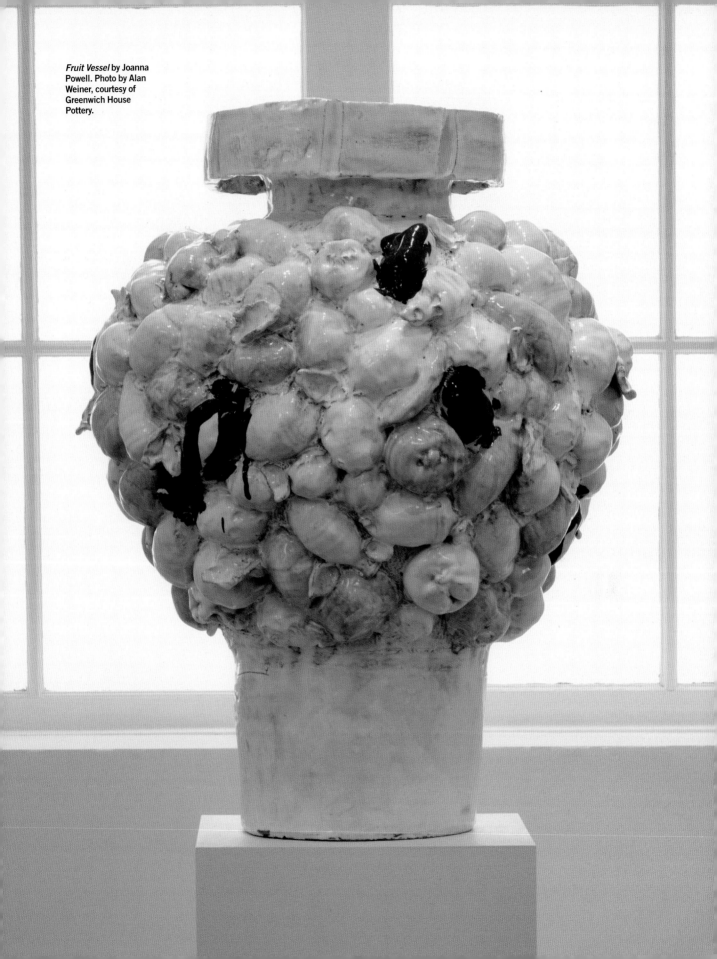

Fruit Vessel by Joanna Powell. Photo by Alan Weiner, courtesy of Greenwich House Pottery.

about the reference to terracotta and its connection to an indigenous ancestry, an ancestry that all people from Latin America have whether it is celebrated or acknowledged. I brought in the majolica as a symbol of colonization of the land and people. You have this white glaze hiding the brown clay. A metaphor for the Spanish covering over the other ancestry and with the association of whiteness being more valuable. Process and material are important in my work, albeit more for their historical and metaphorical influences."

On the next page, you see the work of Jonathan Christensen Caballero, who uses majolica in his work *Seeds of Tomorrow/Semillas del Mañana*. In his mixed media sculptures about domestic labor, he uses majolica as a focal point, drawing your eye to symbols of sustenance and mythic regalia.

Jonathan Christensen Caballero *Seeds of Tomorrow/Semillas del Mañana*. Photo courtesy of the artist.

Stephen Earp draws heavily from historical works and has developed a unique way to visually age his work. After glaze firing, this Galway platter is reheated to 500°F (260°C) and then dipped in a dark crackle stain. After refiring to cone 04, it has the marks of well-used antiques.

Stephen Earp plate. Photo courtesy of the artist.

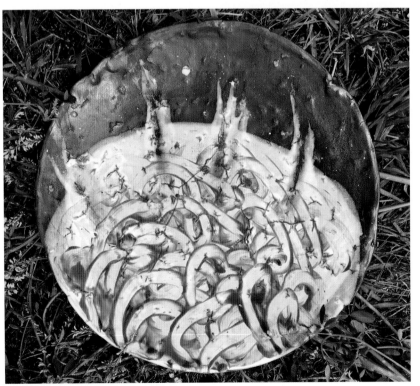

George McCauley plate. Photo courtesy of the artist.

George McCauley takes a unique approach to majolica in that he applies his glaze over already fired atmospheric pots. *"One of my favorite methods is working with high and low temperature combinations. The work in this book is high temperature wood fired with additional firings using my low-fire white glaze, GHOC Redneck Majolica, and AMACO Underglaze. I want to be very clear about my intent, I fire them till they look good!"*
—George McCauley

GHOC REDNECK MAJOLICA (CONE 03–5)

Ferro Frit 3124	75
Ball Clay	25
Opax	18
Bentonite	2

GLAZE AS FORM:
GOOP, NERIFOAMI, AND
LOW-FIRE PORCELAIN

Many of the glaze techniques we have talked about so far are hundreds, if not thousands, of years old. Humans have been making and firing ceramics since at least 28,000 BCE in the late Paleolithic period, when the Venus of Dolní Věstonice was made in what is now the Czech Republic.

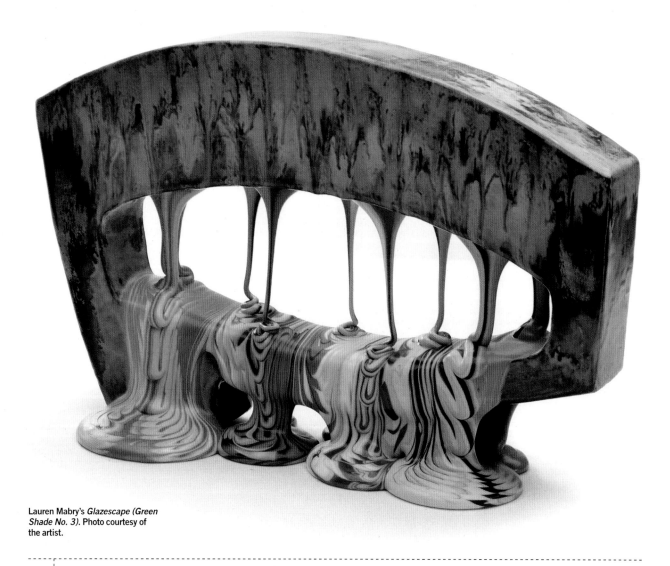

Lauren Mabry's *Glazescape (Green Shade No. 3)*. Photo courtesy of the artist.

Knowing this long history, I am surprised and impressed to see new ceramic advancements being made in my lifetime. Two of these that are becoming more popular are gloop, three-dimensional glaze made into form, and Nerifoami, a similar glaze-clay hybrid that rapidly expands when firing. Both are sensitive to firing temperatures, requiring lots of testing to refine the formula. If you fire them too hot, they will completely melt and run all over your shelves. If fired too low, the materials fail to melt and nothing happens. Lauren Mabry's *Glazescape (Green Shade No. 3)* exists within this beautiful tension harnessing the drips of gloop without turning into a glaze disaster.

Max Henderson talks about the importance of CMC gum in providing malleability to the recipe. Looking back at our discussion on slip composition, notice that EPK is the only particle in the recipe that is absorbent. Without CMC gum, the gloop would be extremely hard to work with. *"Before adding dry materials to the water, completely dissolve the CMC gum in hot water until all granules disappear. Start with 25 percent H_2O (by weight) and, if needed, gradually add water until you have a clay consistency. I usually will make small batches of gloop with the maximum stain (8 percent) and a large batch of the base (no colorant/stain). That way, I can wet mix to dilute the color to my liking, rather than making numerous batches of one stain at various percentages. For my work, I will roll out small sticks of glaze (between 2.5 to 8 g) and let them completely dry before inserting them into the piece. For extra durability, I will sometimes bisque fire the sticks of glaze to cone 016 to reduce breakage during application."*

MAX HENDERSON GOOP (CONE 06–6)

Ferro Frit 3124	55
Edgar Plastic Kaolin	12
Silica	33
CMC gum	0.2%
Mason Stain	up to 8%
H_2O	25–30%

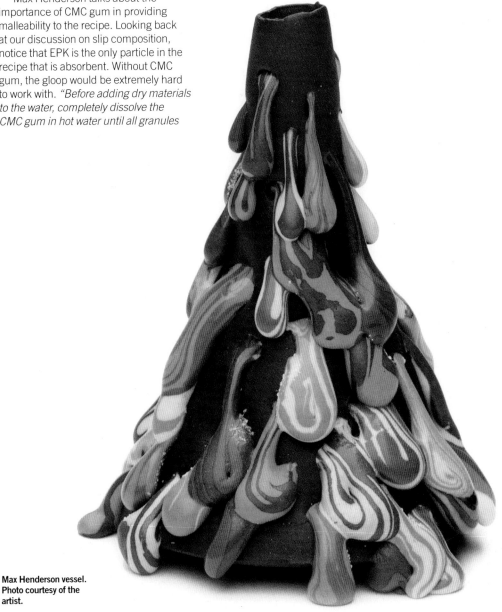

Max Henderson vessel. Photo courtesy of the artist.

Stephen Creech vessel. Photo courtesy of the artist.

Jolie Ngo *Gear Vessel in New Wave*. Photo courtesy of the artist and R & Company.

PATRICK COUGHLIN LOW-FIRE GOOP (CONE 03)

Ferro Frit 3134	40
Silica	40
Edgar Plastic Kaolin	20
Stain	2

Jolie Ngo uses the melting quality of gloop as a point of emphasis on her 3D printed *Gear Vessel in New Wave*. As you look at the artists included in this section, notice they all utilize gloop as a point of contrast within a more stable built-clay structure. This gives the gloop something to melt around, creating visual tension between hard and soft. I also want to point out Ngo's use of white gold luster only on the gloop. It punches up the "What is that?" factor that makes gloop so attractive.

Nerifoami is the technique of building objects with an expanding foam glaze. Stephen Creech has been working with this material and says of the process: "*Nerifoami can be made from glazes containing high LOI materials (loss on ignition), like silicon carbide. The materials off-gas at a point where the*

high viscosity surface tension of the glaze catches the gas. The resulting bubbles expand outward within the glaze. You want to use a particularly stiff glaze, fired at peak temperature, to get the maximum expansion in a foam glaze."

Goop and Nerifoami are used for sculpture, but a similar functional counterpart is low-fire porcelain. Bryan Hopkins worked in high-fire porcelain for many years before he started testing an alternative that would be fully vitrified and translucent at low-fire temperatures. He continues to work with satin and gloss variations of the recipe, all using New Zealand Halloysite, or New Zealand Kaolin (NKZ) and firing to cone 05.

Tony Hansen has done a lot of research in this area as well. Visit digitalfire.com for more information.

Bryan Hopkins basket. Photo courtesy of the artist.

CONE 05 PORCELAIN #1

New Zealand Kaolin	50
Ferro Frit 3134	50
Veegum	3

Mason Stains can be added for color from 1% to 4% of dry weight. Single fire only to cone 05 to create a satin surface.

CONE 05 PORCELAIN #2

New Zealand Kaolin	50
Ferro Frit 3195	50
Veegum	3

Mason Stains can be added for color from 1% to 4% of dry weight. Single fire only to cone 05 to create a gloss surface.

CONE 05 PORCELAIN #3

New Zealand Kaolin	42.5
Ferro Frit 3195 or 3134	47.5
Silica	3.5
Whiting	10
Veegum	3

Mason Stains can be added for color from 1% to 4% of dry weight. Single fire only to cone 05 to create a matte surface.

SATIN AND MATTE GLAZES

For years, I used a satin that I loved only to discover it was a severely underfired mid-range glaze. I was crushed when my glaze technician friend said, "I don't know what that is but it's not a low-fire glaze."

Nongloss surfaces, much like their gloss counterparts, benefit from a complete melt of the glaze materials. Their satin or matte surfaces come from anorthite crystallization that happens in the glaze as the kiln cools. To make sure your glaze is fully melted, try firing two to four cones hotter than your normal target. If the glaze starts to run, it is fully melted. If it glosses out as you fire hotter, your target temperature is lower than a full glaze melt. This is mainly an issue for function wares due to underfired glazes degrading during use, especially from the high temperature alkaline environment of your dishwasher. Satin and matte glazes used in sculpture have more leeway and just need to melt enough to be fused to the object.

Lisa Naples makes beautiful work at cone 1 with a clear satin. *"My Satin Clear glaze was formulated in collaboration with Karla Wagner, my friend and head ceramist at Dal-Tile. Working with a ceramic engineer woke me up to a lot of technical knowledge I never learned in school. In order to achieve the satin surface, I fire my work 'down' as well as 'up' in the kiln. By this I mean that once it hits the goal temperature, instead of allowing the kiln to freely cool, I slow the cooling down from 1,900 degrees to 1,400 degrees [Fahrenheit] [1,038 degrees to 760 degrees Celsius]. This is when the crystals that make up the satin surface grow. If I didn't slow the cooling of the kiln, my glaze wouldn't be nearly as rich and crystalline."*

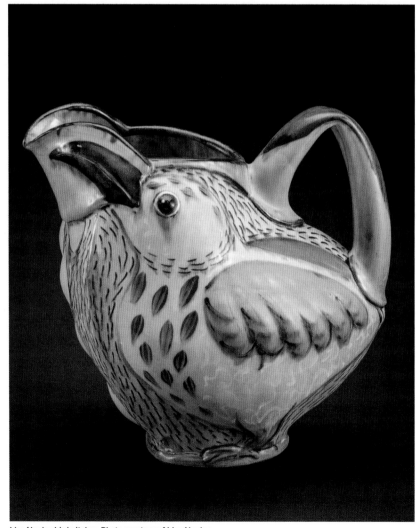

Lisa Naples bird pitcher. Photo courtesy of Lisa Naples.

Detail of Lisa Naples's bird pitcher. Photo courtesy of the artist.

This glaze is one of the tried-and-true glazes that you will find out about in chapter 4.

One major variable within a glaze that affects matting is its alumina-to-silica ratio relative to the temperature you are firing. An abundance of chemically soluble alumina (from kaolin or other clays) usually creates a more matte surface. If you continue to increase alumina within a glaze, you could push it into a higher firing range. The second variable is crystal development, which I discussed at the start of this section. For a technical dive into silica and alumina ratios, check out the Advancing Glazes class by Ceramic Materials Workshop, which does a deep dive into the Stull chart pictured at left. This visual graphic developed in 1912 by Robert Stull helps plot silica and alumina ratios to estimate if a glaze recipe will produce gloss, satin, or matte. Glazy.org shows where a glaze in their database falls on the Stull chart, which is a helpful tool for determining your glaze's likely surface. Stull developed the chart for high-fire glazes, but I find it continues to be valuable at lower temperatures.

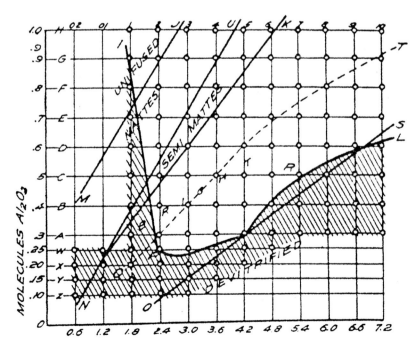

Robert Stull chart explaining alumina to silica ratios. Photo courtesy of Robert Stull.

MAGGIE JASZCZAK MATTE BASE GLAZE (CONE 04)

Ferro Frit 3195	43
Whiting	43
Edgar Plastic Kaolin	14

Maggie Jaszczak candelabras. Photo courtesy of the artist.

HIRSH SATIN MATTE BASE FROM JOE PINTZ (CONE 04-02)

Gerstley Borate	32
Lithium carbonate (fine)	9
Nepheline syenite	4
Silica	35
Edgar Plastic Kaolin	4
Whiting	17
Bentonite	2

Amber: 4% Mason Stain 6404 Vanadium Yellow, 5% Spanish iron oxide

White: 3% rutile

Turquoise: 1.5% titanium dioxide, 0.5% chrome oxide, 1% copper carbonate

Joe Pintz nesting bowl set, earthenware. Photo courtesy of the artist.

Lauren Sandler *Economies of Beans*. Photo courtesy of the artist.

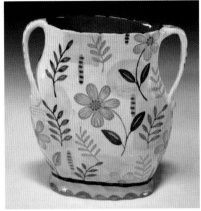

Nancy Gardner vase. Photo courtesy of the artist.

Maggie Jaszczak and Joe Pintz use subtle variations in their glazes to create beautiful combinations. This works particularly well with sets, where the surface unifies the collection of objects.

Lauren Sandler created a family of color with a variety of sheen for her vessel, *Economies of Beans*. She says of her approach, *"I work predominantly with two base glazes, one shiny and transparent, the other matte. I make variations of those glazes with different opacifiers, colorants, and the addition of powdered graphite for the darker tones."* To achieve the reds on the hanging beans that drape the form, she uses the Hirsch Satin Matte Base on the opposite page with these variations.

1. Add 8% Mason Stain 6021 Dark Red

2. Add 10% Zircopax and 8% Mason Stain 6021 Dark Red

3. Add 10% Zircopax and 8% Mason Stain 6026 Lobster

In addition, she uses similar variations of a Lisa Orr gloss base, as well as cold surface techniques of layering red paint with wax and powdered graphite. I find this approach of making a color family to be helpful because it allows each individual element to have impact without creating too much chaos.

There are commercial versions of satin and matte glazes, which tend to be fired lower. To create a more durable body, you can bisque higher, but glaze to the temperature on the bottle. Nancy Gardner layers slips and underglazes under Duncan SN351 Clear Satin Glaze, which she fires to cone 05. There are many advantages to working with commercial glazes, including consistent results and time savings. The main disadvantage traditionally has been the cost. This might change though as homemade glazes like Hirsch Satin Matte Base include ingredients like lithium carbonate that now cost over $79 USD per pound thanks to their use in rechargeable batteries for cars and homes. There is never a better time to learn glaze chemistry so you will be able to substitute cheaper alternatives for more expensive ingredients in your favorite glazes.

ATMOSPHERIC
FIRING

Atmospheric firing harnesses heat from a burning fuel source, like gas, wood, or coal, to bring the objects inside the kiln up to temperature. We often think of high fire when we talk about atmospheric firing, but that is a modern interpretation of an age-old practice.

Artists have been using variations on pit and saggar firing since potters first fired their forms in open camp fires thousands of years ago. Artists like Virgil Ortiz use traditional firing methods to make contemporary vessels and sculpture. His pigment is made from boiled wild spinach and fired in a traditional Cochiti Pueblo pit fire.

"When the wild spinach purple flowers bloom, it's time to pick them and process them to make our black paint. Removing only the leaves, it takes up to seven days of boiling to reduce them to a sticky paste. That is then put into cornhusks to cure for next year's use." —Virgil Ortiz

PJ Anderson blends sci-fi, smoke firing, and rope to create her sculptures. The smoke-fired patina of the terra sigillata on her figures makes you wonder whether the figure has just time warped from the future or the past. The deep blue-black terra sig has 10 percent manganese added to create its rich tone. When firing, beware of the toxicity of manganese fumes and wear your respirator.

Figure by PJ Anderson. Photo courtesy of the artist.

Photo courtesy of Virgil Ortiz.

Photo courtesy of Virgil Ortiz.

Photo courtesy of Virgil Ortiz.

Virgil Ortiz traditional storage container. Photo courtesy of the artist.

ROTHSHANK FLASHING SLIP (CONE 04-10)

Edgar Plastic Kaolin	20
Grolleg Kaolin	50
Tile #6 Kaolin	20
Silica	10

Justin Rothshank jar. Photo courtesy of the artist.

ALL PURPOSE WHITE SLIP (04-10)

Edgar Plastic Kaolin	28
OM4 Ball Clay	28
Silica	22
Ferro Frit 3124	22

Add Mason Stains to 1 cup (235 ml) of slip

1 teaspoon for 6410 Canary, 6305 Teal, 6219 French (Green)

1 tablespoon (15 ml) for 6242 Bermuda (Green), 6028 Orange, 6666 Cobalt-Free (Black), 6088 Dark Red or 6025 Coral Red, and Zircopax

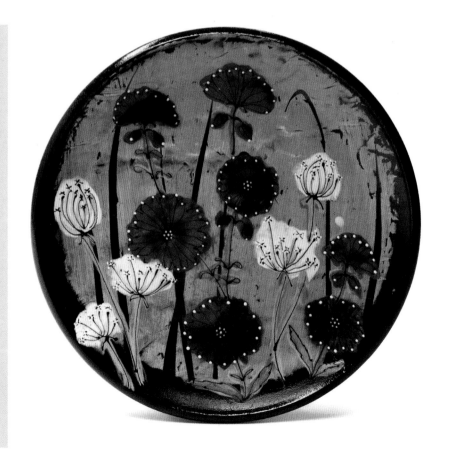

Teresa Pietsch *Chicory Plate*. Photo courtesy of the artist.

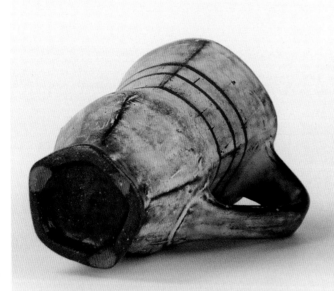

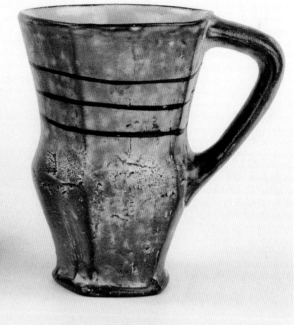

Tom Jaszczak mugs.
Photo courtesy of
the artist.

CREAMY SLIP (CONE 2): CAN BE TINTED WITH MASON STAINS

Nepheline syenite	20
Ferro Frit 3124	10
Tennessee #1 Ball Clay or XX Sagger	70

WHITE LINER GLAZE (CONE 2)

Ball clay	22
Gerstley Borate	14
Ferro Frit 3195	42
Zircopax	22

YELLOW SLIP (CONE 2)

Nepheline syenite	31.58
XX Sagger	63.16
Silica	5.26
Zircopax	5.26
Titanium dioxide	10.53

Like many young potters, I romanticized wood and soda firing for their dramatic flashing effects. Over the past decade, more potters are developing these techniques at low-fire temperatures. There is an obvious environmental advantage to using less fuel than cone 10, but potters also enjoy the challenge of figuring out something unexpected and new. Justin Rothshank fires his work to around cone 02 and builds layers with flashing slips, underglaze, and decals. He has written an excellent primer called *Low-Fire Soda* that is widely available.

Teresa Pietsch and Justin Rothshank create vibrant color palettes that are not commonly seen in atmospheric work. They use less soda than is typical at high fire, using the technique to create a slight sheen on the work.

Tom Jaszczak creates beautiful neutral spotting in his slips while firing his soda kiln to cone 2. The mugs shown above are dipped in the creamy slip listed above. The variation in the slip contrasts beautifully with his crisp geometric underglaze painting. He suggests ball milling the slips, which creates smaller particle sizes that are more responsive to atmosphere.

Matt Kelleher pitcher.
Photo courtesy of the
artist.

KELLEHER BLUE SLIP (CONE 3)

Ferro Frit 3124	35
Grolleg Kaolin	35
Kentucky Stone	30
Mason Stain 6242 Bermuda (Green)	5

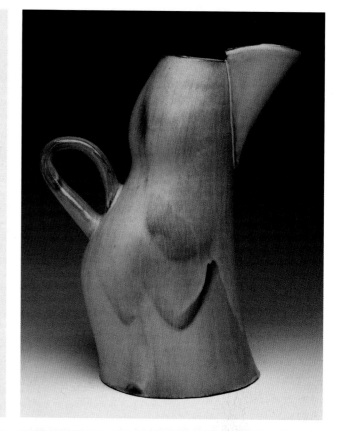

Matt Kelleher pitcher.
Photo courtesy of the
artist.

KELLEHER RIVULET GREEN (CONE 3)

Fusion Frit F-367	23
Strontium carbonate	42
Edgar Plastic Kaolin	17
Silica	18
Chrome oxide	1

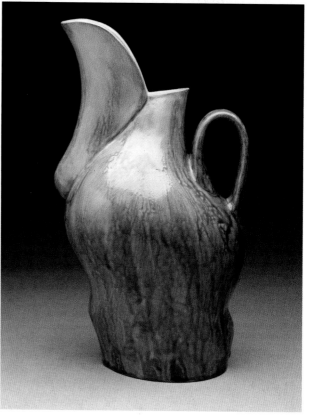

Sam Clarkson quilted cup. Photo courtesy of the artist.

Ron Meyers teabowl. Photo courtesy of the artist.

Cone 3 is the upper temperature threshold included in this low-fire book. Matt Kelleher has been a forerunner in developing slips and glazes for this temperature in a soda kiln. I love that he has formulated a fake ash glaze at cone 3.

"This is a high strontium, low alumina/ silica glaze I created to mimic fake ash glazes found at cone 10. It works with many different oxide colorants. Mason stains stabilize the glaze and prevent rivulets." —Matt Kelleher

Sam Clarkson and Ron Meyers have both made bodies of work for low firing in the wood kiln. Sam used local California terracotta clay that hc found whcn mountain biking to make his signature stamped teabowl. He fired the clay to cone 3, which was hot enough to vitrify, making it watertight without glaze. Ron's cup was fired to cone 1 with a flashing slip and liner glaze.

"This work came from an inner desire to make more 'sustainable' ceramics, and to add another chapter to the locally made story. I enlisted my daughter Maya's help in researching Santa Cruz clays as part of an elementary school science fair project. We dug and tested five clays I had encountered while biking. After this project, I was inspired to dive into a new way of working and making—a reinvention of sorts. The results were not terribly inspiring, all the native clays were fairly short and melted below cone 5. The local clay needed a local fuel source, and the forests of the Santa Cruz mountains yield an abundance of firewood. I followed a vision of Bizen style wood-fired pots made from the mountain we lived on. The clay I chose was easily accessible and abundant, short, had almost no green strength, and melted at cone 4. Undeterred, I followed the clay into an exploration of cone 3 wood firing. Some lovely pots and lessons came out of this process."

LUSTER

If cone 3 is the high end of this book, the low end is cone 020 where lusters are often fired. Joanna Powell uses commercial luster in her *Flower Vessel no. 1* and *Fruit Vessel with Bangles*. These lusters use the combustion of organic compounds in their resin solution to catalyze a reaction that creates the metallic surface. They are painted on the surface of the object and fired to cone 018.

Commercial gold lusters are sold in many forms, including two-ounce bottles (57 g), in sheets of solid decal color that can be cut into shapes, and loaded in felt-tip pens. There are also multiple shades of gold luster, which have warmer or cooler appearances. Use light directional brush strokes, not back and forth, to apply luster to the surface of your object. If luster pools in one spot, brush it out to achieve a smooth coat. Cleaning will remove residual gold in the bristles, so you might want to store brushes in an airtight container with a cosmetic sponge saturated with lavender oil or clove oil to keep the brushes soft. When cleaning brushes is necessary, use a commercial luster essence.

Joanna Powell *Flower Vessel no. 1* and *Fruit Vessel with Bangles*. Photo by Alan Weiner, courtesy of Greenwich House Pottery.

There are multiple categories of lusters, including fuming lusters, which rely on the reduced atmosphere of the kiln. Ibrahim Khazzaka, featured later in the chapter, lays out a few helpful safety tips when working with all types of lusters: wear gloves to avoid contact with ingredients that might be soluble, clean tools and buckets immediately after use, and wear a respirator while applying or firing.

Luster technology was developed in glass and refined on glaze in the ninth-century Abbasid Caliphate. Many of my favorite luster pots were made in Kashan, Iran, during the Seljuk period. The dish below, from the late 1100s, shows the amber color of Persian luster, as well as a masterful use of positive and negative space in the design. The backgrounds of pots in this era are filled with curvilinear lines that energize the space. In-glaze lusters became popular again in the European imagination when Alan Caiger-Smith and his contemporaries started

producing wares at Aldermaston Pottery in England. Scott Barnim (below) was influenced by Caiger-Smith and continues his style of reduced luster firing.

For his process, Barnim bisques to cone 03 before glazing with a base glaze to cone 05. The lusters are then painted on top of the fired glaze and fired again with periods of reduction to cone 019. He writes about the importance of the base glaze in the brightness of the luster.

"Tin glaze, [majolica] and [lusterware] come from the same starting point in Persia. Developed in the ninth century in Iraq, tin-glaze was a way to compete with early porcelains from Tang dynasty China (618–907) that entered the market through the trade route that centuries later Marco Polo would call 'The Silk Road'. The [luster] compound of metal salts mixed with clay, ochre, and vinegar to make a pigment, could be painted on this new white glaze surface and fired a third time to a low red heat and profoundly reduced

BARNIM BELLA WHITE BASE (CONE 05)

Good for silver lusters	
Ferro Frit 3195	16
Ferro Frit 3124	40
Ferro Frit 3134	21
Kaolin	7
Silica	12
Zinc	4
Zirconium silicate	5
Tin oxide	8

Scott Barnim vase. Photo courtesy of the artist.

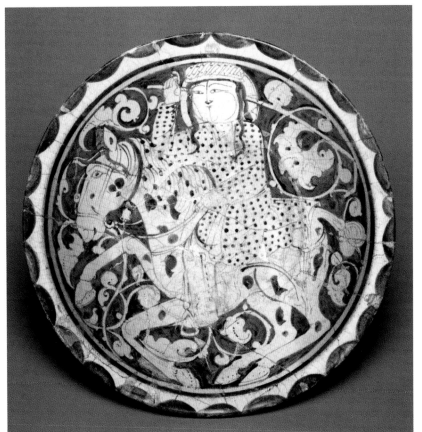

Luster Dish with Polo Player, 1170–1200. Kashan, Seljuq period of Iran.
Photo courtesy of the Cleveland Museum of Art.

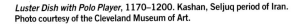

Scott Barnim jug. Photo courtesy of the artist.

BARNIM COBALT BASE (CONE 05)

Used with silver luster

Ferro Frit 3124	50
Ferro Frit 3195	20
Strontium carbonate	10
Nepheline syenite	10
OM4 Ball Clay	10
Zinc	3
Tin	1.5
Cobalt oxide	2

RED LUSTER (CONE 019)

Calcine to 020 and then mix with white vinegar and ball mill for a few hours.

Copper carbonate	30
Kaolin	60
Red iron oxide	10

RED ORANGE GOLD LUSTER (CONE 019)

Calcine to 020 and then mix with white vinegar to a thin paste and ball mill.

Silver chloride	7
Tin oxide	7
Copper sulfide	17
Kaolin	56
Red iron oxide	8
Alumina hydrate	5

SILVER LUSTER (CONE 020)

Mix with common white vinegar to thin paste and ball mill for a few hours.

Silver carbonate	20
Red ochre	10
Kaolin	70

Figure 1: Greg Daly vessel. Photo courtesy of the artist.

in the kiln chamber. The white background produced brilliant lustres from golds to the deepest reds. From the year 800 CE to 1800 CE, it was the only process to make a lustrous or reflective/metallic surface on ceramic. By 1800 CE, Wedgewood in England and Meissen in Germany developed an industrially viable alternative for [luster], which is the resin base [luster] that is still used today."

Greg Daly is a master of luster and has graciously written about firing lusters for the book.

"There are four types of [luster]: Persian pigment lustres, [luster] glazes containing silver/ copper, fuming with metal salts, and resin lustres. I am focusing on [luster] glazes. Silver is your key metal along with copper, but like pigment lustres they develop the [luster] surface at slightly different temperatures. Taking silver you can develop [colors] from yellow, apricot tones, purples to pure silver at 600–800°C [1,112–1,472°F]. Red lustres from copper prefer 780–840°C [1,436–1,544°F] for best results. A yellow [luster] glaze from silver (in this case silver nitrate) is relatively simple but requires a few extra steps than in a regular glaze firing. First, glaze the piece using the recipe on page 115 and fire to 1,060–1,080°C [1,940–1,976°F] in either a gas or electric kiln (oxidized). The resulting glaze will be completely clear (Figure 4) and requires a follow-up, lower temperature, reduction firing in a gas kiln to develop the [color]. In this '[luster] firing,' the variables you have to play with are temperature, generally between 600–750°C [1,112–1,382°F], and time, from 30 seconds to perhaps 30 minutes and degree of reduction. To prepare for the [luster] firing you will need to completely close off the flue using a damper and completely close the primary air to the burners (including the space around the burner ports), to create a yellow/orange reducing flame that will remove as much oxygen from the atmosphere of the kiln as possible. It's also important to make sure that your kiln room is well ventilated, since things will likely get smoky!

Once you're familiar with how to adjust your kiln, fire the piece up in an oxidizing atmosphere at approximately 150–250°C [302–482°F] per hour, depending on the size of your work, until it has reached

Figure 2: Opening kiln. Photo courtesy of Greg Daly.

the desired temperature (650–750°C [1,202–1,382°F]), confirmed by the use of pyrometric cones (019, 018, 017). Turn off the primary air, close the damper and perhaps increase the gas pressure to create a very smoky and reducing atmosphere. At this point an incredible transformation will take place within seconds. As the smoky atmosphere reduces the silver oxide within the glaze, minute particles of silver will begin to form mere nanometers under the surface. If you want to leave the result of the firing up to chance you can simply time the reduction phase with a stopwatch, however if you want to maintain more creative control, it's possible to see how the [color] is developing by opening the door of the kiln during firing. This may sound dangerous and possibly insane, but with some precautions it is relatively safe. At around 700°C [1,292°F] the interior of the kiln has only just reached red-hot and is at a much lower temperature than the average raku firing, so ensuring that you're wearing nonflammable clothing, gloves, and glasses and that any loose hair is tied back should be adequate to keep you safe.

When first opening the kiln, hold the bottom of the door so that your hand is away from the rising hot air and only open it a [centimeter] or so. As unburnt gas escapes from the kiln it will mix with oxygen in the air and ignite as a flame along the top of the door (see Figure 2). Once this burns itself out, it is safe to open the door further to peek inside the kiln

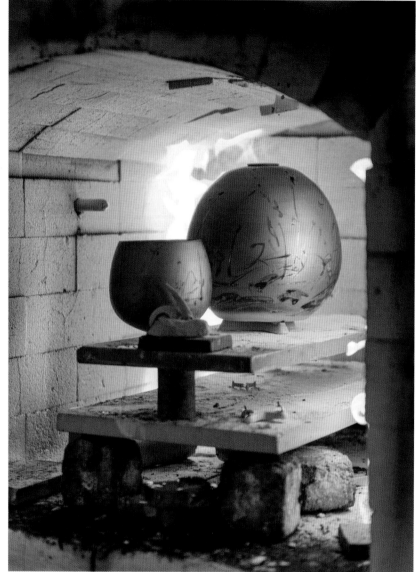

Figure 3: Looking at the glaze surface. Photo courtesy of Greg Daly.

and check on the [color] development (Figure 3). Keep the burners on during this process, as they will help to maintain the temperature and provide a good light source to see the developing [color] of the glaze. Close the door and if you are satisfied with the [color], turn off the gas and let the kiln cool naturally, otherwise continue reducing for another 30 seconds to a minute before checking on the [color] again. The longer you reduce and the higher the temperature, the larger the silver particles will become, changing the [color] of the glaze from yellow to peach to pink and sometimes to purple.

Figure 5 shows four identical bowls that have undergone different firing cycles.

Moving from top left, the first bowl shows the clear glaze before the [luster] firing. The second was reduced for 30 seconds at 700°C [1,292°F], producing a glossy yellow finish that has a slight iridescence when held up to the light. The third was reduced for 30 seconds, but at the slightly higher temperature of 720°C [1,382°F], resulting in a much deeper apricot yellow than the second. The fourth was reduced for three minutes at 780°C [1,436°F] to create a satin, iridescent, deep purple surface that, on closer inspection, varies between bright pink and peacock blue. The texture too is very different, a much more satin finish that diffuses that light reflecting off the surface of the pot.

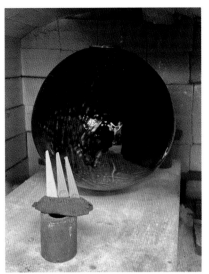

Figure 4: Loading the kiln.
Photo courtesy of Greg Daly.

GREG DALY'S LUSTER BASE GLAZES

	Yellow Luster Glaze	Blue Luster Glaze	Turquoise/Red Glaze
Ferro Frit 3110/ 4110	90	90	90
Silica	5	5	5
Kaolin	5	5	5
Silver nitrate	4	4	
Cobalt oxide		3	
Copper carbonate			3

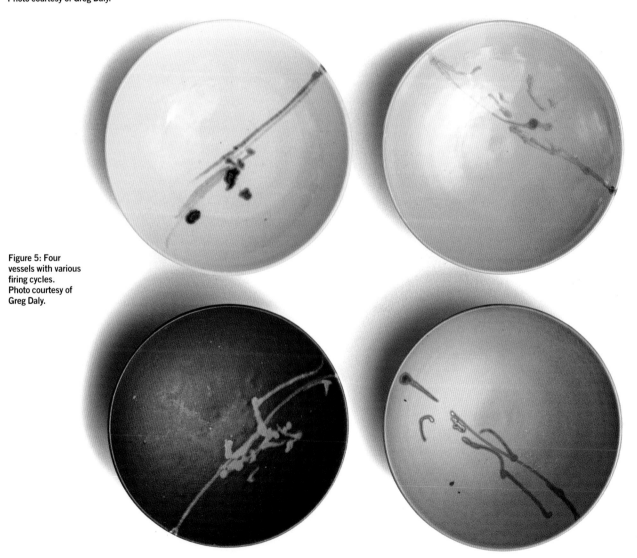

Figure 5: Four vessels with various firing cycles. Photo courtesy of Greg Daly.

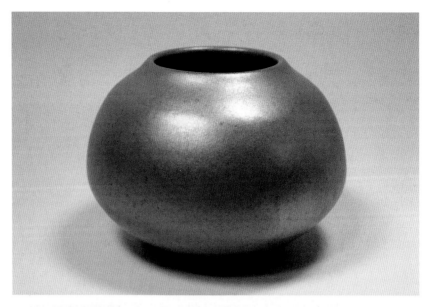

Close-up of luster
surface. Photo courtesy
of Pewabic Pottery.

As well as the reduction firing, there are other factors you can play with to affect the outcome of the glaze. Spraying or brushing the glaze on, thick or thin, will drastically alter the final appearance of both the [color] and texture. The blue vase in Figure 1 was decorated by brushing and spraying the glaze to encourage variation in the surface. Swapping out the silver nitrate for copper carbonate (see recipe on page 115) gives a whole new turquoise glaze (used in Figures 1 and 4 to provide additional decoration), which when reduced at temperatures between 780–820°C [1,436–1,508°F] and for a longer reduction period, can create bright metallic reds and coppers! I've been using this yellow [luster] glaze for over ten years and still am surprised and excited by the variable results it produces. I can think of no better way to conclude than with the words of Alan Caiger-Smith, 'The real secrets of [luster] are hidden not in chemical records or firing schedules, nor in any universal principles of design, but in the maker's own life.'"

Detroit's Pewabic Pottery has revived its production of luster glazed wares, which have roots in the early 1900s when the company was founded. Glaze tech Alex Thullen shares his thoughts, "I use a selection of boron-based frits in various combinations to create base glazes that will give me the surfaces and textures that I'm looking for, generally using a combination of copper, silver, and/or bismuth as the colorants. These glazes are fired in a modified electric kiln to cone 04 and are reduced to create the dramatic colors, luster effects, and iridescence that these glazes are known for." The amount

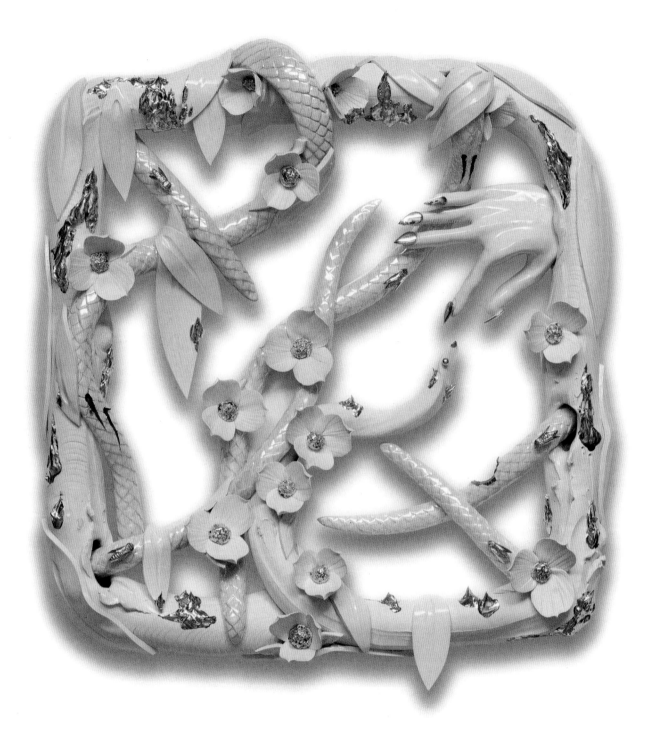

Alex Anderson *That thing you want*. Photo courtesy of the artist.

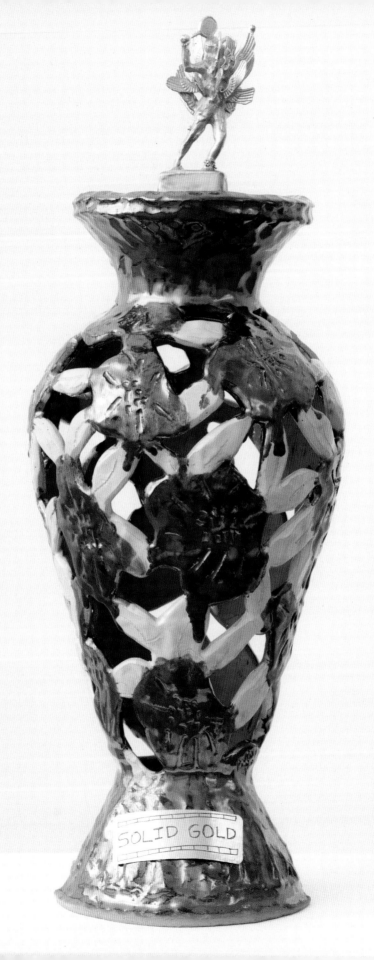

Stephanie Kantor *Solid Gold*. Photo courtesy of the artist.

of variation possible due to glaze thickness and level of reduction makes each piece unique within the larger glaze line.

Alex Anderson is using lusters on his sculpture to entice the viewer to move closer to the piece. In *That thing you want*, you notice gold luster first, before being drawn in by the subtle shimmer of the mother of pearl luster on the snake form. Lusters have this effect, creating an attraction that cannot be ignored by the viewer. Stephanie Kantor plays with this as she references trophies, accomplishments, and striving with *Solid Gold*. Her ceramic vessel is hollow but stylistically grand with its lustered finial.

Ibrahim Khazzaka references the force of attraction in a spiritual context with his Kashkul, or Sufi begging bowls. *"Using lusters, I seduce the viewer into coming closer to carefully examine and notice their own image shifting and changing as they circle these artifacts that glorify humility and the voiding of the self, in order to receive the Beloved."* The forms are based on the shape of the largest seed in the world, the coco de mer, which is native to the Seychelles Islands. He says of the work, *"In Persia the husk was found on the shores and used by beggars, mostly those who follow the Sufi tradition. A short double string would be attached to the husk, which would then be used to collect food, money, and water. The bowl also acted as a symbol for voiding oneself to receive God, and since it looked like a boat, it also symbolized the journey of the wandering beggar."* Ibrahim has developed a line of in-glaze lusters that highlight the forms.

KHAZZAKA SILVER LUSTER GLAZE (CONE 020)

Ferro Frit 3110	50
Gerstley Borate	50
Silica	7
Kaolin	9
Silver nitrate	3

Photos courtesy of Ibrahim Khazzaka Kashkul.

DECALS

Posey Bacopoulos's work is a great transition between lusters and decals. She uses gold luster decals as a counterpoint to her painterly majolica surfaces.

Posey Bacopoulos teapot. Photo courtesy of the artist.

Decals are printed pigments adhered to a plastic film that can be applied to the surface of a pot via the water-slide method. You can source premade pattern decals from companies like Held Holland, cut your own shapes on a die cutter from commercial sheets of solid decal color, have your own designs printed by a custom decal shop, or print your own sepia-toned decals with a laser printer. Decals are affected by the gloss or matte quality of the surface on which they are applied. Posey uses a matte majolica glaze, which provides contrast to the gold while also subduing its shine. Her pots are glaze fired to cone 04 before a third decal firing to cone 017.

Eric Pardue uses both store-bought decals, which are lead-fluxed to fire to cone 022–016, and home-printed laser toner decals, which fire to the temperature your glaze softens. The surreal composition on his teapot is made from the lower firing commercial decals, which he fired to cone 018. If you want to print decals at home, you can purchase decal paper on Amazon that can be run through a laser printer. Laser-printer toner contains iron, which fires to a monochromatic sepia color. You might have to do some testing to see where your glaze softens, with the goal of fusing the decal into the surface without the glaze melting so much it blurs the image. Try firing the decals two cones below your

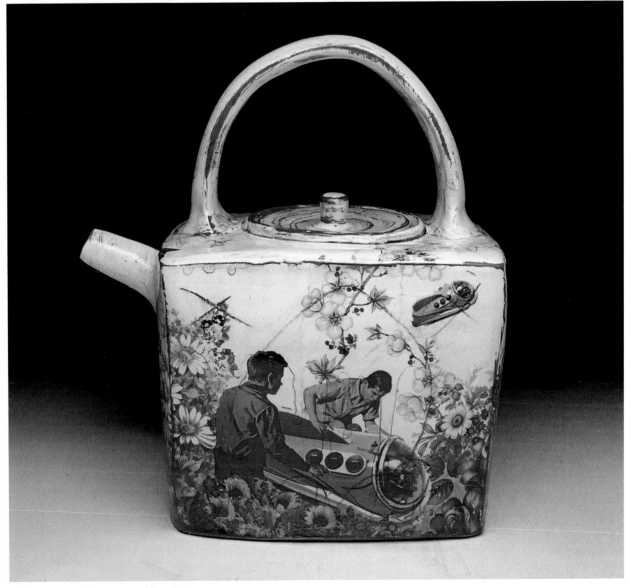

Eric Pardue teapot. Photo courtesy of the artist.

Water-slide application of decal. Photo courtesy of Eric Pardue.

maximum glaze temperature and adjust up or down from there.

While choosing your decal, think about how the image, which is flat, will be placed on the three-dimensional form. If you have skills in Photoshop, or a similar program, I recommend you utilize it as a digital sketching tool. By using the layers function, you can quickly move through dozens of decal placements before you have to commit to doing it in real life on the pot. It's better to make those decisions before your decal is wet in your hands and needs to be applied. If you're working on a nonflat surface, be mindful of rippling in

the decal's surface during application. You can minimize this by cutting right up to the edge of the pictorial space, but you also might need to dart, or cut away portions, to make the decal sit flat on the curved surface. While it's possible to use decals over light texture, it's much easier to apply them on a smooth surface.

Regardless of the type of decal, you'll use the water-slide method for application. Dip the decal in water for 1 to 2 minutes until the decal is fully hydrated and soft. At this point, the printed surface will detach from the backing paper, allowing you to slide the image onto the ceramic

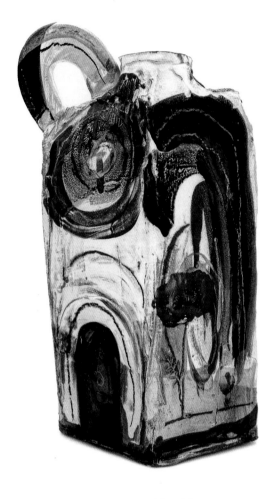

Justin Rothshank bottle. Photo courtesy of the artist.

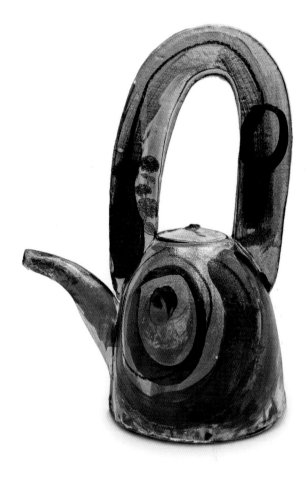

Justin Rothshank teapot. Photo courtesy of the artist.

pot. Lightly smooth the decal with a lint-free cloth or rubber rib to remove air bubbles, which could leave a void in the image during firing.

The Justin Rothshank bottle on the opposite page is a good example of how decaled decoration can accentuate previous layers of information. The poppy blends into the gestural underglaze painting, while providing a warm counterpoint to the cool blue and green around it. Note that multiple types of decals can be fired at the same time. Justin Rothshank applied the poppies and floral gold decals to his bottle before firing to cone 018. If you have

decals that fire to different temperatures, apply the highest first before firing them to temperature, then apply the lower temperature decals, and fire again.

Brian Jones worked with graphic designer Dima Drjuchin and custom shop Milestone Decal Art to create decals for his line of Marc Maron–themed mugs. The decals are five-color silkscreen water-slide decals, which are fired to cone 017. The detail possible with custom printing has improved dramatically in the last ten years. In this case, the attention to detail personalizes the cats, moving their images from caricature to portraiture. This makes

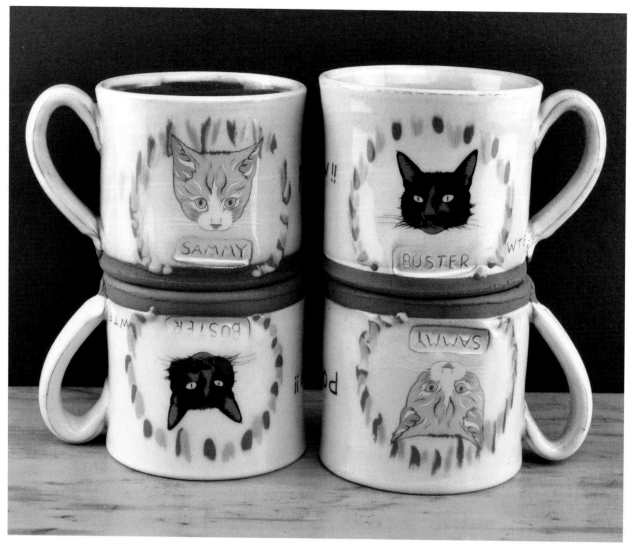

Brian Jones mugs with
Sammy and Buster
decals. Photo courtesy
of the artist.

them extra potent in their emotional tug on
your heart strings.

Consider cost when choosing your
decal type. Laser printed decals are the
cheapest. They cost around $3 USD a
sheet plus the cost of toner for your laser
printer. Stock patterns of gold decals
can be purchased for around $25 USD
a sheet, and custom prints can cost as
much as $100 USD a sheet. This seems
like a lot, but you can maximize efficiency
by fitting as many decals as possible within
the paper size. If your decal is on the
smaller side, you might fit 30 to 40 of them
on a 10- x 16-inch (25 x 41 cm) decal
sheet. With custom prints, you also have to
factor in the setup cost for each new print,
which varies depending on the printer.

To create a color palette that highlights
his decals, Brian layers two glazes.
The base is Karby's with highlights of a
thickened version of SWO. The dots of
SWO remain raised creating a subtle 3D
pattern of color. *"I apply Karby's thick,
thicker than I think it should be applied.
It gets richer when it's that thick, and it
can run in interesting ways when SWO is
on top of it. I fire to a cool 03 and then hold
at temp for 45 minutes."*

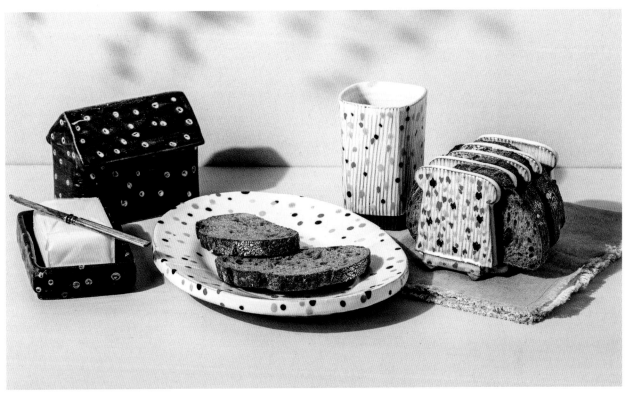

Brian Jones breakfast wares. Photo courtesy of the artist.

KARBY'S (CONE 03)

Gerstley Borate	23
Silica	30
Spodumene	30.7
Edgar Plastic Kaolin	4.5
Ferro Frit 3195	8.4
Whiting	3.5

SWO (CONE 03)

Ferro Frit 3124	72
Nepheline syenite	12
Silica	10
Edgar Plastic Kaolin	6

Pink: 8% Mason Stain 6000 Shell Pink

Orange: 8% Mason Stain 6030 Mango

Blue: 6% Mason Stain 6376 Robin's Egg

Green: 6% Mason Stain 6204 Victoria Green

Yellow: 6% Mason Stain 6450 Praseodymium

CHINA
PAINTING

China painting is another overglaze technique that involves building up layers of color.

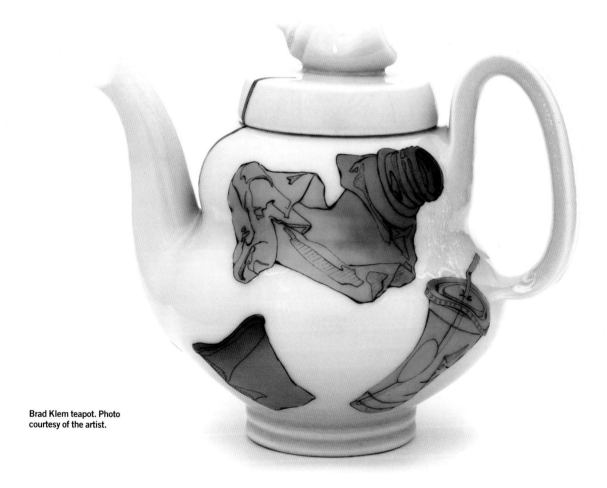

Brad Klem teapot. Photo courtesy of the artist.

Brad Klem expresses his concern about environmental degradation with work that seduces you with its bright surfaces. He fires his porcelain to cone 10 before doing successive lower firings for China painting. He says of his interest in the medium, *"China paint is a ceramic material that allows for elevated control, vibrancy, and clarity while providing the technical freedom I desire in my artistic expression. My approach is primarily self-taught and driven by my inclination toward using dynamic lines and vibrant colors."* I've never done China painting and was intimidated to try the technique. Brad thankfully wrote about his process for the following section of the book.

Preparing China paint by grinding. Photo courtesy of Brad Klem.

China paint is a finely ground glass pigment formed by combining various mineral compounds and oxides. These pigments contain a flux that allows them to melt and fuse permanently to the surface of glazed ceramic. They are mixed with a painting medium, applied to fired glaze wares, and fired again. I typically fire my work between two and four times in the cone 020 to 016 range.

MEDIUMS

The variety of mediums used with China paint are vast and can be daunting. I've narrowed my usage to a few oil-based mediums that allow me to create various effects. I clean brushes and palettes with rubbing alcohol, avoiding more toxic organic solvents like turpentine.

Mediums I Use:

Mineral oil

Lavender oil

Pen oil (70% clove oil + 30% mineral oil)

Grounding oil (thickened linseed oil)

Red resist (This is a water-based coating that's used to block out areas where you don't want color to be applied. It hardens and is easily removed with tweezers afterward.)

Applying China paint with a sponge. Photo courtesy of Brad Klem.

MIXING

For most applications, I start by mixing my powdered pigment with mineral oil until I reach a thick consistency resembling toothpaste (80 percent powder to 20 percent oil). I work the mixture thoroughly on my glass palette with a knife or a paint muller for the best results. I can store this thick paste for long periods in small containers or directly on my palette, and when I'm ready to use it, I add lavender oil with my brush until it's thin enough to flow effectively on my work.

Variations

Add pen oil until reaching the consistency of ink. Using a crow quill pen, I can draw directly on my work.

Grounding oil gives the paint a self-leveling property that eliminates inconsistencies and allows seamless blending and larger areas of smooth color. I apply this using a "pouncing" technique with a makeup sponge (pictured above).

Liz Quackenbush uses a blend of overglaze techniques to create her unique color palette. In the platter pictured opposite, she adds layers of gold luster and glass enamels to her majolica decorated pot.

"After building and bisquing my pots to cone 06, I glaze them using the [majolica] glaze. The patterns are drawn onto this glaze with pencil, which burns out during the firing. The colored pigments are painted on the unfired glaze. I use a variety of white nylon brushes with long bristles so that I can achieve long smooth brushmarks. The glaze-decorated pots are fired to cone 04. The next step is painting on the lustres. The lustered pots are fired to cone 17. The glass enamels are mashed and mixed with the anti-freeze and water solution and then painted onto the lustered pottery. Two layers are applied with a firing to cone 022 after each layer."

Brad Klem *Don't worry about the mess*. Photo courtesy of the artist.

Liz Quackenbush platter. Photo courtesy of the artist.

Detail of brush work. Photo courtesy of Liz Quackenbush.

SCULPTURAL SURFACES

While potters are constrained by functional surfaces, sculptors have a broader range of surface choices, both fired ceramic and room temperature. The slow building of a sculptural surface is a process of brushing, spraying, or otherwise applying layers of underglaze or glaze.

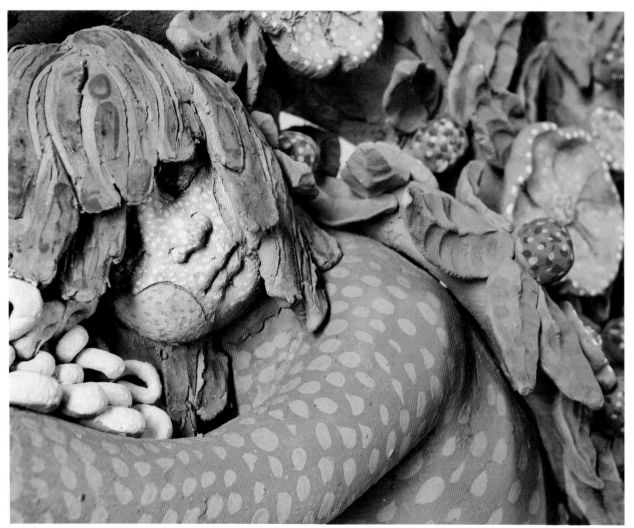

Andréa Keys Connell's *Hug 1* detail. Photo courtesy of the artist.

Andréa Keys Connell's *Hug 1* shows her approach to repetitious mark making as a way to build surface on a work. She applies AMACO Underglazes and fires once to cone 04.

Sculptural clay bodies are formulated with the same core ingredients (clay, flux, silica, etc.) as those used for throwing or handbuilding, but with extra attention to shrinkage and dry strength. Andréa adds 25 percent grog, 25 percent sand, and 1 handful of fiber to her core recipe to make the body suitable for large-scale building. I've included her recipe for making large outdoor work in the "Choosing Your Clay" section of chapter 1.

Rate of firing is important with sculpture, as thicker work needs to be fired slower than thin-walled pots. A long soak below 212°F (100°C) is recommended to encourage physical water to evaporate. Residual water inside the walls of the piece will turn to steam as it reaches 212°F (100°C), which creates pressure that will blow sections off the greenware piece. Uneven thermal expansion, due to uneven heat distribution in the kiln, could create stress and cracking within the sculpture. Andréa Keys Connell provides her firing schedule, at right, to help ease large work through potential problem spots. The last ramp is coded 9999, which triggers a Barlett controller to go as fast as possible. You could slow that down to rise between 250°F (121°C) to 400°F (204°C) per hour.

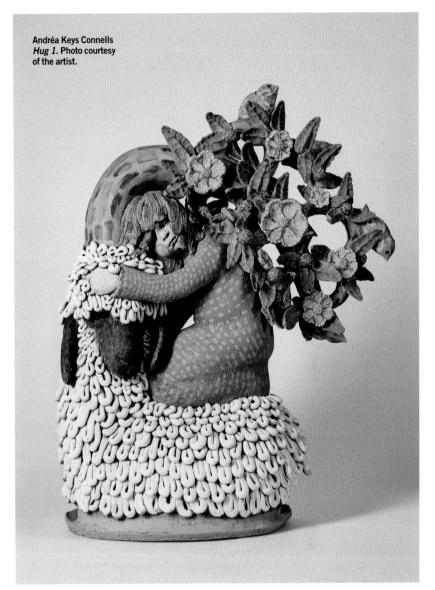

Andréa Keys Connells *Hug 1*. Photo courtesy of the artist.

ANDRÉA KEYS CONNELL FIRING SCHEDULE

	Rate (°F/hr) (°C/hr)	Temp (°F) (°C)	Hold (hrs)
1	50°F (10°C)	210°F (99°C)	24
2	75°F (24°C)	500°F (260°C)	
3	100°F (38°C)	1,200°F (649°C)	1
4	9999°F (9,999°C)	1,945°F (1,063°C)	

Richard James *Portmanteau*. Photo courtesy of the artist.

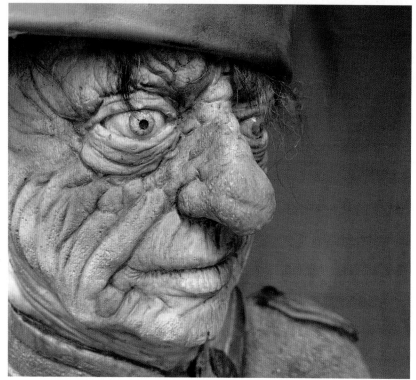

TJ Erdahl *The Meat Monger*. Photo courtesy of the artist.

Many sculptors I spoke with for the book talked about firing their work multiple times in order to build up the surface. Richard James explains his approach.

"My surface is created by airbrushing (and washing off) numerous layers of underglaze. Once the underglaze is dry, I rehydrate the surface using a fine mist water bottle in one hand and a heat gun in the other. Once the underglaze starts to run, I will 'freeze' it in place with the heat gun. Once I like what I see, I will set that color in the kiln to cone 08, so that the next color rehydration will not wash away the previous layer. I mix together numerous AMACO Velvet Underglazes and Mason Stains to get the color I am looking for instead of using 'paint straight from the tube.' Once the sculpture is finished, it will be fired for the final time to cone 04 and a layer of wax or furniture top coat will be added to protect the surface."

You can see the advantage of this method within the variegated surface of his work *Portmanteau*.

TJ Erdahl fires his work multiple times, building up surfaces that often culminate with a layer of encaustic wax.

Zach Tate *The Neighbors Hate Me.* Photo courtesy of the artist.

The redness on the nose and cheeks of *The Meat Monger* starts as a thin wash of red underglaze. He then adds a layer of encaustic to deepen the color. He says of his use of encaustic, *"Primarily, I use it to give localized color to areas that need it, such as a shadow under a nose or to enhance the depth of a wrinkle on the skin of a face. When applying, I use a hot plate as a pallet and mix colors as needed. I also use a propane torch to move the color and melt it into the surface of the ceramic sculpture."*

Zach Tate multi-fires his work, starting high and working progressively lower. He says of his approach to firing, *"In order to achieve the fit on the clay that I am looking for, I tend to bisque fire fairly high and then glaze progressively cooler with each firing as I layer glaze surfaces and drawings with stains. Sometimes, I will modify a commercial glaze with a flux or refractory depending on the effect I am looking for."* He suggests adding 1 to 2 tablespoons of lithium carbonate (15 to 28 ml) to any pint of AMACO LG-10 Clear Transparent glaze to create a "bright" glaze that breaks over hard edges. His piece *The Neighbors Hate Me* was bisqued to cone 5 with glazes multifired to cone 3.

In his piece *Dark Water*, Rickie Barnett contrasts a dark blue felt with the otherwise subtle color palette of underglazes. The addition of nonceramic elements provides an absolutely saturated blue, as well as a new texture that draws the viewer closer to the piece.

In her sculpture *Y lo Mumura el Rio*, Renata Cassiano pays homage to Talavera ceramics from Mexico while exploring themes of connection and identity. She says of the series: *"The works are an exploration of cultural identity through material and technique. Talavera tells a story of expansion, appropriation, colonialism, and assimilation. The pieces were made in my studio in Veracruz with clay from a deposit nearby our house. I then collaborated with a Talavera studio in Puebla called 'Celia.' I gave them the design and instruction on how it should be glazed, and they executed it. I wanted the traditional patterns and colors from what we know as Talavera de Puebla, the blue over white. I was not allowed to do it myself because they guard their recipes and techniques."*

Rickie Barnett *Dark Water*. Photo courtesy of the artist.

Renata Cassiano *Y lo Mumura el Rio*. Photo courtesy of the artist.

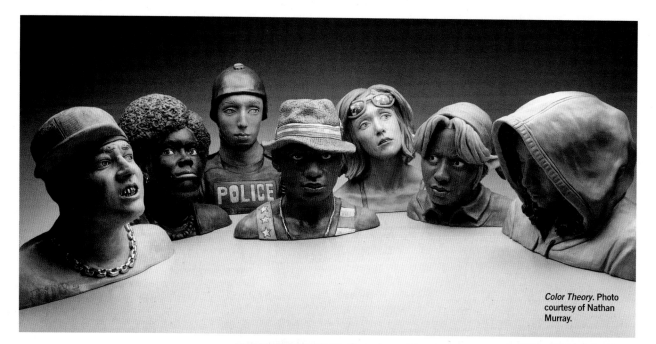

Color Theory. Photo courtesy of Nathan Murray.

Nathan Murray applies base layers of terra sigillata and underglaze before applying nonceramic pigments for the pieces in his *Color Theory* Exhibition. This allows him to control color while still maintaining the feeling of a ceramic object. He also uses clay to make original sculptures for public art pieces that are cast in bronze. Shirley Tyree and Malcolm X are both featured for his series on prominent BIPOC (Black, Indigenous, and People of Color) citizens of Nebraska.

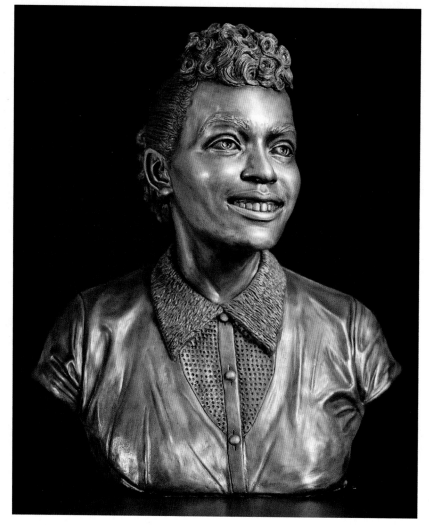

Right: *Shirley Tyree* in bronze. Photo courtesy of Nathan Murray.

Opposite: *Malcolm X* in progress in clay. Photo courtesy of Nathan Murray.

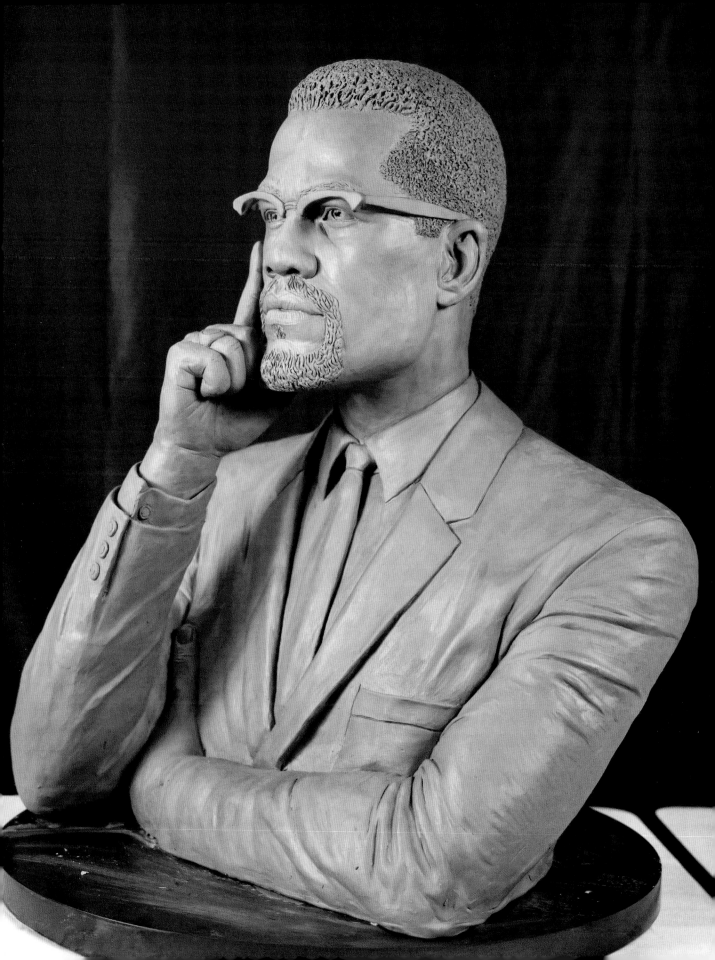

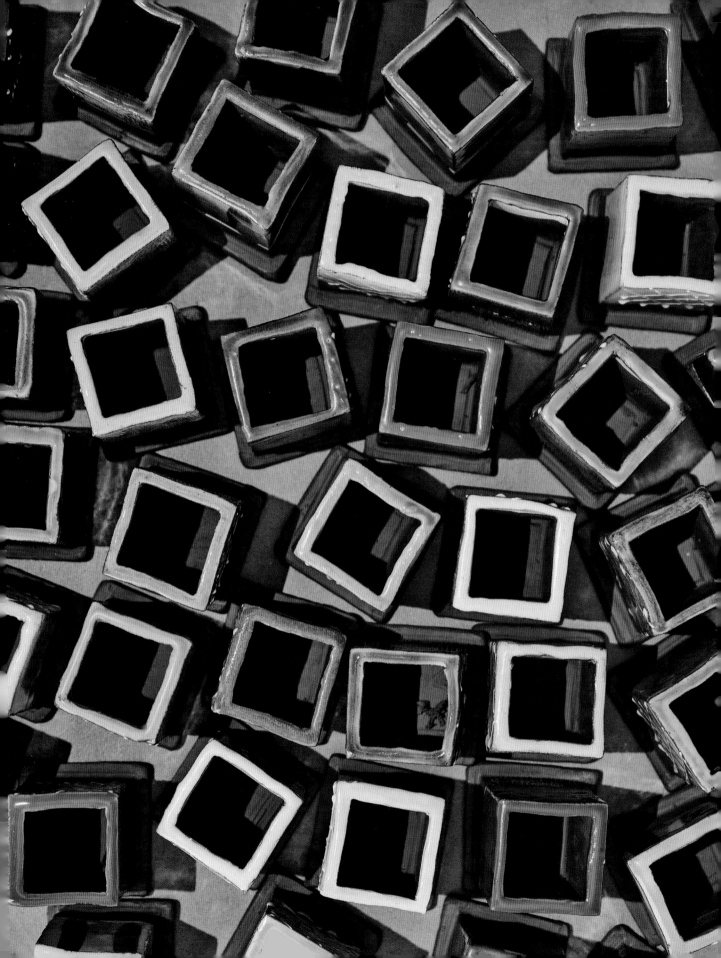

TRIED-AND-TRUE GLAZE RECIPES

While researching glazes for the book, my goal was to find reliable recipes that have potential for further development. I've used many of these for years in my studio, while others were introduced recently by artists who are featured in the book. The colorants we used for testing are only the tip of the iceberg of color development. I encourage you to research the artists who use these glazes for further inspiration, as well as test on your own. I've chosen to show singular glazes and not dipped or sprayed combinations, which can be a rich area to experiment. This batch is a great starting point for your research, but if they don't scratch your itch, I recommend searching Glazy.org or Ceramics Arts Network, where you'll find hundreds more.

GLOSS GLAZES

Gloss glazes are translucent and often transparent, allowing you to see decoration underneath. When applied thickly, they often have microbubbles that cause a milky appearance.

A thinner coat or a drop-and-hold firing schedule are suggested for a crystal clear appearance. Gloss glazes are ideal for food safe surfaces as they are more durable than their matte counterparts.

SHOKO CLEAR

Gerstley Borate	55%
Edgar Plastic Kaolin	30%
Silica	15%
Total	**100%**

Shoko Teruyama has developed a beautiful color palette around a translucent clear glaze that takes colorants well. The glaze has visual fluidity, pooling in texture without running off pots. Because of the Gerstley Borate, this glaze jells in the bucket but is also an excellent brushing glaze. It works nicely brushed over other translucent glaze or by itself. She says of her process, *"I often work with stronger colors underneath and softer color on top to achieve depth. For example, copper green dots underneath with rutile/copper on top, cobalt dots underneath with turquoise on top, intense red dots underneath with softer red on top."* The glaze is also known as Worthington Clear and Gail Kendall's Clear. Fire to the cone 04–02 range.

Shoko Clear with colorant additions. Photo courtesy of Dominic Episcopo.

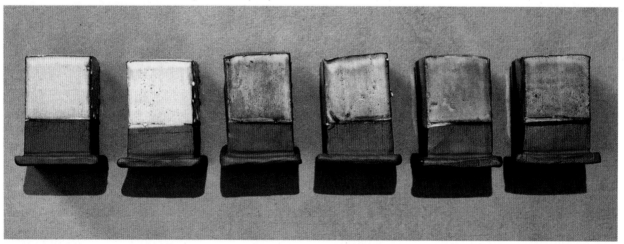

| Salmon Begonia: 2% Mason Stain 6032 Coral, 0.33% titanium dioxide | Yellow: 10% Mason Stain 6464 Zirconium | Green: 3% copper carbonate | Blue Storm: 1% copper carbonate, 0.33% cobalt carbonate, 1% Mason Stain 6450 Praseodymium | Blue: 1% Mason Stain 6450 Praseodymium, 0.66% cobalt carbonate | Wolfberry Gray: 3% Mason Stain 6381 Blackberry Wine |

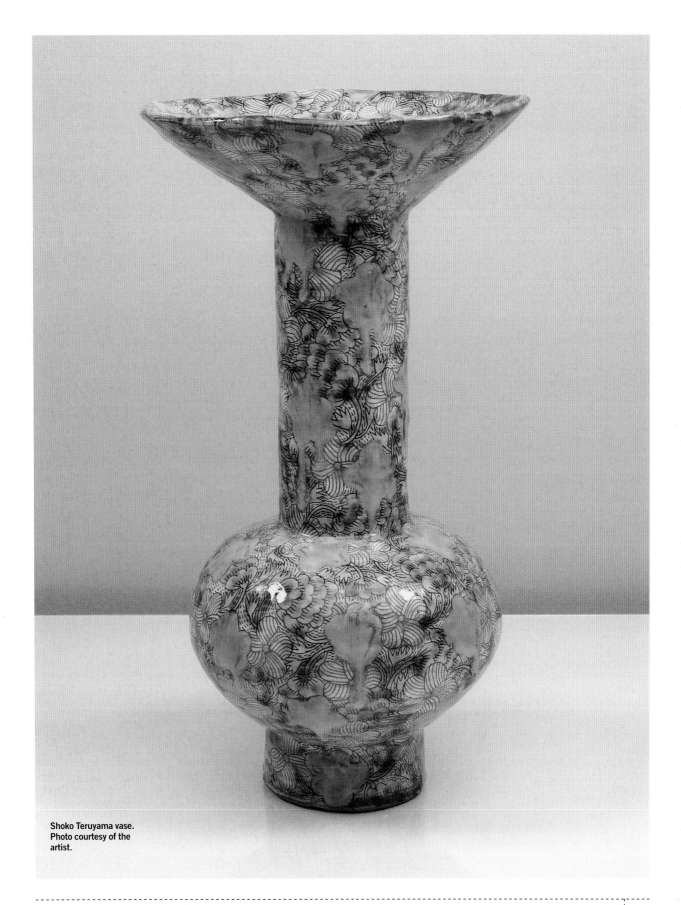

Shoko Teruyama vase.
Photo courtesy of the
artist.

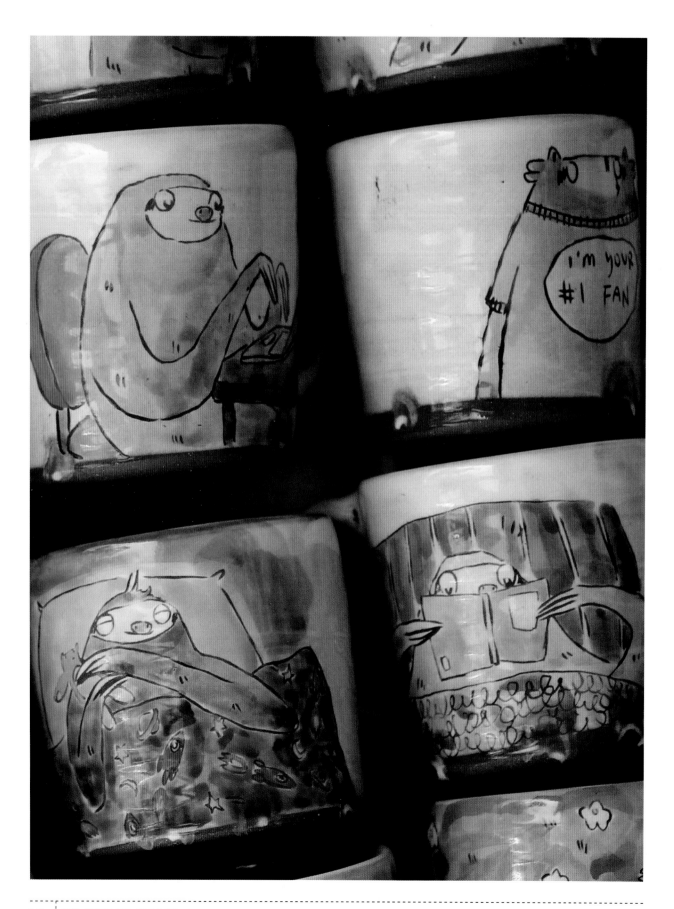

When I taught a Fall Six Week Concentration at Penland School of Craft in 2021, our class did extensive color testing on this glaze. Alex Paat and Celia Feldberg had fun naming these unique combinations.

QUIGLEY CLEAR

Ferro Frit 3195	65%
OM4 Ball Clay	15%
Ferro Frit 3110	10%
Ferro Frit 3249	10%
Total	**100%**

This glaze is an all-purpose high-gloss glaze that is very stable from cone 03–2. Thickness of application affects color saturation when using a tinted version. Celia Feldberg uses this on top of her watered-down underglazes to great effect. Tony Hansen developed this glaze, and he calls it G1916Q.

Opposite: Celia Feldberg mugs. Photo courtesy of the artist.

Isissa Komada-John's *heal four* uses Quigley Clear over a white earthenware with underglaze decoration. Photo courtesy of the artist.

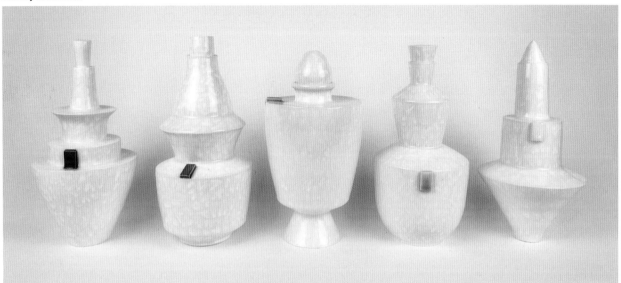

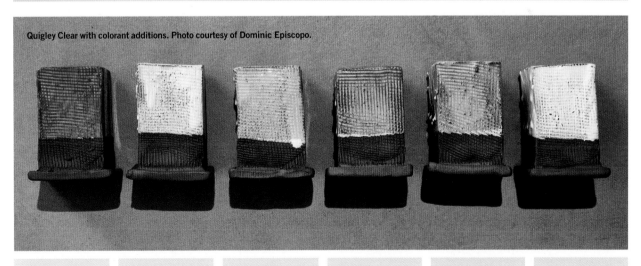

Quigley Clear with colorant additions. Photo courtesy of Dominic Episcopo.

| Red: 10% Mason Stain 6026 Lobster | Yellow: 6% Mason Stain 6404 Vanadium Yellow | Green: 3% copper carbonate | Blue: 0.5% cobalt carbonate, 1% copper carbonate | Purple: 3% Mason Stain 6385 Pansy Purple, 3% Mason Stain 6001 Alpine Rose | White: 8% Zirconium |

DARBY CLEAR

Spodumene	45%
Gerstley Borate	36%
Silica	19%
Total	**100%**

One of the most versatile glazes we tested, Darby works well in both electric and soda kilns in the cone 04–5 range. Teresa Pietsch and Justin Rothshank both use it as their liner glaze in the soda kiln. The color response was so vibrant that it felt like working with crayon colors.

Teresa Pietsch *Clematis Pocket Vase.* Photo courtesy of the artist.

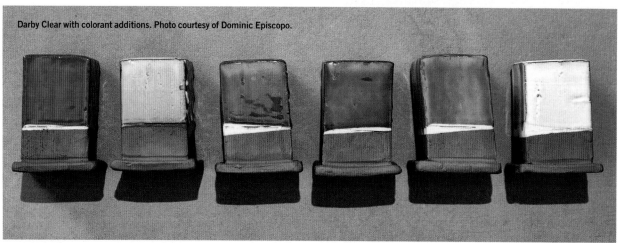

Darby Clear with colorant additions. Photo courtesy of Dominic Episcopo.

Red: 10% Mason Stain 6026 Lobster	Yellow: 6% Mason Stain 6404 Vanadium Yellow	Green: 3% copper carbonate	Blue: 0.5% cobalt carbonate, 1% copper carbonate	Purple: 3% Mason Stain 6385 Pansy Purple, 3% Mason Stain 6001 Alpine Rose	White: 8% Zirconium

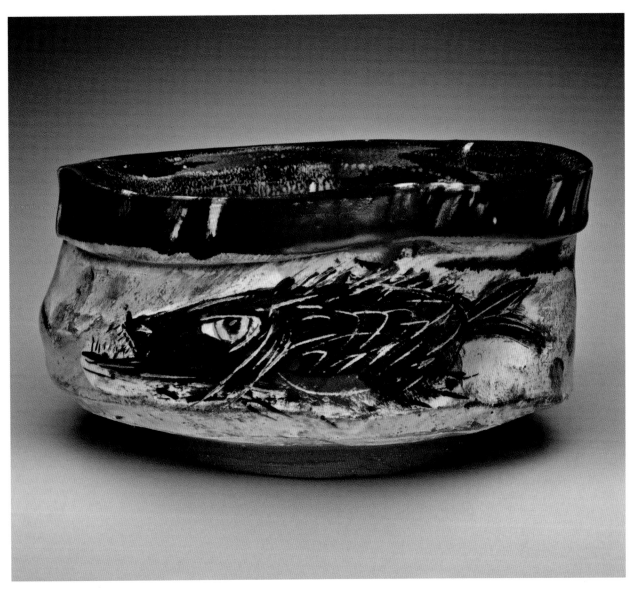

RON MEYERS CLEAR

Ferro Frit 3124	80%
Edgar Plastic Kaolin	10%
Silica	10%
Total	**100%**

This glaze is used by many low-fire potters for its simple recipe and ease of use. Note that it will form microbubbles in the glaze coat, leaving a milky appearance. Try using a thin coat or a drop-and-hold firing cycle to eliminate bubbles. Fire in the cone 04–1 range.

Ron Meyers fish bowl. Photo courtesy of the artist.

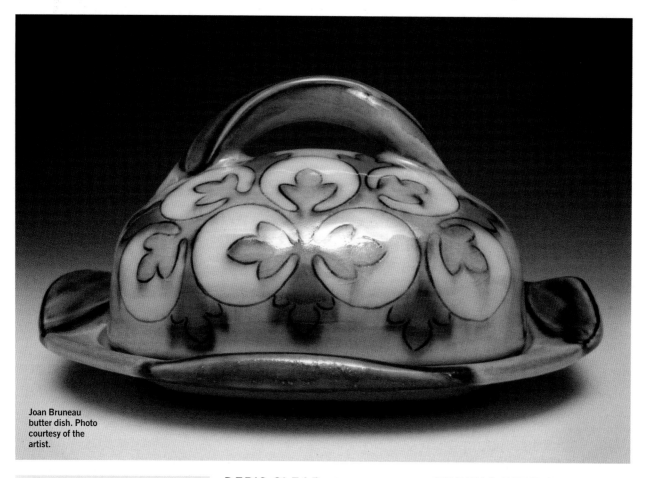

Joan Bruneau butter dish. Photo courtesy of the artist.

JOAN BRUNEAU'S SUGGESTED COLORANT ADDITIONS

Butter Yellow: 2.5% Mason Stain 6404 Vanadium Yellow

Honey: 6% burnt umber

Turquoise: 2.5% copper carbonate

Blue: 2.5% copper carbonate + 0.25% cobalt carbonate

Teal: 3% copper carbonate + 0.25% chrome oxide

Red: 4% Chili Pepper Red Chrysanthos Stain US033

Chartreuse: 2% Mason Stain 6450 Praseodymium + 0.4% Mason Stain 6315 Zirconium Vanadium

DEB'S CLEAR

Ferro Frit 3195	45%
Ferro Frit 3134	30%
Edgar Plastic Kaolin	25%
Total	**100%**

This is a gloss clear that is transparent where thin and translucent when thicker. Joan Bruneau and others use it with colorant additions. Kari Radasch recommends a specific gravity range of 1.55 to 1.65 for best application. See Resources for more info on calculating specific gravity. Fire in the cone 04–02 range.

PINNELL BEST CLEAR

Gerstley Borate	35%
Ferro Frit 3289	25%
Edgar Plastic Kaolin	20%
Spodumene	20%
Total	**100%**

This is a gloss clear that is made with Ferro Frit 3289, a high-barium frit. I've found that its easy brushability makes it perfect for adding accents of color over top of another base glaze. Pictured on this pitcher with copper carbonate 1 percent and cobalt carbonate 0.5 percent. By itself, it has a fluid surface quality similar to Shoko Clear. Fire in the cone 04–1 range.

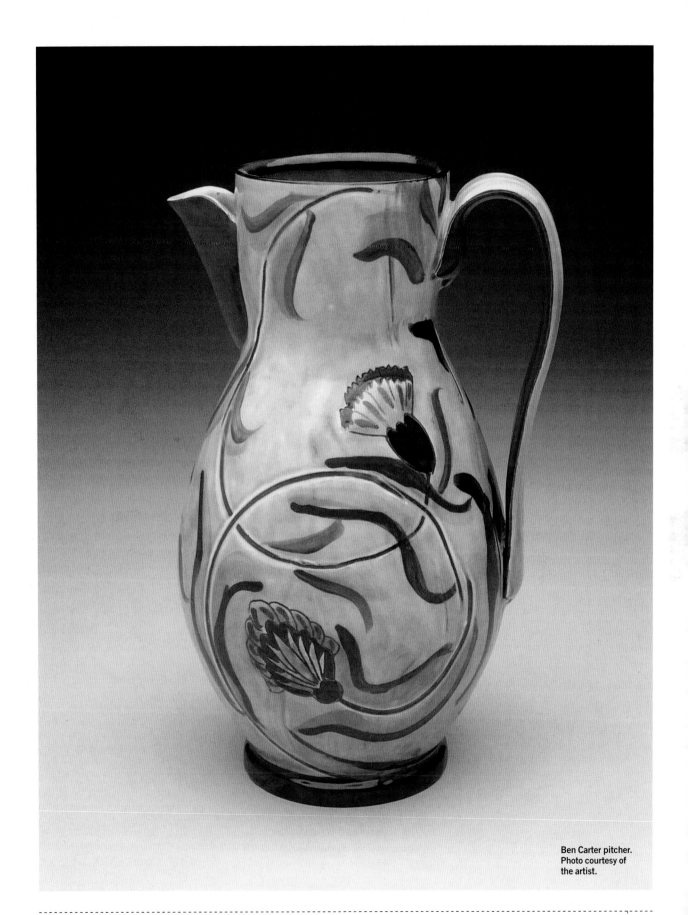

Ben Carter pitcher.
Photo courtesy of
the artist.

SATIN AND MATTE GLAZES

Satin and matte glazes have a semi-opaque appearance due to crystallization during cooling. Their surface can vary from a waxy feel to a dry matte, which is not ideal for food-safe surfaces. Many glazes will appear satin or matte if they are underfired.

To make sure your glaze is fully melted, test two cones hotter than your normal target. If the glaze starts to run, it's fully melted. If it glosses out as you fire hotter, your target temperature is too low for the glaze to melt. Under fired glazes are more likely to degrade during use on a functional pot.

Naples Wagner Satin with colorant additions. Photo courtesy of Dominic Episcopo.

NAPLES WAGNER SATIN

Wollastonite	34%
Ferro Frit 3134	28.6%
Edgar Plastic Kaolin	25.8%
Lithium carbonate	5.3%
Ferro Frit 3110	3.9%
Silica	2.4%
Total	**100%**

Lisa Naples and Karla Wagner developed this translucent satin for the cone 01–2 range. It takes color well and has a waxy surface. To increase crystal development in the surface, try slowing down to a controlled cool of 100°F (38°C) per hour between 1,900°F (1,038°C) and 1,400°F (760°C).

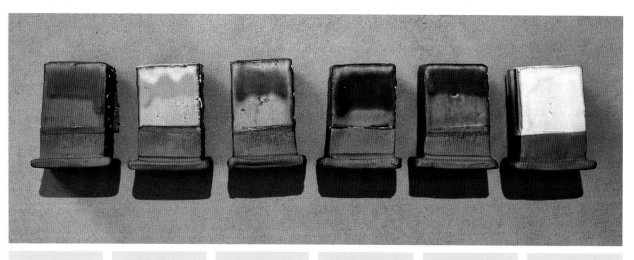

| Red: 10% Mason Stain 6026 Lobster | Yellow: 6% Mason Stain 6404 Vanadium Yellow | Green: 3% copper carbonate | Blue: 0.5% cobalt carbonate, 1% copper carbonate | Purple: 3% Mason Stain 6385 Pansy Purple, 3% Mason Stain 6001 Alpine Rose | White: 8% Zirconium |

Opposite: Two rabbits embrace by Lisa Naples. Photo courtesy of Jim Greipp.

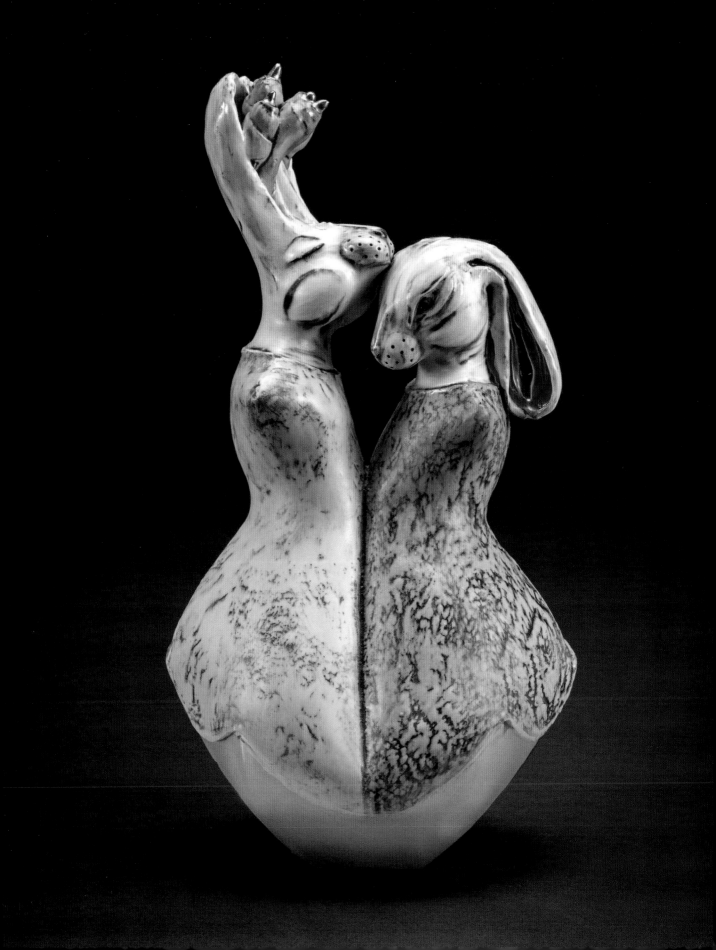

HIRSCH SATIN MATTE

Silica	35%
Gerstley Borate	31%
Whiting	17%
Lithium carbonate	9%
Edgar Plastic Kaolin	4%
Nepheline syenite	4%
Total	**100%**

This translucent satin matte develops a waxy surface at the cone 04–02 range. On the test tiles, you can see that a double dip of Hirsch Satin Matte creates classic phase separation, a favorite of many cone 6 high-boron glazes. This phenomenon occurs as the glaze melts and separates based on slightly different chemistries. The visual result is a variegated surface that appears like running water.

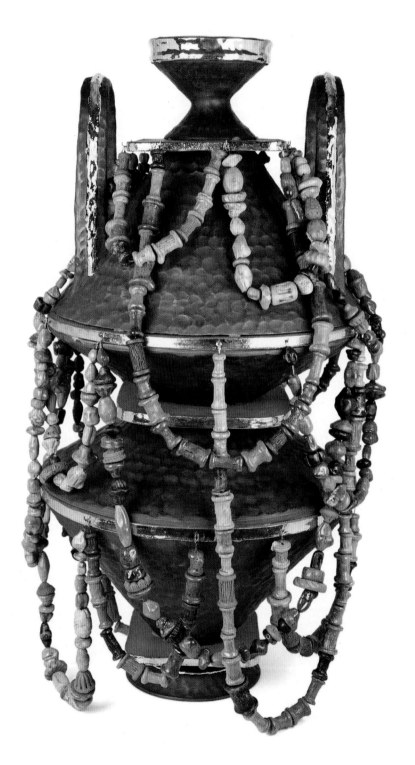

Lauren Sandler *Whorls and Spools.* Photo courtesy of the artist.

Trays by Joe Pintz.
Photo courtesy of
the artist.

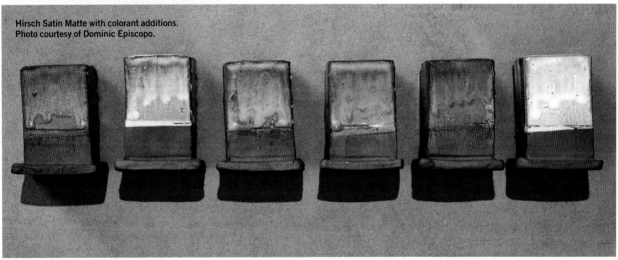

Hirsch Satin Matte with colorant additions.
Photo courtesy of Dominic Episcopo.

| Red: 10% Mason Stain 6026 Lobster | Yellow: 6% Mason Stain 6404 Vanadium Yellow | Green: 3% copper carbonate | Blue: 0.5% cobalt carbonate, 1% copper carbonate | Purple: 3% Mason Stain 6385 Pansy Purple, 3% Mason Stain 6001 Alpine Rose | White: 8% Zirconium |

KATZ SATIN

Ferro Frit 3195	51%
Edgar Plastic Kaolin	23%
Spodumene	13%
Whiting	13%
Total	**100%**

Matt Katz formulated this transparent waxy satin for cone 04–1 range. Isissa Komada-John uses this over her underglaze and slip decoration.

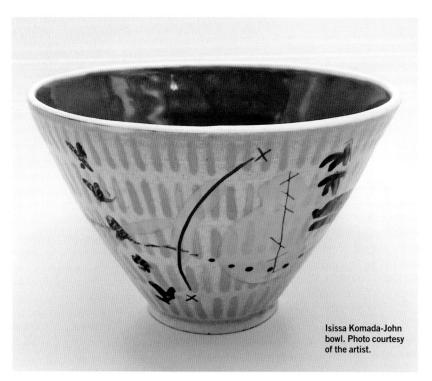

Isissa Komada-John bowl. Photo courtesy of the artist.

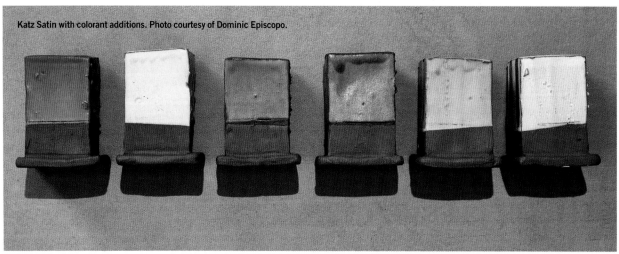

Katz Satin with colorant additions. Photo courtesy of Dominic Episcopo.

Red: 10% Mason Stain 6026 Lobster	Yellow: 6% Mason Stain 6404 Vanadium Yellow	Green: 3% copper carbonate	Blue: 0.5% cobalt carbonate, 1% copper carbonate	Purple: 3% Mason Stain 6385 Pansy Purple, 3% Mason Stain 6001 Alpine Rose	White: 8% Zirconium

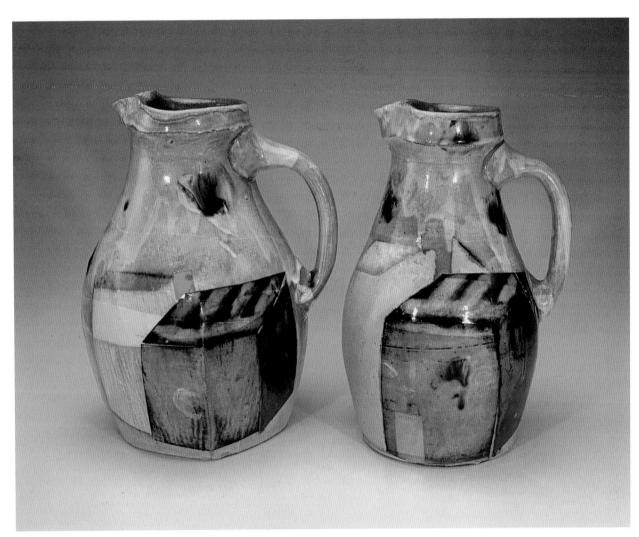

JACKIE'S SATIN

Silica	44%
Gerstley Borate	38%
Lithium carbonate	8%
Edgar Plastic Kaolin	5%
Nepheline syenite	5%
Total	**100%**

This opaque satin for the cone 06–04 range will start to bubble when fired hotter. It's not suitable for interior food surfaces. Michael Connelly's pitcher on the above has Jackie's Satin with 10 percent tin and 5 percent rutile. Trace amounts of chrome in the rutile flash the tin pink. Both Jackie's Satin and Zaeder Matte could use more testing and research. I included them because they make great surfaces, even though they are not as well balanced chemically as the other glazes in this chapter.

Michael Connelly pitchers. Photo courtesy of the artist.

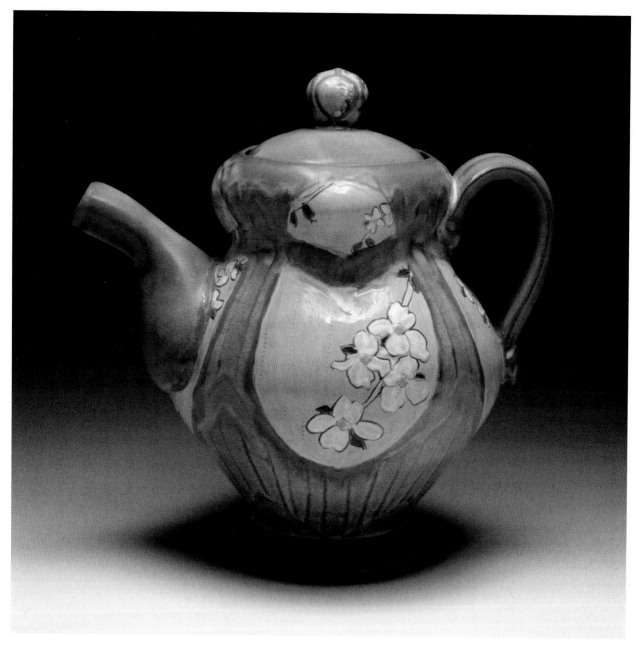

ZAEDER MATTE

Ferro Frit 3134	38%
Wollastonite	24%
OM4 Ball Clay	21%
Silica	12%
Lithium carbonate	5%
Total	**100%**

Zaeder Matte is a smooth translucent matte that breaks frosty when fired hotter. It's pictured above fired to cone 03 but would be better fired in the cone 1–2 range. It looks great over colored slips. Like Jackie's Satin, Zaeder Matte is not as well balanced chemically as other glazes in this chapter, but I included it because it makes great surfaces.

Ben Carter teapot. Photo courtesy of the artist.

TIN GLAZES

For this book, we chose these four popular tin glazes out of the dozens that are being used in North America today. We tested for ease of use and color response, keeping in mind which would be best suited for beginners.

On the tiles below, you can see them side by side with the vertical lines indicating a brushed application and horizontal lines indicating that the glaze was poured. Left to right are Quackenbush Majolica, Arbuckle-Bole Majolica, Anderson Majolica, and Ostrom Tin glaze. All four of these tin glazes have their merits, but the Quackenbush Majolica and Arbuckle-Bole Majolica were the easiest to use. Start with these if you are a beginner to majolica.

There are color and surface differences between the glazes, but the biggest takeaway was that thickness matters. Thinner application looked smoother but had the presence of pinholes in multiple tiles. In our case, the thicker application was brushed on. It had no pinholes, but the painted color dispersed more into the glaze. When choosing a base glaze to work with, keep track of the amount of water used when mixing. Mackenzie McDonald noted that she starts mixing her glaze with 60 percent water and then adds more if needed during sieving.

We ran our preliminary tests using flat tiles to make the application of colored pigment easier. To see if the pigment moves on a vertical surface, you could fire them upright resting against a kiln stilt or test the glaze on a pot. Majolica glazes are formulated to be stiff, which helps keep the color right on the surface and the line quality sharp.

After the base glaze is applied and has thoroughly dried, you paint the colorants on the dry, unfired glaze surface. A flux is needed to help the colorant blend into the glaze as it fires. Spectrum makes commercial majolica pigments with its 300 series, but most of the folks in this book mix their own. Gerstley Borate works well 2:1 or 3:1 by volume with colorants because its thixotropic nature increases brushability. The boron in the material

Tests of majolica bases. Photo courtesy of Dominic Episcopo.

will give a subtle reticulation to the color, while also pushing the hue towards pastel. Ferro Frit 3124 is also commonly used, as well as other frits, with bentonite added to harden the raw surface and add brushability. Frit, water, and colorant alone are very powdery dry, separate out in water, and don't brush well. Colorants vary in how refractory they are, so you'll need to test which percentages of flux work the best for each. CMC gum is often added to colorant blends or to the base glaze to keep colorants from smudging. It acts as a flow agent when brushing on glaze or colorant and as a binder as it dries. For more information on the history of tin glaze and the way artists are using it today, look at "Tin Glaze" in chapter 3.

It's important to understand the technical aspects of majolica, balanced with the conceptual weight of image and object making. In ceramics, we turn impermanent ideas into permanent art objects. Barring a disaster, or a trip to the dumpster, your pots and what you choose to say with them could last hundreds of years. Walter Ostrom talks about the importance of this and how the physical quality of pottery makes it a good vehicle for communication. *"Remember: a pot is a pot, a painting is a painting, a sculpture is a sculpture. Think about what your piece says. Is the back acknowledged or is it treated as a painting? Acknowledging the back is critical. It defines it as tri-dimensional."* He utilizes the full surface of the pot with his *Axis of Evil* soap dish, a cheeky form not normally associated with politics.

Photo courtesy of Walter Ostrom.

Walter Ostrom *Axis of Evil* soap dish, front and back. Photo courtesy of the artist.

QUACKENBUSH MAJOLICA

Ferro Frit 3124	67
Silica	17
Ferro Frit 3110	9
OM4 Ball Clay	7
Zirconium	10

Liz Quackenbush developed this glaze for the cone 04–03 range. She colored the glaze with 10 percent Zircopax. Michelle Im adds Zircopax, as well as Mason Stains between 5 to 8 percent to create bright base colors. We found the glaze worked well being dipped or brushed on.

Liz Quackenbush butter dish lid. Photo courtesy of the artist.

Michelle Im *Journey to Carrot Kingdom.* **Photo courtesy of the artist.**

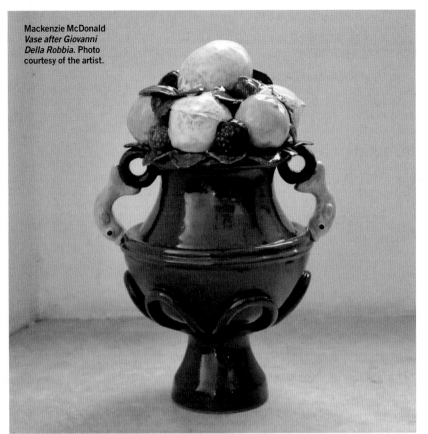

Mackenzie McDonald *Vase after Giovanni Della Robbia*. Photo courtesy of the artist.

ARBUCKLE MAJOLICA

Ferro Frit 3124	66
Minspar 200	17
Tile #6 Kaolin	11
Nepheline syenite	6
Tin	4
Zirconium	9
Bentonite	2

This glaze is named after Linda Arbuckle and used by many others. Add 4 percent tin, 9 percent Zircopax, and 2 percent bentonite to achieve a creamy white. Mackenzie McDonald adds 14 percent Zircopax and 1 percent CMC gum in solution. It's also called MJ's Majolica after Mary Jo Bole.

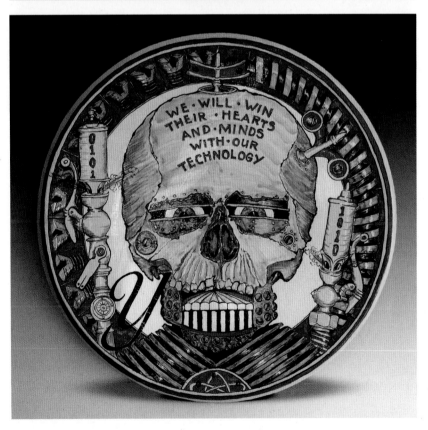

Bill Brouillard *Whistle Skull*. Photo courtesy of the artist.

OSTROM TIN GLAZE

Ferro Frit 3124	35
Ferro Frit 3134	23
Ferro Frit 3195	23
Nepheline syenite	16
Edgar Plastic Kaolin	3
Zirconium	12
Bentonite	2

Walter Ostrom developed this glaze for the cone 010–04 range. Matt Wedel used this for his *Wonderers* with 12 percent Zircopax and 2 percent bentonite added. The washes are 1 part stain and 3 parts Ferro Frit 3124.

Matt Wedel *Wonderers*. **Photo courtesy of Jeff McLane.**

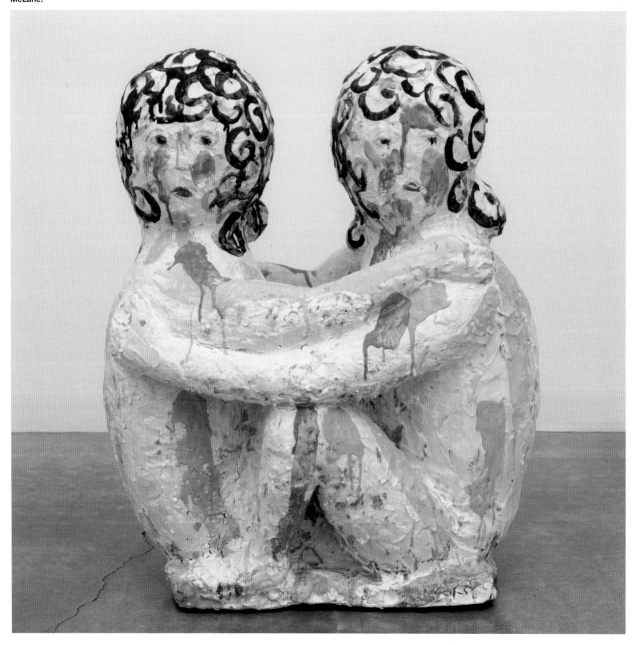

ANDERSEN MAJOLICA

Ferro Frit 3124	66.6
OM4 Ball Clay	16.7
Silica	16.7
Zirconium	7

Stan Andersen developed this glaze, adding 7 percent Zircopax to the base. *"I mix the stains in water, adding a spoonful of the 3124 frit to a spoonful or so of the colorant. This is done by eye and experience."* He used the following Mason Stains for his tulip vases pictured below: 6003 Crimson, 6271 Mint, 6219 French (Green), 6433 Praseodymium Yellow.

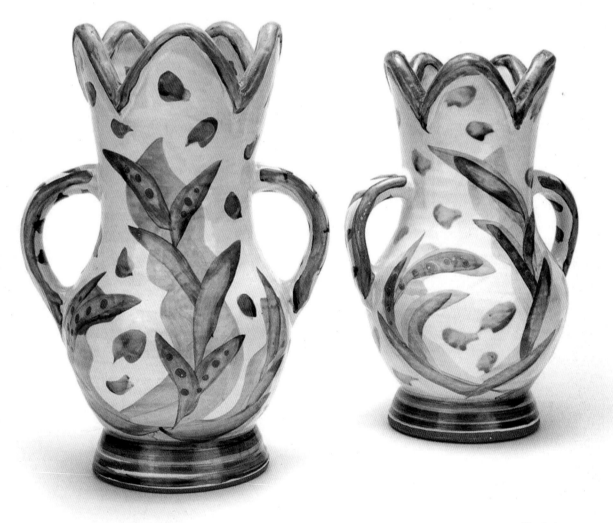

Stan Andersen vases with handles. Photo courtesy of the artist.

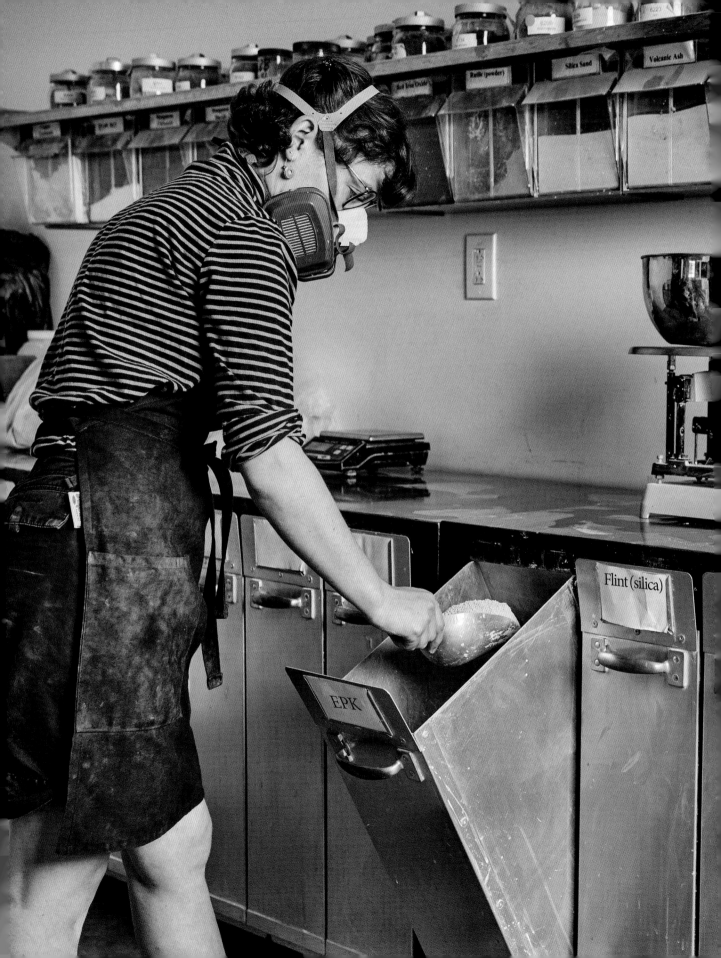

LAB TESTS

This chapter features tests I run when I'm trying to understand a new glaze. I start with a basic colorant test, which gives you an idea of how the colorants respond to the balance of fluxes. You can use the progression test and triaxial blend to help refine color, as well as solve glaze fit issues by testing independent variables. I've also included firing schedules that you might find helpful. As you move from the testing stage to using your glazes in full production, you'll probably need to adjust glaze color, fit, or firing schedule. Those are normal adjustments, so don't worry too much if you can't get the glaze to look like it does on your test tile the first time around. If you run into a glaze defect, refer back to chapter 2 for help with troubleshooting.

**Testing new glazes.
Photo courtesy of
Dominic Episcopo.**

ADDING COLORANTS
TO A GLAZE

If you're new to mixing your own glazes, you might be wondering where to start.

Colorants in The Clay Studio glaze lab. Photo courtesy of Dominic Episcopo.

First, think about your glaze surface. Do you want a gloss, satin, or matte glaze? You can choose one of the many great options from chapter 4 for your test. In order to create 100-gram batches for each colorant, we will mix a 600-gram batch and then subdivide. Multiply the total of the batch (600) by the percentage of water you will add (60 percent). Start with 60 percent for satin/matte and 70 percent for gloss. Add the 360 grams of water to your 600 grams of dry glaze material and thoroughly mix with an immersion blender. Label six small containers and test tiles with corresponding letters (A to F) before

pouring 160 grams of glaze into each container. Set these to the side.

Next, choose the colorants to add to the glaze, including both cool and warm colors to test a broad spectrum. Measure each colorant blend, keeping in mind that we are starting with 100-gram batches. Mix colorants into a paste with a few drops of water before adding to the appropriate container. You might need to remix with a blender or sieve with a small 60 mesh Talisman Mini Test Sieve to make sure colorants are dispersed. Be careful not to cross-contaminate your colorants or glazes with dirty equipment. It's best

practice to wash measuring cups when switching materials. Dip each tile into the corresponding container with a double dip to create a thicker coat covering the top ½ inch (1.3 cm) of the tile. You could also dip once and then brush a second coat over the right half of the tile. This allows you to compare thickness side-by-side. The goal is to assess how much the glaze will run when thick. Let dry overnight and fire to the appropriate temperature.

Once fired, compare your tiles in both studio and natural light. Does the glaze seem undersaturated or oversaturated with color? Did the colorant change the

surface of the glaze? Does the amount of water you used to mix the glaze seem sufficient? If the double dip looks great but the single looks weak, then you might try remixing with less water. Lastly, make sure to thoroughly document your observations and snap a photo of the tiles. Many phones allow you to mark up photos when you are in editing mode, which means you can take notes on the photo itself. To get a more subtle blend of colors, try the "Understanding Colorants through Triaxial Blends" lab on page 168.

Jenn Cole jar with no colorant in the base. Photo courtesy of Clay AKAR.

Fired Naples Wagner Satin showing the effect of colorant additions. Photo courtesy of Dominic Episcopo.

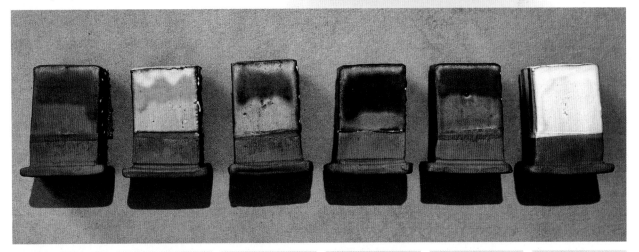

| Red: 10% Mason Stain 6026 Lobster | Yellow: 6% Mason Stain 6404 Vanadium Yellow | Green: 3% copper carbonate | Blue: 0.5% cobalt carbonate, 1% copper carbonate | Purple: 3% Mason Stain 6385 Pansy Purple, 3% Mason Stain 6001 Alpine Rose | White: 8% Zirconium |

PROGRESSION
TESTS

A progression test slowly increases one variable within a glaze while keeping the others constant. You'll use this when testing how much of a colorant is needed to achieve the color you want.

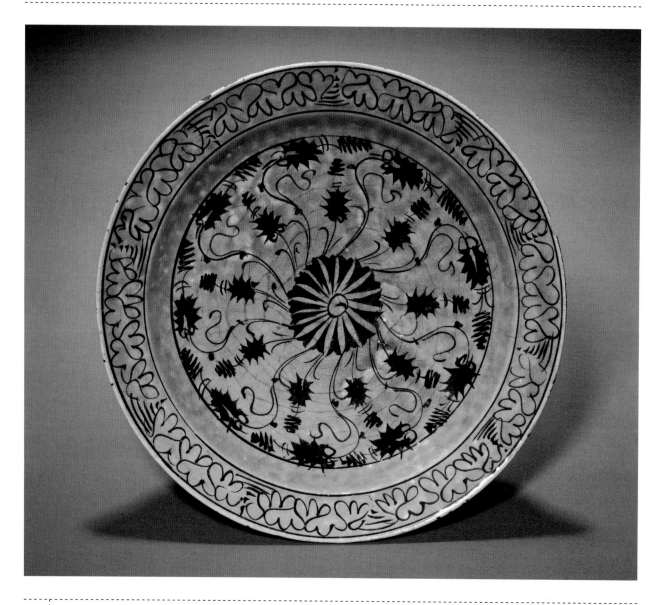

You can also run a progression test increasing silica and/or clay to fix crazing in a glaze. We wanted a challenge, so we attempted to fix the crazing in John Gill's Water Blue Glaze, a high-sodium glaze replicating the turquoise on this plate from the Caucasus region circa 1600.

To start, we mixed 100 grams of the original formula with 70 percent water. For each test, we would add dry silica to the wet solution and mix before dipping a test tile. With a progression test that has many steps, you'll need to add water to your starting batch. If you do find a percentage of material that fixes the crazing, it would be good to retest a fresh batch with 70 percent water to confirm your result. We ran the test with 4 percent, 8 percent, 12 percent and 16 percent silica, which had no impact on the crazing. We kept increasing to 20 percent, 24 percent, 28 percent, and 32 percent silica, which also had no impact on the crazing but did change the surface of the glaze from gloss to satin. This shifted our thinking towards adding silica and alumina.

We tried alumina oxide first with a progression of 3 percent, 6 percent, 9 percent, and 12 percent. We ran the same test with Edgar Plastic Kaolin, which would provide both silica and alumina at the same time. We tested percentages of 4 percent, 8 percent, 12 percent, and 16 percent. Both the alumina and Edgar Plastic Kaolin progressions failed to eliminate crazing but did turn the glaze from gloss to satin and eventually matte. The additions were pushing the glaze from a melted to unmelted state, which could be remedied by firing hotter. With more testing, you might be able to make a craze-free mid-range version.

This style of progression test did not achieve our goal of eliminating crazing, but it does show that formulating a functional low-fire glaze around Ferro Frit 3110 is not easy. It has high thermal expansion and is also extremely soft, making this formula a decorative glaze not suited for functional pots. The next step would be to replace some of the Ferro Frit 3110 with lithium carbonate, which has a similar color response to sodium but with lower thermal expansion. You could also replace some of the Ferro Frit 3110 with a lower expansion magnesium frit, being mindful that in high enough amounts this could turn the copper from turquoise to a more grass green.

Opposite: *Dish*, c. 1600. Caucasus or northern Iran. Kubachi ware. Photo courtesy of the Cleveland Museum of Art.

GILL'S WATER BLUE GLAZE

Ferro Frit 3110	77%
Silica	10%
Edgar Plastic Kaolin	7%
Gerstley Borate	6%
Bentonite	3%
Copper carbonate	2%
Total	**105%**

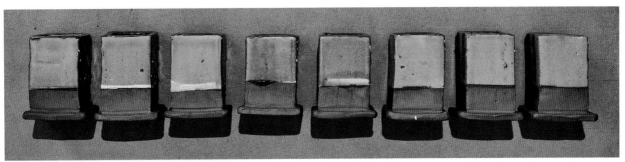

Silica progression test. Photo courtesy of Dominic Episcopo.

Alumina and EPK progression test. Photo courtesy of Dominic Episcopo.

UNDERSTANDING COLORANTS THROUGH TRIAXIAL BLENDS

I've built my color palette around a preference for intense warm colors that are surrounded by subdued cool tones. To create structure, I often start with a triad of color before adding new colors to see how they affect the color relationship.

The jar pictured at right came from a triad of dark blue, dark chrome green, and red. After a few rounds of making, I added purple before modifying the other colors to be brighter or darker. A great tool for tinting and shading colors is a triaxial blend, which creates many variations within a section of the color spectrum. This triaxial was made with 2 percent copper, 2 percent rutile, and 1 percent cobalt with the goal of finding a modulated blue green.

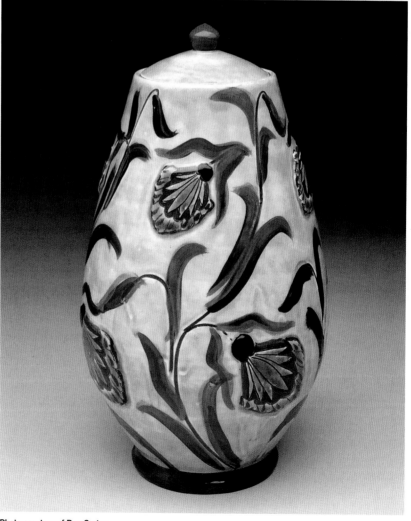

Photo courtesy of Ben Carter.

A: 3 g copper carbonate	**B:** 2 g copper carbonate + 1 g rutile	**C:** 2 g copper carbonate + 0.33 g cobalt carbonate	**D:** 1 g copper carbonate + 2 g rutile	**E:** 1 g copper carbonate + 1 g rutile + 0.33 g cobalt carbonate
F: 1 g copper carbonate + 0.6 g cobalt carbonate	**G:** 3 g rutile	**H:** 2 g rutile + 0.33 g cobalt carbonate	**I:** 1 g rutile + 0.6 g cobalt carbonate	**J:** 1 g cobalt carbonate

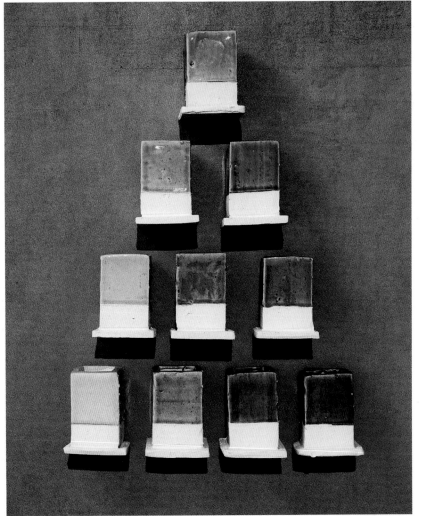

A
3% copper carbonate

100% A

66% A 33% B | 66% A 33% C

33% A 66% B | 33% A 33% B 33% C | 33% A 66% C

100% B | 66% B 33% C | 33% B 66% C | 100% C

B
3% rutile

C
1% cobalt carbonate

Start the triaxial by labeling ten plastic cups and tiles with corresponding letters (A to J). Weigh and mix a 1,000-gram batch of your glaze with the amount of water that will achieve the best glaze consistency. If you're unsure, use approximately 60 percent water for matte glazes and 70 percent for gloss glazes. After mixing, subdivide into your prelabeled cups. To calculate the glaze needed in each cup, add the weight of dry glaze (1,000 g) to the weight of water added (60 percent or 600 g). Divide this by the number of containers, which equals 160 grams of mixed glaze. Now, pick three colorants at varying percentages for testing. They will form the outside points of the triangle (A, G, J in the image at left). For instance, you might pick 3 percent copper carbonate, 3 percent rutile, and 1 percent cobalt carbonate. Follow the amounts above to mix your glaze. You can avoid clumping by adding a few drops of water to the dry colorant to make a paste before you add it to your glaze. Prepare and mix your colorants with an immersion blender, making sure to clean the blender between mixtures. Once mixed, dip your tiles with a double dip towards the top. Let dry overnight and fire to the appropriate cone.

To make the colorants easier to measure, we rounded up the amounts (in grams) where possible, with the exception of cobalt carbonate since it is such a potent colorant.

Triaxial blend with copper, rutile, and cobalt. Photo courtesy of Dominic Episcopo.

RESOURCES

This section features firing schedules, technical information on frits, and other resources that will help shape your understanding of low-fire glaze.

FAST FIRING TO CONE 04
This is a schedule for fast firing thrown or slip cast work to cone 04. It's an overall fast rise.

	Rate (°F/hr) (°C/hr)	Temp (°F) (°C)	Hold (min)
1	50°F (10°C)	210°F (99°C)	30
2	350°F (177°C)	1,840°F (1,004°C)	
3	108°F (42°C)	1,945°F (1,063°C)	5

DROP AND HOLD FIRING SCHEDULE FOR CONE 03
This is a drop and hold firing schedule for cone 03. It's a fast rise, slow peak, and slow cool.

	Rate (°F/hr) (°C/hr)	Temp (°F) (°C)	Hold (min)
1	108°F (42°C)	240°F (116°C)	60
2	350°F (177°C)	1,887°F (1,031°C)	15
3	108°F (42°C)	1,987°F (1,086°C)	5
4	999°F (537°C)	1,887°F (1,031°C)	30
5	150°F (66°C)	1,400°F (760°C)	

ANDRÉA KEYS CONNELL FIRING SCHEDULE
This is Andréa Keys Connell's firing schedule for large sculpture. It's a slow rise until 1,200°F (649°C) and then a fast rise to peak.

	Rate (°F/hr) (°C/hr)	Temp (°F) (°C)	Hold (hrs)
1	50°F (10°C)	210°F (99°C)	24
2	75°F (24°C)	500°F (260°C)	
3	100°F (38°C)	1,200°F (649°C)	1
4	9,999°F (9,999°C)	1,945°F (1,063°C)	

FRIT COMPARISON CHARTS

Frit	Description	Melting range
Ferro Frit 3110	3110 is an alkaline frit with bright color response and high thermal expansion (may cause crazing) that produces a less-durable glaze.	1,400–1,700°F (760–927°C)
Ferro Frit 3134	3134 is a calcium-boron frit that gives good glaze durability. Ferro Frit 3134 is low-alumina/high-boron.	1,450–1,600°F (788–871°C)
Ferro Frit 3124	3124 is a calcium-boron frit that gives good glaze durability. Ferro Frit 3124 is medium-alumina/low-boron.	1,600–1,750°F (871–954°C)
Ferro Frit 3195	3195 is medium-alumina/high-boron frit.	1,550–1,750°F (843–954°C)

Ceramic materials tables and flashcards for studying can be found in the handouts section of lindaarbuckle.com. Ceramic databases with in-depth analysis of materials can be found at glazy.org and digitalfire.com. Ceramic Materials Workshop offers classes at ceramicsmaterialsworkshop.com. You might find the following books to be helpful in your understanding of glaze.

FURTHER READING

Clay and Glazes for the Potter by Daniel Rhodes

The Potter's Dictionary of Materials and Techniques by Frank Hamer and Janet Hamer

Lustre by Greg Daly

The Complete Guide to Mid-Range Glazes and *The Complete Guide to High-Fire Glazes* by John Britt

Gabe Kline's *Amazing Glaze* series

Wild Clay: Creating Ceramics and Glazes from Natural and Found Resources by Matt Levy, Takuro Shibata, and Hitomi Shibata

Creative Pottery: Innovative Techniques and Experimental Designs in Thrown and Handbuilt Ceramics by Deb Schwartzkopf

ABOUT THE AUTHOR

ABOUT THE GLAZE TECHNICIAN

Ben Carter is an artist, educator, and podcast producer based in New Jersey. He received his BFA from Appalachian State University and his MFA from the University of Florida. His professional experience includes being an artist-in-residence at the Archie Bray Foundation for the Ceramic Arts in Helena, Montana, and Anderson Ranch Arts Center in Snowmass Village, Colorado, and the Education Director of the Pottery Workshop in Shanghai, China. He has lectured and exhibited widely in the United States, Canada, China, Australia, and New Zealand.

In addition to his studio work, he is the host of the *Tales of a Red Clay Rambler* podcast, where he interviews artists about their craft, creativity, and lifestyle, and the executive producer of *The Brickyard Network*, a collection of ceramic podcasts. He has authored a full-length book, *Mastering the Potter's Wheel*, published by Voyageur Press in 2016, and was named Ceramic Artist of the Year that year by *Ceramics Monthly*.

Celia Feldberg is an artist living in Philadelphia, Pennsylvania. Born in England and raised in Massachusetts, she earned her BFA in ceramics from the Massachusetts College of Art and Design in Boston in 2019. She makes illustrated pottery, teaches, and maintains an active involvement at craft schools. She is currently a resident artist at The Clay Studio of Philadelphia.

INDEX

A

absorption, 26, 38
Abundance Charger (Hannah McAndrew), 72
aesthetic testing, 26
Akan memorial heads, 42
Aldermaston Pottery, 111
alumina, 31, 101
Andersen, Stan, 26, 51, 52, 90, 161
Anderson, Alex, 21, 117, 119
Anderson, PJ, 104
antimony (Sb), 48
Apothecary Jar (Giunta di Tugio), 53
aprons, 15
Arbelaez, Natalia, 90, 93
Arbuckle, Linda, 41, 85, 86, 88, 89, 159
atmospheric firing, 104–109
Axis of Evil (Walter Ostrom), 157

B

Bacopoulos, Posey, 120, 121
Barnett, Rickie, 134
Barnim, Scott, 111, 112
Bartel, Tom, 47, 57, 63
Bernard, Nicholas, 55
bins, 12–13
blistering, 37
Brandl, Jessica, 70–71
Brennan, Kaitlyn, 77
Brink, Jenna Vanden, 40
Brouillard, Bill, 159
Brouillard, William, 84
Brueck, Scott, 17
Bruneau, Joan, 68, 69, 70, 146
Buck, Lisa, 72
Bungart, Troy, 90

C

Caballero, Jonathan Christensen, 93, 94
cadmium (Cd), 50
Caiger-Smith, Alan, 111
Carpenter, Kyle, 62
Carrot Vase (Christy Culp), 46
Carter, Ben, 33, 147, 154
Cassiano, Renata, 134, 135

Chalmers, Pattie, 68
Chappell, Rebecca, 72, 73
Chen, Lilia, 17
Chicory Plate (Teresa Pietsch), 106
China painting, 126–129
Christen, Victoria, 76
chrome (Cr), 43, 46, 153
Cinelli, Mike, 81
Clarke, Bede, 74
Clarkson, Sam, 109
clay
 absorption, 26, 38
 dunting, 37–38
 moisture expansion, 26
 plasticity, 25
 porosity, 19–21
 selection, 18–21
 shrinkage, 25, 26
 testing, 24–26
cleanup, 17
Clematis Pocket Vase (Teresa Pietsch), 144
CMC gum, 97, 156
cobalt (Co), 41, 44, 169
Cole, Jenn, 77
colorants
 adding to glaze, 164–165
 antimony (Sb), 48
 cadmium (Cd), 50
 chrome (Cr), 43, 46, 153
 cobalt (Co), 41, 44, 169
 copper (Cu), 32, 43, 113, 116, 169
 erbium (Er), 51
 ilmenite (Fe + Ti), 49
 iron (Fe), 17, 18, 19, 26, 42, 49
 manganese (Mn), 45
 neodymium (Nd), 51
 nickel (Ni), 49
 praseodymium (Pr), 48
 rutile (Ti + Fe), 49, 169
 selenium (Se), 50
 tin (Sn), 51, 84–95, 111, 155–161
 titanium (Ti), 49
 vanadium (V), 47, 48
 zirconium (ZrO2), 51
color development, 54–59

Color Theory (Nathan Murray), 136, 137
Connell, Andréa Keys, 130, 131
Connelly, Michael, 64, 65, 153
copper (Cu), 32, 43, 113, 116, 169
Covered Jar (Ben Owen), 50
crawling, 39
crazing, 36
Creech, Stephen, 98
crystal development, 31, 49, 59, 101, 148
Culp, Christy, 46, 74

D

Dal-Tile, 100
Daly, Greg, 113–116
Dark Sunset Bottle (Nicholas Bernard), 55
Dark Water (Rickie Barnett), 134
decals, 120–125
deflocculation, 34
Dish (Castel Durante), 45
Dish (Caucasus or northern Iran), 166
Dondero, Maria, 75
Don't worry about the mess (Brad Klem), 129
Drjuchin, Dima, 122
dunting, 37–38
Dutch Treat (Walter Ostrom), 87

E

Earp, Stephen, 95
earthenware, 18, 21
Economies of Beans (Lauren Sandler), 103
efflorescence, 21
electronic scale, 13–15
El mito del regreso (Joey Quiñones), 21, 22
erbium (Er), 51
Erdahl, TJ, 132, 134
Evaluation of Exposures at a Pottery Shop (Lilia Chen, Jessica Ramsey, and Scott Brueck), 17
Excision (Alex Anderson), 21

F

Feldberg, Celia, 68, 69, 140, 142
Fitch, Doug, 71
Fliegel, Shanna, 66, 67
flocculation, 34
Flower Vessel no. 1 (Joanna Powell), 110
fluxes, 30–31, 34
The Fountain (Lindsay Montgomery), 88, 89
frits, 32, 34
Fruit Vessel (Joanna Powell), 91
Fruit Vessel with Bangles (Joanna Powell), 110
fuming lusters, 111

G

Gardner, Nancy, 103
Gear Vessel in New Wave (Jolie Ngo), 98
Gill, Andrea, 56
glass formers, 30, 31
Glazescape (Green Shade No. 3) (Lauren Mabry), 96, 97
Glazy, 31, 101
gloop, 97, 98
gloss glazes, 140–147
gold lusters, 110

H

Hansen, Tony, 98, 142
Hargens, Ursula, 76
Henderson, Max, 97
Hopkins, Bryan, 98, 99
Horse (Tang Dynasty), 31
House (Sana Musasama), 73
Hug 1 (Andréa Keys Connell), 130, 131
Hyperglaze, 31

I

ilmenite (Fe + Ti), 49
Im, Michelle, 85, 86, 158
iron (Fe), 17, 18, 19, 26, 42, 49

J

James, Richard, 132
Jaszczak, Maggie, 102, 103

Jaszczak, Tom, 107
Jones, Brian, 122, 124, 125
Journey to Carrot Kingdom
 (Michelle Im), 158
Juicy Fruit Jar (Maura Wright),
 64

K

Kantor, Stephanie, 118, 119
Kelleher, Matt, 108, 109
Kendall, Gail, 72
Khazzaka, Ibrahim, 111, 119
Klem, Brad, 126, 128, 129
Komada-John, Isissa, 143, 152
Kwong, Eva, 55

L

Lantin, Martina, 86, 89
Large Ribs and Pellets Jug (Doug
 Fitch), 71
lead, 30–31
lichen glazes, 39–40
lithium, 13, 30, 31, 36, 134
low-fire porcelain, 98–99
Luster Dish with Polo Player
 (Kashan), 111
lusters, 110–119

M

Mabry, Lauren, 96, 97
majolica, 84, 86, 90, 155, 156
manganese (Mn), 17, 45
Mangus, Kirk, 55
Maron, Marc, 122, 124
masks, 15, 17
matte glazes, 100–103,
 148–154
McAndrew, Hannah, 71, 72
McCauley, George, 95
McDonald, Mackenzie, 159
The Meat Monger (TJ Erdahl),
 132, 134
*Memento (Figure with Inverted
 Heart)* (Tom Bartel), 47, 57
Methane Cow (Kip O'Krongly),
 75
Meyers, Ron, 63, 109, 145
Mickey Mouse Me (Kensuke
 Yamada), 19
Milestone Decal Art, 122
Miller, Catie, 44
moisture expansion, 26
Montgomery, Lindsay, 88, 89
mopping, 17

Morrel Vase (Ronan Peterson),
 40
Mosque Lamp, 20
Murray, Nathan, 136
Musasama, Sana, 72, 73

N

N95 masks, 15, 17
Naples, Lisa, 100–101, 148, 149
The Neighbors Hate Me (Zach
 Tate), 133
neodymium (Nd), 51
Nerifoami, 97, 98
Ngo, Jolie, 98
nickel (Ni), 49

O

O'Krongly, Kip, 75
opacifiers, 51
Orr, Lisa, 58, 59
Ortiz, Virgil, 104, 105
Ostrom, Walter, 51, 53, 86, 87,
 156, 157, 160
Owen, Ben, 50
oxides, 30

P

Paat, Alex, 140
Palette Serpentine (Holly
 Walker), 65
Pardue, Eric, 121
Payphone (Shalene Valenzuela),
 68
Peterson, Ronan, 39, 40, 57
Pewabic Pottery, 116
Pharis, Mark, 81
Pietsch, Teresa, 106, 107, 144
pinholing, 37
Pinnell, Pete, 78, 80, 81
Pintz, Joe, 49, 102, 103, 151
plasticity, 25
*Plate with a Portrait of a
 Gentleman* (Italy), 43
porcelain, 62–63, 98–99
Portmanteau (Richard James),
 132
Powell, Joanna, 90, 91, 110
praseodymium (Pr), 48
Print Maker (Paul Andrew
 Wandless), 66
Prudence (Andrea della Robbia),
 92

Q

Quackenbush, Liz, 128, 129,
 158
Quiñones, Joey, 21, 22

R

Radasch, Kari, 48, 80, 146
Ramsay, Anna, 76
Ramsay Ceramics, 23
Ramsay, Kevin, 76
Ramsey, Jessica, 17
recipes
 All Purpose White Slip
 (04–10), 106
 All Purpose White Slip (Cone
 04–10), 63
 Andersen Majolica, 161
 Andréa Keys Connell's
 Sculpture Body (Cone
 04–1), 23
 Arbuckle Majolica, 159
 Barnim Bella White Base
 (Cone 05), 111
 Barnim Cobalt Base (Cone
 05), 112
 Bartel Engobe Base (Cone
 04–02), 57
 Betty's Bisque Slip (Cone
 04–2), 64
 Carty White Earthenware
 (Cone 04–02), 23
 Clarke Overglaze/Underglaze
 Stain Mix, 74
 Cone 05 Porcelain #1, 99
 Cone 05 Porcelain #2, 99
 Cone 05 Porcelain #3, 99
 Creamy Slip (Cone 2), 107
 Darby Clear Glaze, 144
 Deb's Clear Glaze, 146
 Faux Lead Base (Cone
 04–02), 57
 Fine Amber Sparkle
 Aventurine (Cone 04), 59
 Gail Kendall Amber (Cone
 04–2), 71
 Georgie's Low-Fire White
 Casting Slip (06–04), 23
 Ghoc Redneck Majolica
 (Cone 03–5), 95
 Greg Daly's Luster Base
 Glazes, 115
 Hard Clear Base (Cone
 05–2), 70
 Hirsch Satin Matte, 150

Hirsh Satin Matte Base From
 Joe Pintz (Cone 04–02),
 102
Jackie's Satin, 153
John Gill Blue Glaze, 167
Karby's (Cone 03), 125
Katz Satin, 152
Kelleher Blue Slip (Cone 3),
 108
Kelleher Rivulet Green (Cone
 3), 108
Khazzaka Silver Luster Glaze
 (Cone 020), 119
Linda Arbuckle's Red Clay
 (Cone 04–2), 23
Lisa Naples Red Clay (Cone
 02–2), 23
Lobster (Cone 04), 66
Maggie Jaszczak Matte Base
 Glaze (Cone 04), 102
Max Henderson Goop (Cone
 06–6), 97
Naples Wagner Satin, 148
Orr Crackle-Free Base (Cone
 04), 58
Ostrom Tin Glaze, 160
overview of, 32–34
Patrick Coughlin Low-Fire
 Goop (Cone 03), 98
PB Matte Majolica (Cone
 04), 121
Peterson Lichen Glaze (Cone
 04–6), 40
Pinnell's Best Clear Glaze,
 147
Quackenbush Majolica, 158
Quigley Clear Base Glaze,
 32, 142
Radasch OM4 Base, 79
Ramsay Red Fritware Casting
 Slip (Cone 04), 23
Red Luster (Cone 019), 112
Red Orange Gold Luster
 (Cone 019), 112
Rhonda's Blue/Black Terra
 Sigillata, 82
Ron Meyers Clear Glaze, 145
Rothshank Flashing Slip
 (Cone 04–10), 106
Runny Clear Base (Cone
 05–2), 70
Shoko Clear Glaze, 141
Silver Luster (Cone 020), 112
starter kit, 13
SWO (Cone 03), 125

White Liner Glaze (Cone 2), 107

Yellow Slip (Cone 2), 107

Zaeder Matte, 154

reduction firing, 113–114

Robbia, Andrea della, 92

Robbia, Luca della, 90

Rothshank, Justin, 106, 107, 122, 123, 145

rutile (Ti + Fe), 49, 169

S

safety, 15, 16–17, 31, 104, 111

Sanders, Amy, 19

Sandler, Lauren, 103, 150

satin glazes, 100–103, 148–154

scales, 13–15

sculptural surfaces, 130–137

"scumming" (efflorescence), 21

Seeds of Tomorrow/Semillas del Mañana (Jonathan Christensen Caballero), 93, 94

selenium (Se), 50

shivering, 36–37

shrinkage, 25, 26

silica, 30, 31, 101

Simon, Sandy, 43

slip layering, 62–77

slipware, 71

software, 31

Solid Gold (Stephanie Kantor), 118, 119

spodumene, 31

stabilizers, 30

starter kit, 13

Steam-Punk Buddha (William Brouillard), 84

storage bins, 12–13

Stull chart, 101

Stull, Robert, 101

Summerfield, Liz Zlot, 82

T

Tate, Zach, 133, 134

terracotta, 18, 19, 21

terra sigillata, 78–83

Teruyama, Shoko, 54, 60, 140–141

testing

absorption, 26

aesthetic testing, 26

colorant addition, 164–165

moisture expansion, 26

plasticity, 25

progression tests, 166–167

shrinkage, 25, 26

test batches, 16

tiles for, 27

triaxial blends, 168–169

That thing you want (Alex Anderson), 117, 119

Theseus and Minotaur (Shoulder of a Black-Figure Hydria) (Antimenes painter), 18

Thullen, Alex, 116

tin (Sn), 51, 84–95, 111, 155–161

titanium (Ti), 49

toxicity, 17, 31, 104

Treehouse (Celia Feldberg), 69

Tugio, Giunta di, 51, 53

Turkey Hen and Poults Platter (Catie Miller), 44

Turquoise Chesterfield with Abstract Painting Cup (Pattie Chalmers), 68

Tyree, Shirley, 136

U

underglaze layering, 62–77

V

Valenzuela, Shalene, 68

vanadium (V), 47, 48

Vase after Giovanni Della Robbia (Mackenzie McDonald), 159

Vase with Handles (Stan Andersen), 52

W

Wagner, Karla, 100–101, 148

Walker, Holly, 65

Wandless, Paul Andrew, 66

water access, 13

Wedel, Matt, 160

Weiner, Alan, 110

What if We Could Ask Our Future Selves a Question? (Shanna Fliegel), 67

Whistle Skull (Bill Brouillard), 159

White Topography (Nicholas Bernard), 55

Whorls and Spools (Lauren Sandler), 150

Willers, Rhonda, 83

Wonderers (Matt Wedel), 160

Wright, Maura, 64

X

X, Malcolm, 136

Y

Yamada, Kensuke, 19

Y lo Mumura el Rio (Renata Cassiano), 134, 135

Z

zirconium (ZrO_2), 51, 86

ALSO AVAILABLE

Mastering the Potter's Wheel
by Ben Carter
ISBN: 978-0-7603-4975-5

Mastering Hand Building
by Sunshine Cobb
ISBN: 978-0-7603-5273-1

Amazing Glaze by Gabriel Kline
ISBN: 978-0-7603-6103-0

Mastering Kilns and Firing
by Lindsay Oesterritter
ISBN: 978-0-7603-6488-8

Amazing Glaze Recipes and Combinations
by Gabriel Kline
ISBN: 978-1-58923-980-7

Mastering Sculpture: The Figure in Clay
by Cristina Córdova
ISBN: 978-0-7603-7309-5

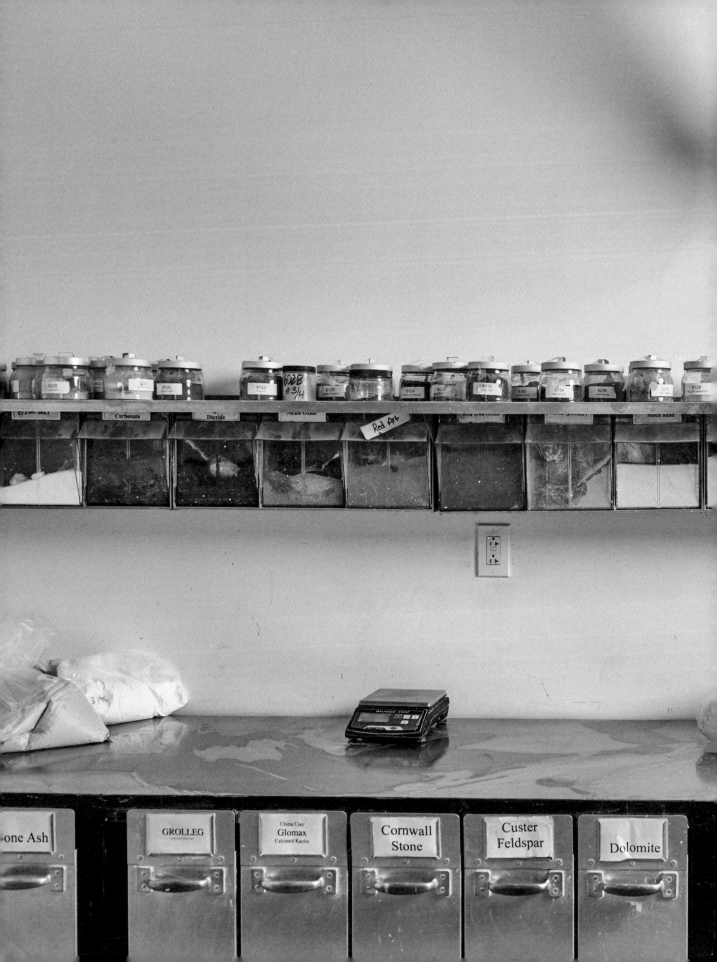